Holding On

Iain Scott

This book is dedicated to Becky
who gives everything.

First published in 2012 by HPT Books

HPT Books is part of
The Human Potential Trust
The Oasis
Highbrook Lane
West Hoathly
Sussex RH19 4PL
England

A catalogue record for this book is available from the British Library.

Proceeds from the sale of this book, including the author's/photographer's
royalties, will be used for our charitable work.

ISBN 978-1-899131-05-1

Printed and bound by Tien Wah Press (Pte) Ltd, Singapore.

Page 1: *Holding on.*

Pages 2-3: *A white rhino emerges from the bushes in Kruger National Park.*

Right: *A male lion early one morning in Etosha National Park.*

Overleaf: *An Indian tiger looking up.*

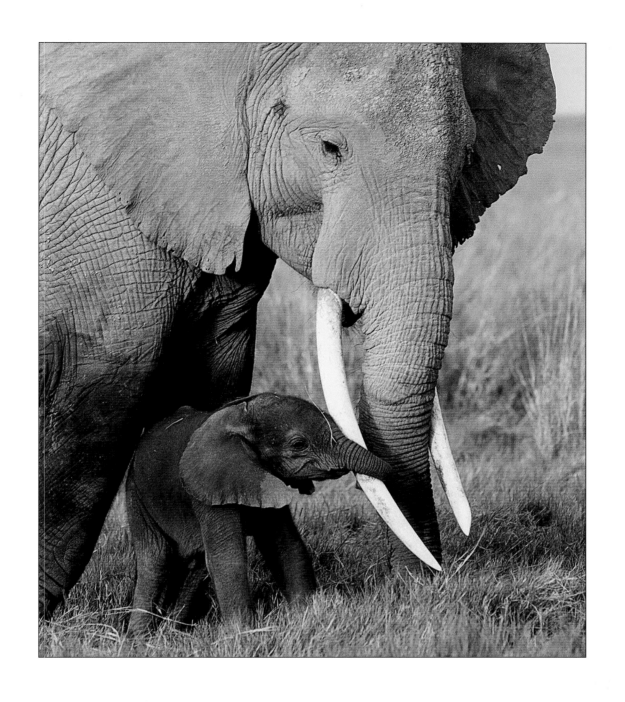

Holding On

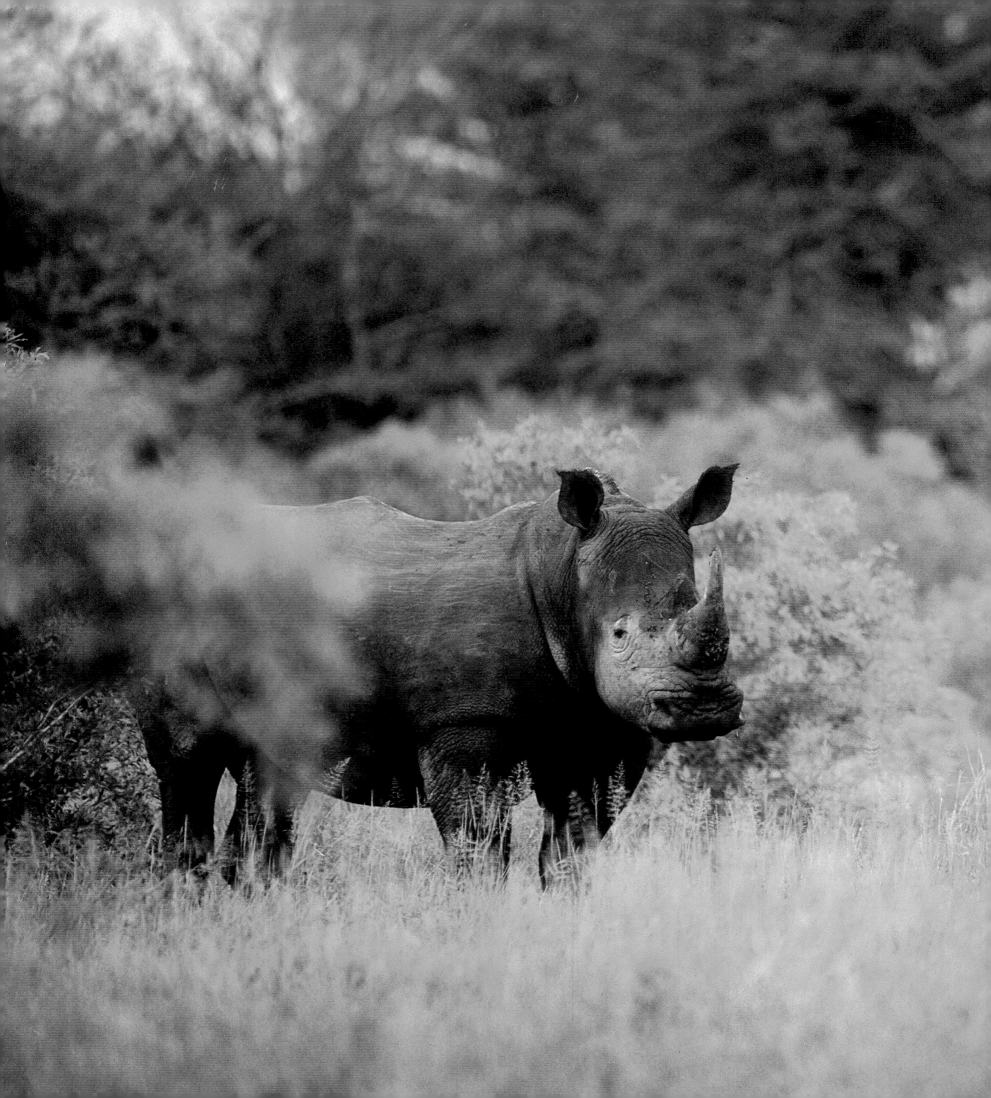

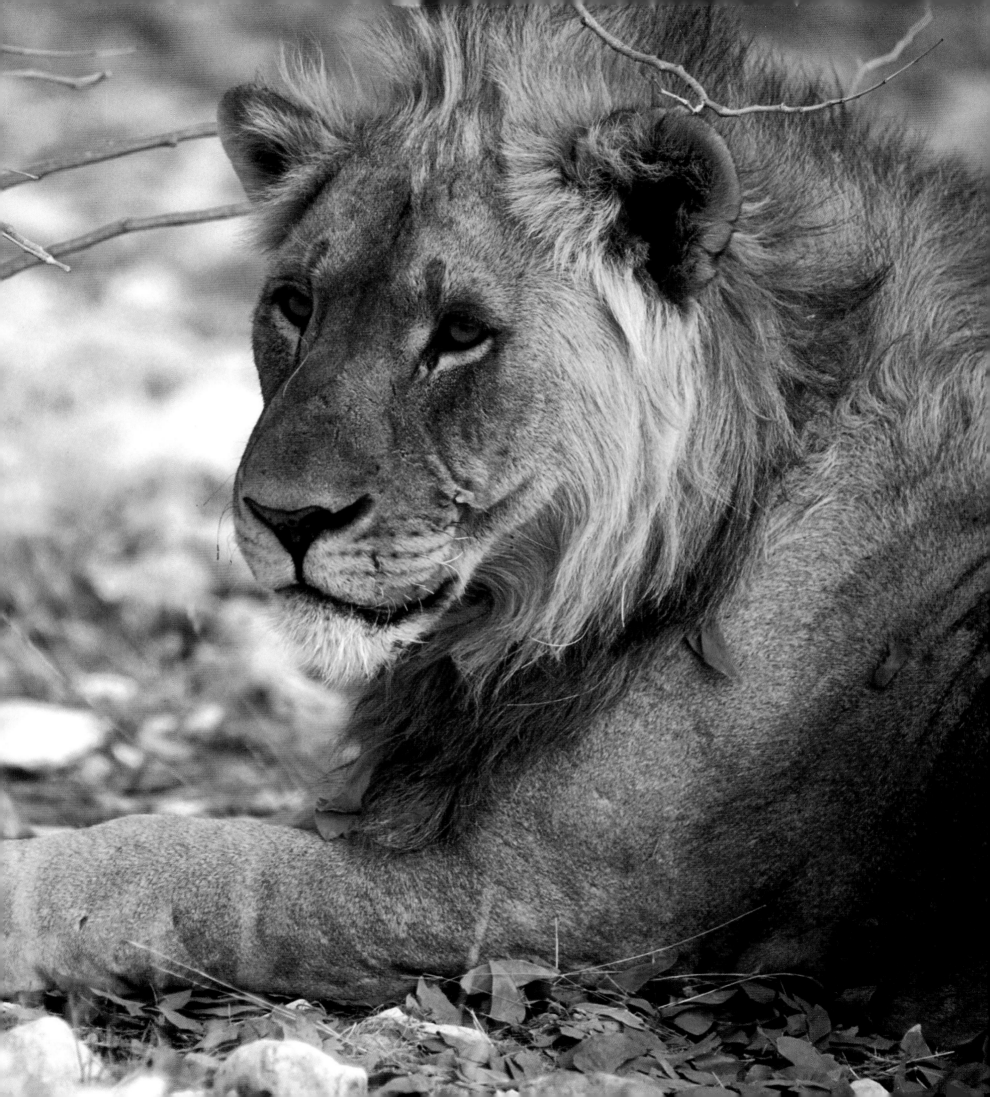

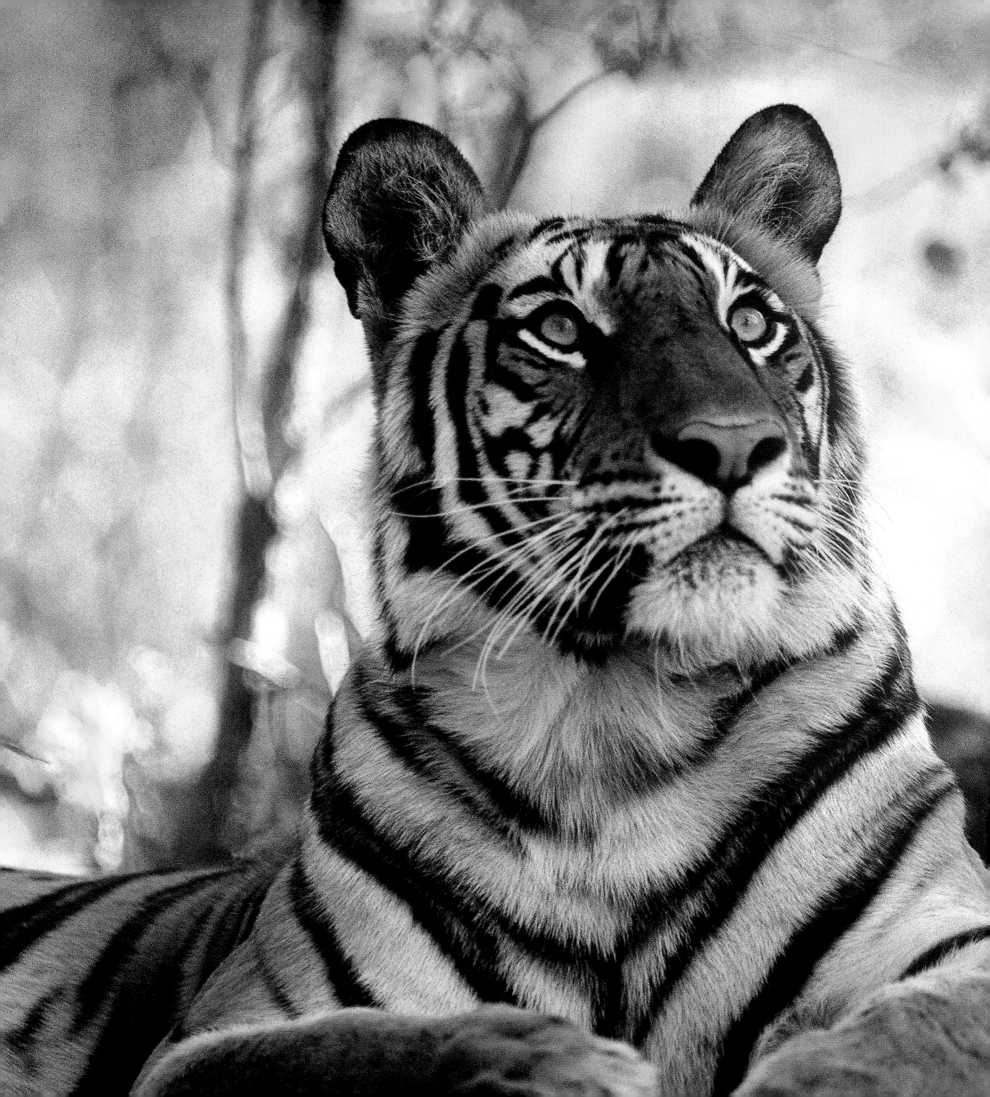

Contents

Introduction

A good beginning.....
...but not good enough

This is a book about some of the problems facing our planet's wildlife. It is also a book about solutions to these problems.

There is no doubt that many species are endangered. They are "holding on" but far from being safe. Countless other species are becoming rare and likewise face an uncertain future. What we human beings do over the coming years and decades ahead will be crucial for these wild animals and plants.

Obviously, this is a coffee-table book and so the photographic images have to be high quality. But, unusually for a book of this type, I trust that the accompanying words also stand out. They are intended to be hard-hitting and educational. If endangered species are indeed "holding on", barely surviving, then there isn't time for pussy-footing about. So I make no apologies if my words are challenging. I am realistic and straight-forward in my approach, knowing that this is necessary if we are to make a difference and change things for the better. Fooling ourselves won't change anything - and delays can be costly.

The nature conservation movement has made a good beginning but there is still a very long way to go. People confuse awareness with achievement. Whereas awareness of our many environmental problems has undoubtedly grown, actual achievement has been limited. We now need to do more. Much more.

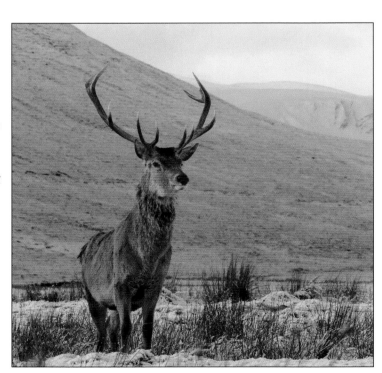

Right: A red deer stag in the Scottish Highlands. When will wolves be returned to this wilderness as a natural predator?

Far right: An endangered black rhino comes to drink in the late afternoon at Rietfontein waterhole in Etosha National Park, Namibia. Etosha is one of the few places in Africa where the black rhino is holding on.

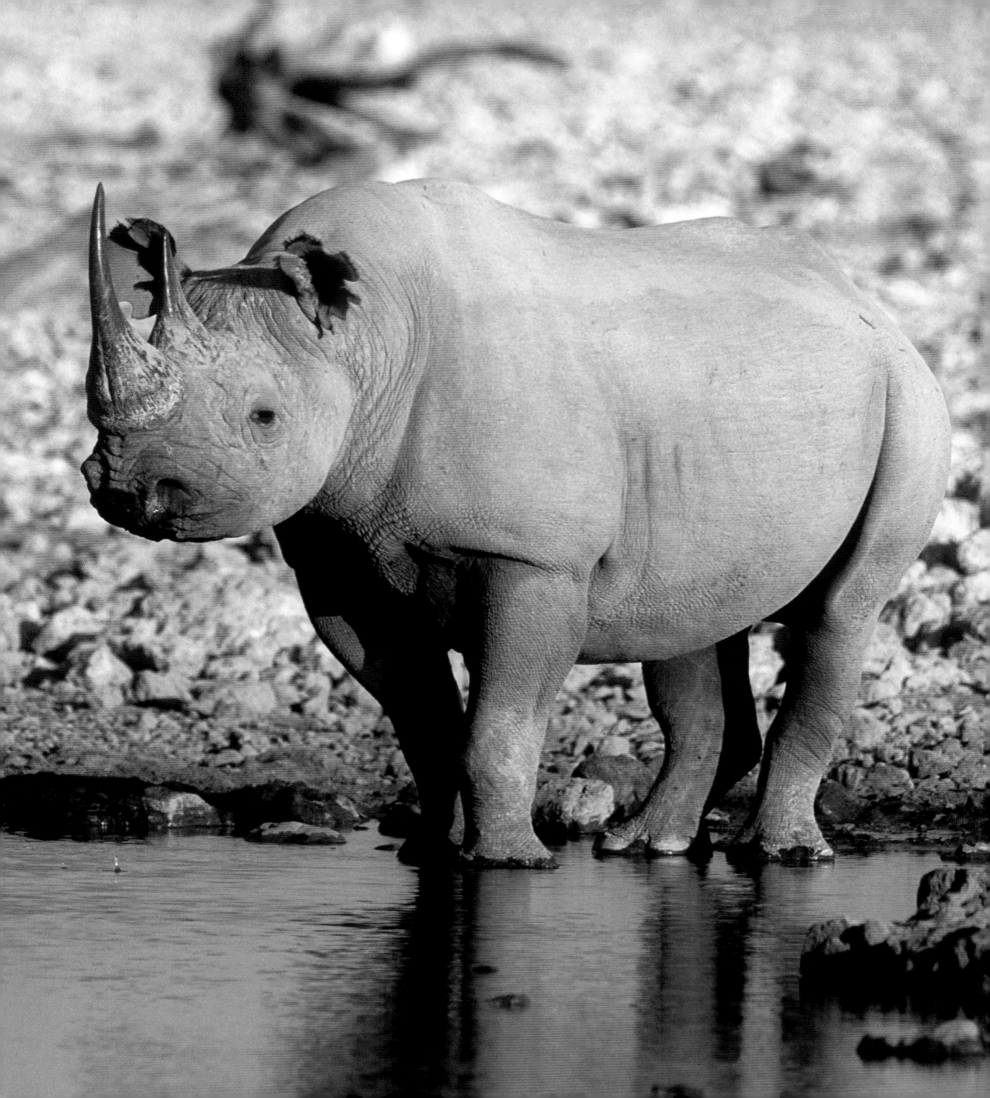

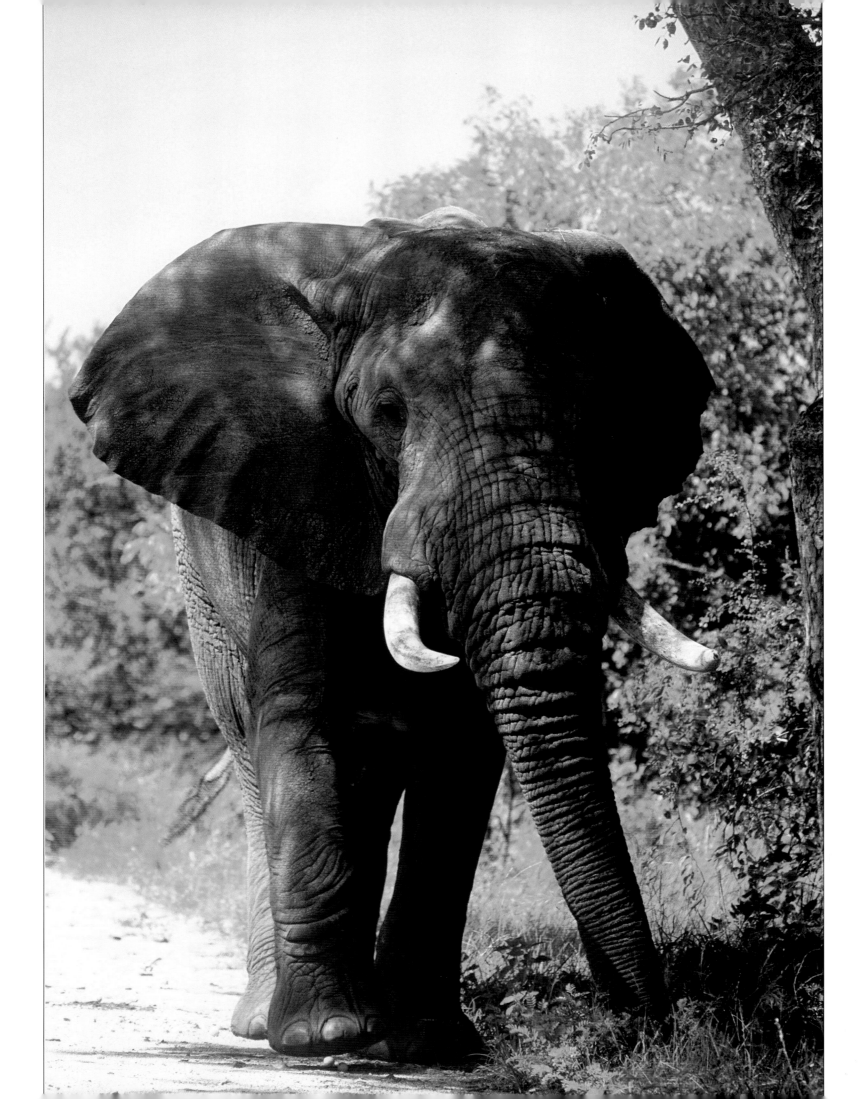

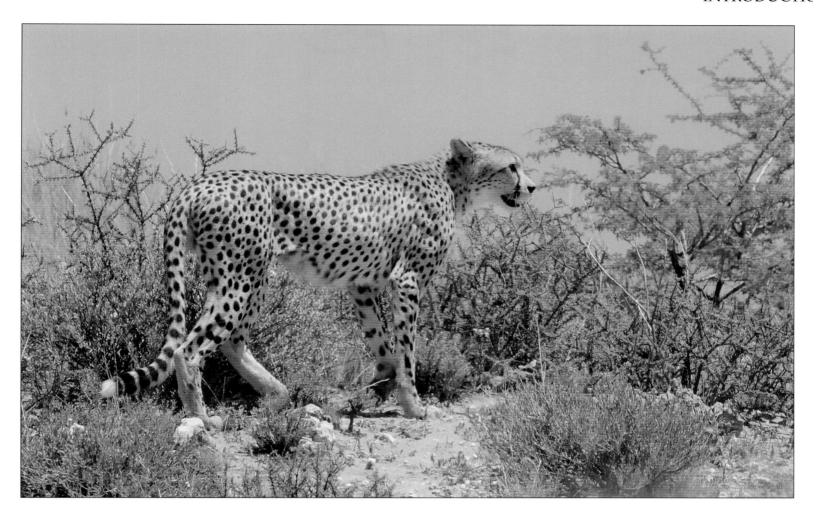

So my aim with the words of this book is to be thought-provoking - in addition to the images, which I hope will re-confirm your appreciation for the wonders of nature. A good beginning is just that.....a good beginning. But it is not yet good enough and we need to be big and brave to face this sobering fact - rather than getting carried away with our new-found environmental awareness.

If we are to overcome the considerable problems facing wildlife and the all-important natural habitats throughout the world, we now need to expand our thinking and go beyond the current limitations. This improved thinking must then be translated into real and appropriate action. This is a challenge that we cannot ignore if there is to be significant progress.

Immature human behaviour has caused the problems and we are now beginning to wake up to what is happening. To repair the damage we have done will require maturity. It is time to grow up. Indeed, it is our duty to make things better.

In the first major section of this book, I make the case that size matters; more space for wildlife is needed. This is especially true when the aim is to conserve large animals and predators. The African elephant and lion, in particular, are good examples of this issue and both demonstrate the fact that size matters.

Above: Cheetah numbers in the Kalahari have recently increased, but only because lions have significantly decreased. Overall, the cheetah is becoming more threatened as the years go by. A lot of space is required to accommodate healthy populations of both predators.

Left: A male elephant enjoys eating the fruit of a marula tree in Kruger National Park.

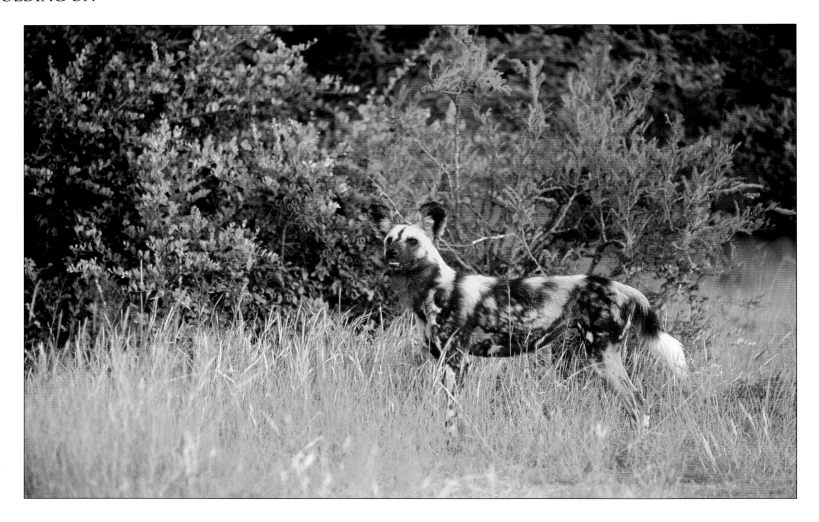

Above: The African wild dog is holding on in Kruger National Park, South Africa, although numbers have declined in recent years. Lion predation causes up to a third of all wild dog deaths. This particular wild dog had just spotted a male lion waiting in ambush for them, saving its pack a lot of potential trouble.

Right: The tiger is facing extinction in the wild, despite decades of conservation effort.

In another section, I focus on a success story: the re-introduction of wolves to Yellowstone National Park in the USA. It is a case history involving entrenched beliefs that took years to combat and which continue to this day. But the wolves are back and doing well.

I then go on to ask why well-known megafauna such as tigers and rhinos are still endangered after 50 years of conservation effort. Why has the situation gone from crisis to crisis, backwards instead of forwards? What has gone wrong? What has been missed or overlooked?

Towards the end of the book, I outline the reasons why Komsberg Wilderness Nature Reserve in South Africa is so unusually successful. This is more than just a success story. Komsberg's pioneering example suggests a better way forward for the future.

Finally, I conclude by outlining the biggest challenges that lie ahead. Again, I am blunt and explain why human behaviour must improve.

There are a number of crucially important lessons to be learnt here for anyone who is concerned about our planet's wildlife.

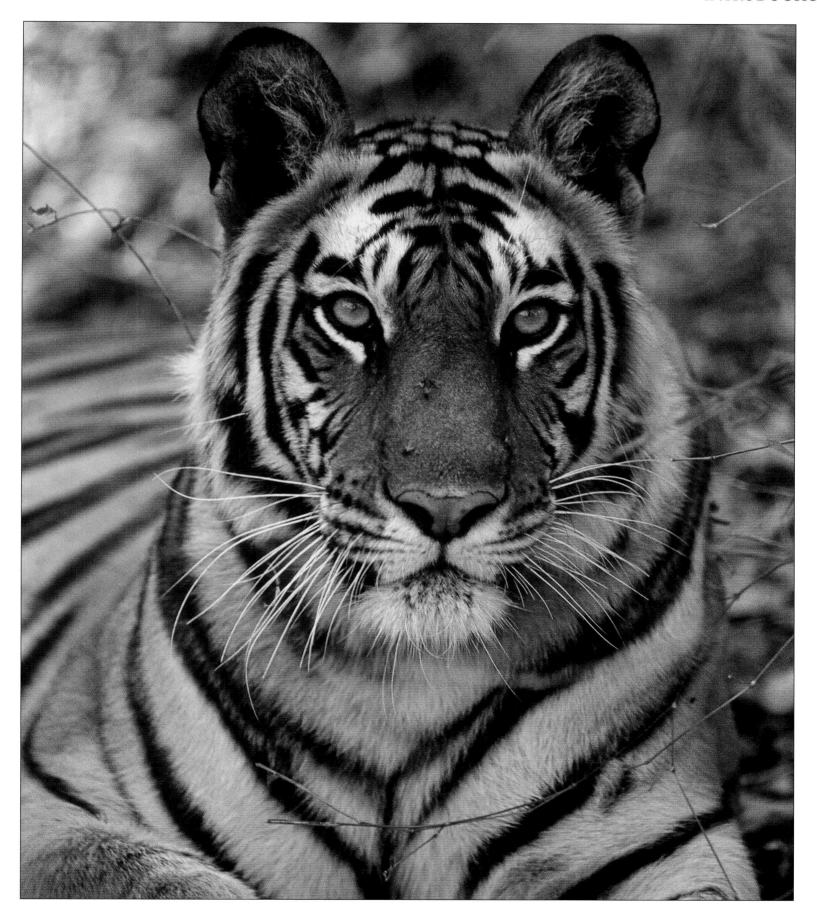

Size matters
Big animals and predators
need a lot of space

Elephants and lions are two of the most popular wild animals. They demonstrate in several ways that size matters. Elephants are huge and this makes them dominant; lions are the biggest and most powerful of Africa's predators. But, more importantly, they need a lot of space in which to live.

Elephants are the largest of our land mammals. The African elephant is the biggest of the two species. Elephants require a lot of food, spending between 60% and 70% of their waking hours feeding. An adult male consumes an average of 140kg (310lb) of vegetation each day. They drink as much as 225 litres (50 gallons) of water in a 24-hour period. The diet of an elephant is varied and includes grasses, reeds, herbs, shrubs, succulent plants, and trees.....leaves, twigs, branches, bark, seedlings, flowers, fruit, seeds, roots, and tubers. They commonly push over whole trees.

With their enormous appetite, size, and strength, elephants can have a huge impact on their environment. They can turn woodland into grassland. In the past, when their food supply became short, elephants simply moved elsewhere. In time the trees regenerated. Now the situation is different. Elephants are mostly restricted to national parks. As big as these may seem to the casual visitor, space is nevertheless limited. If elephants wander onto neighbouring farmland in search of food, they are regarded as troublesome and dangerous. If restricted within a national park, they are often accused by park managers of being "destructive" to their own habitat. As elephants flourish and a change of habitat takes place, a few other species may decline as a result of their environmental needs being lost.

The reality, however, is that the elephants are merely doing what elephants do - which includes knocking over trees. There simply isn't enough space nowadays for them to keep moving on, as the habitat goes through its cycle of change. We humans have taken too much space for ourselves.

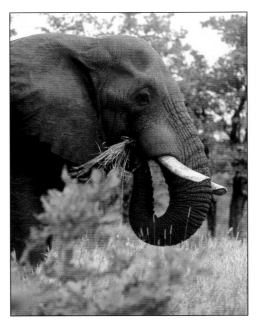

Right: *Elephants spend a lot of time eating.*

Far right: *One of Kruger National Park's large tuskers.*

14

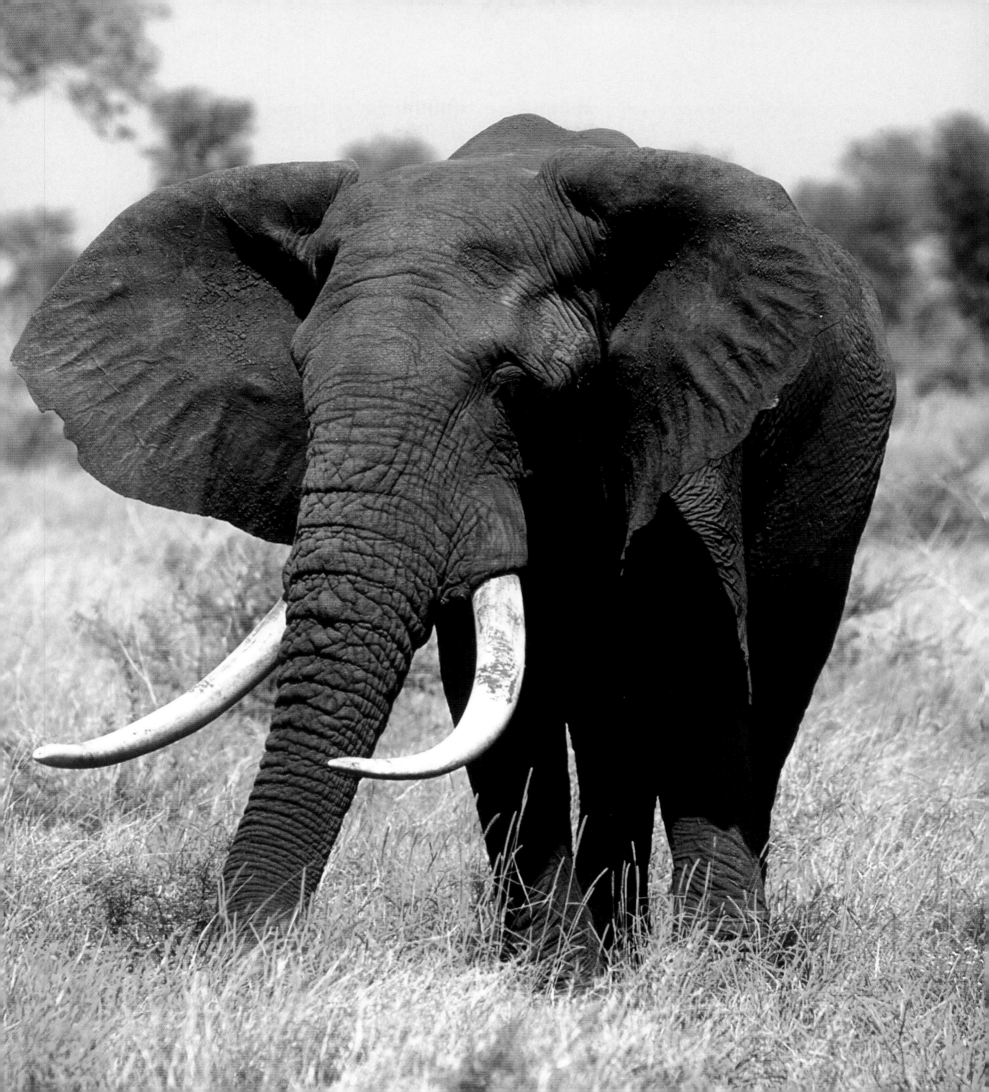

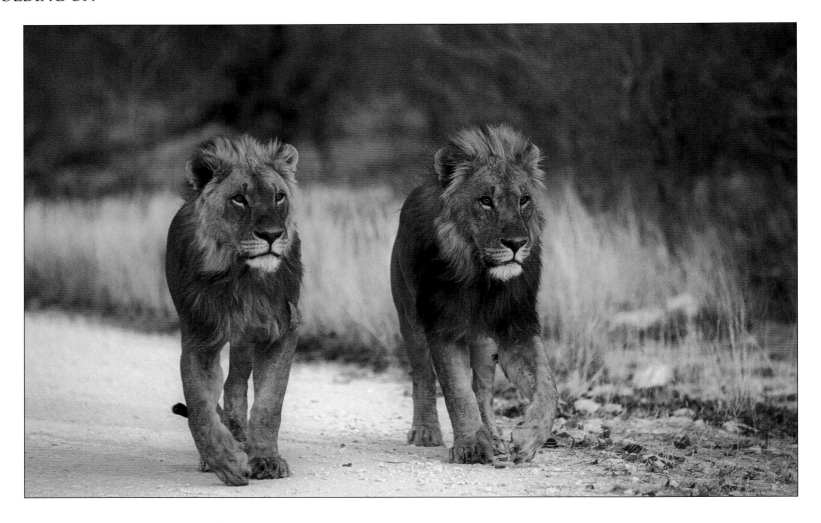

Above: Male lions often form coalitions. They are usually brothers but can be unrelated.

Right: The mating of lions lasts only a few seconds but is frequently repeated and up to 50 copulations in 24 hours is not uncommon. Despite an average of 300 copulations each time a female comes into heat, she is only 25% likely to become pregnant.

Lions are big predators. A male lion can weigh up to 260kg. They eat other animals such as zebra, buffalo, and various antelope. These prey species, in turn, need an area of land big enough to provide all their essential living requirements. Furthermore, there must be a large number of these animals so that they too can survive as well as support a healthy population of lions. To complicate matters still further, there are other predators - such as leopard, hyena, and cheetah - that also need to eat to survive. When you think about this wider picture, it is easy to understand that a big space is required to accommodate everything.

Lions are highly territorial. This aggressive behaviour is part of their survival mechanism. They defend their territory against other prides and individual lions - and other competing predatory species - in order to safeguard their food supply. As it is, many cubs die due to starvation. A single pride of lions is usually made up of 4 to 12 adult females, cubs, and one or more adult males. In the Serengeti, the average home range of a lion pride is 65 sq km (woodland) to 184 sq km (grassland). The largest recorded is 3,438 sq km in the Kunene region of north-west Namibia. A territory must have sufficient prey to feed the pride all year round and have water available throughout the year. Many prides are necessary to sustain a healthy lion population. Again, I trust you get the general idea that size matters.

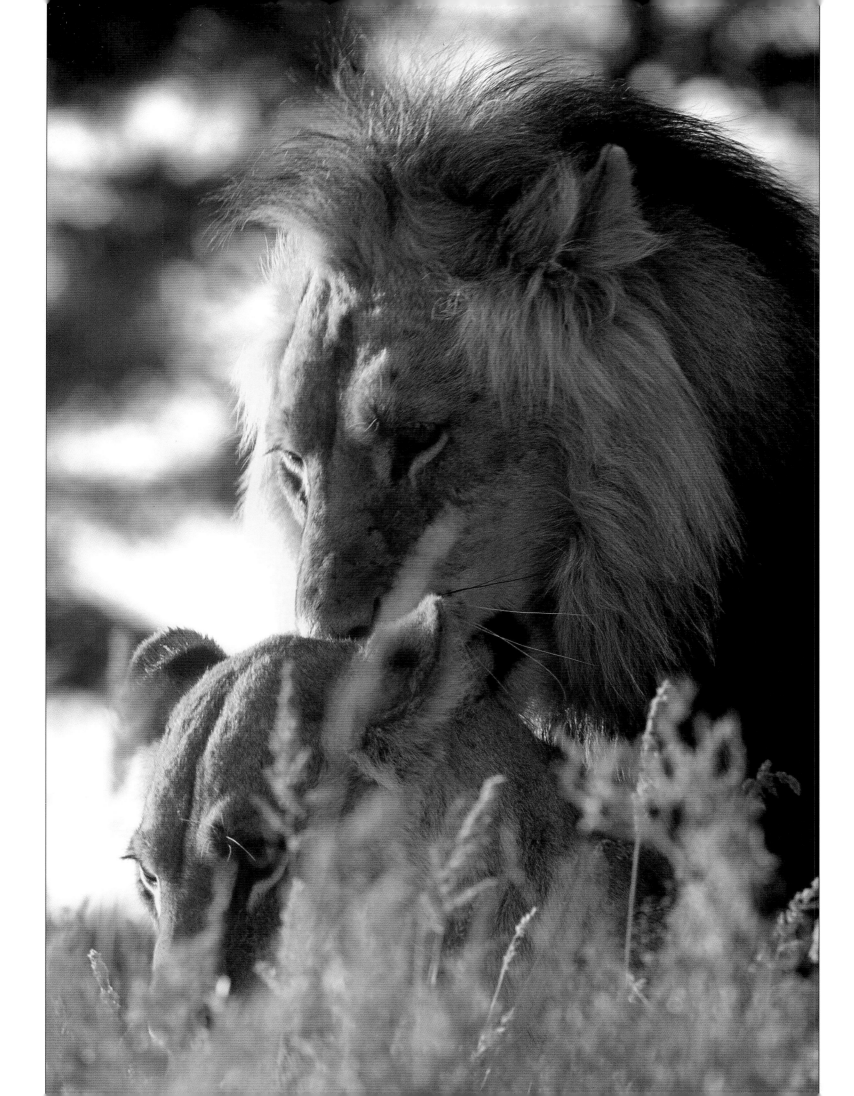

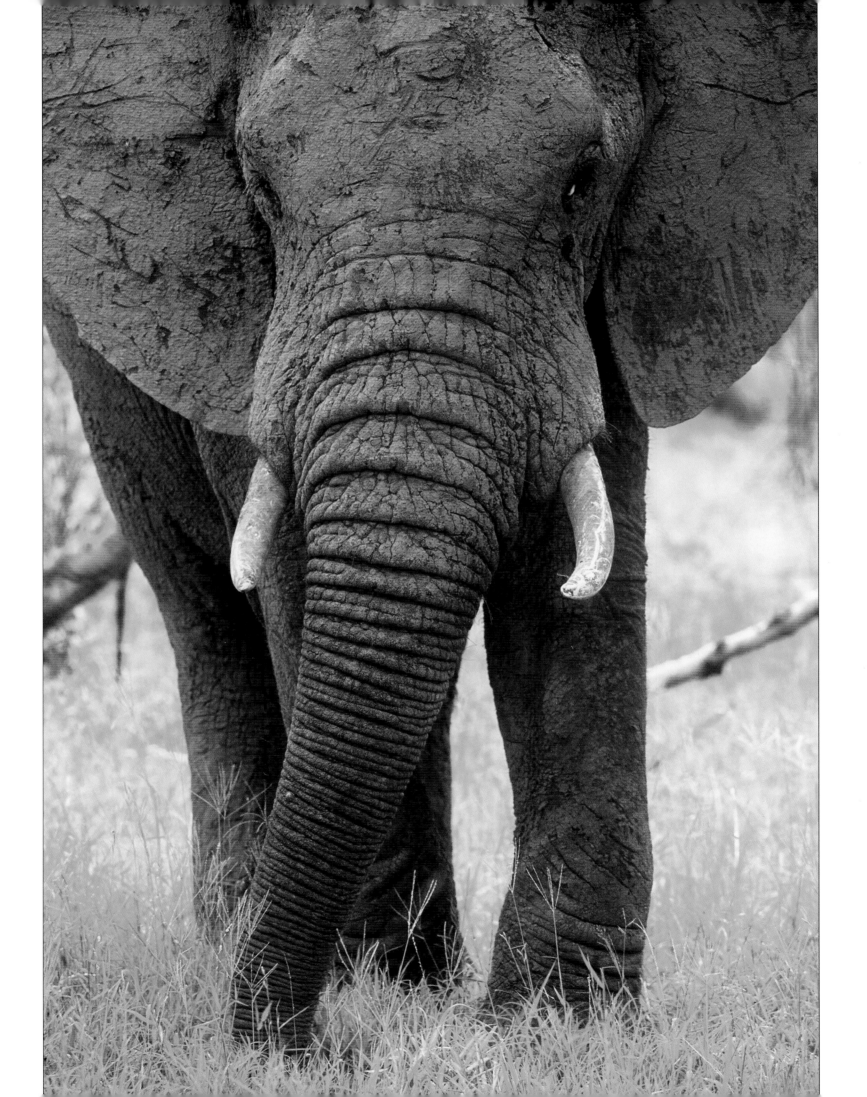

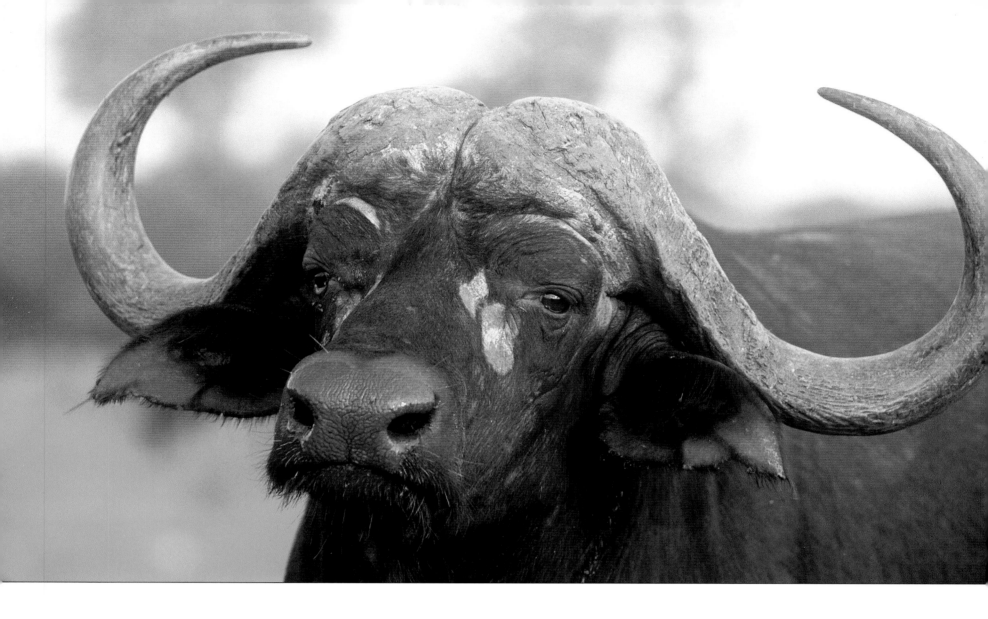

Human activity dominates our world. Houses are either clustered together in the massive urban sprawl of cities and towns or else dotted around the countryside. Other buildings are then constructed in the form of shops, schools, hospitals, offices, factories, sports centres of various description, churches and mosques, power generating plants, petrol stations, airports, railway and bus stations, and much more. Countless farms provide food, along with the exploitation of our oceans and seas. Commercial forests supply wood for various purposes. Quarries yield additional building materials. Reservoirs are constructed to help cater for our considerable water usage. Roads allow us to travel around. And so on.

Meanwhile, nature struggles with what is left.

As the human population has increased, we have exploited more and more of our planet's natural resources. Going back to the times of the Roman Empire and Jesus of Nazareth, the world population was probably about 250 million. It didn't reach half a billion until the mid-17th century. There were 1 billion people by the year 1800 or thereabouts. The 2 billion mark was reached by the 1930s. Exponential growth then more quickly resulted in there being 3 billion people by 1960, 4 billion by 1975, and 5 billion by 1987. A few months after my book *What Will It Take? A Deeper Approach To Nature Conservation* was published in 1999, the world population of human beings

Above: Buffalo are big animals and frequently form large herds, not least for defence against attack from lions. Again, they need a lot of space.

Left: Elephants eat a variety of different foods. This male is eating finger grass, freshly re-grown after good rains.

19

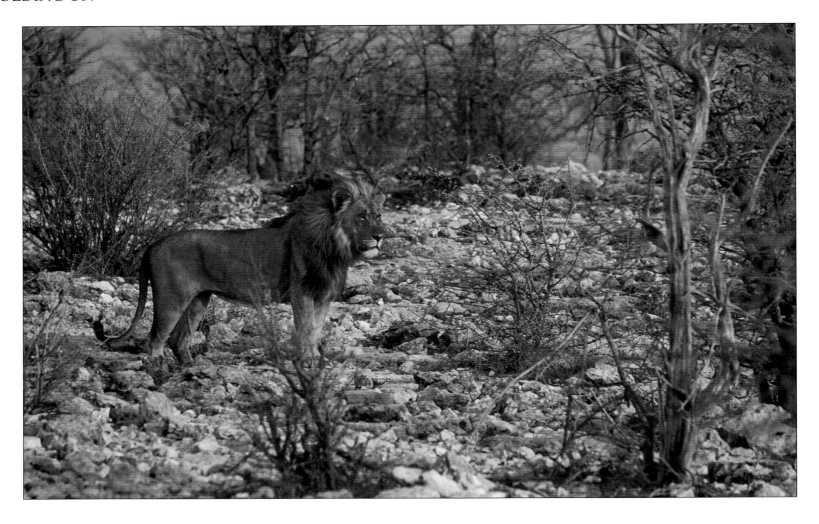

Above and right: Lions need large territories with sufficient prey to eat. Many different territories and prides are required to maintain a viable long-term lion population. The male (right) is spray marking his territory. The scent of urine against the tree has the effect of communicating his presence to other potentially competing males that might wander into the area.

exceeded 6 billion. We reached 7 billion at the end of October 2011, just as I was finishing this book. It is likely that the world population will be 8 billion or more by 2025.

As a teenager, 40 years ago, I was deeply concerned that there were too many people. A further 80 million people every year have been added to the growing total since then. These are staggering numbers that have changed the face of our planet. There has been an extra 4 billion people added to the world's human population since I was born, more than doubling it during my lifetime to date - and I am only 54 years of age. Such mathematical facts cannot be ignored.

The biggest natural resource consumed by human beings is space. A variety of crucial habitats for wildlife have been destroyed, damaged, or severely limited as a result of our expanding dominance. Take away these all-important habitats and most wildlife will then struggle to flourish. During this past half-century or so, we have lost countless wild animal populations; what was once common is now rare or at least rarer than before.

Even the once-common lion is now officially classified as being vulnerable to extinction. When I predicted this many years ago to my colleagues, I could see the doubt on their faces despite their respect for me. Much of "the wild" has now gone. There are simply too many people.

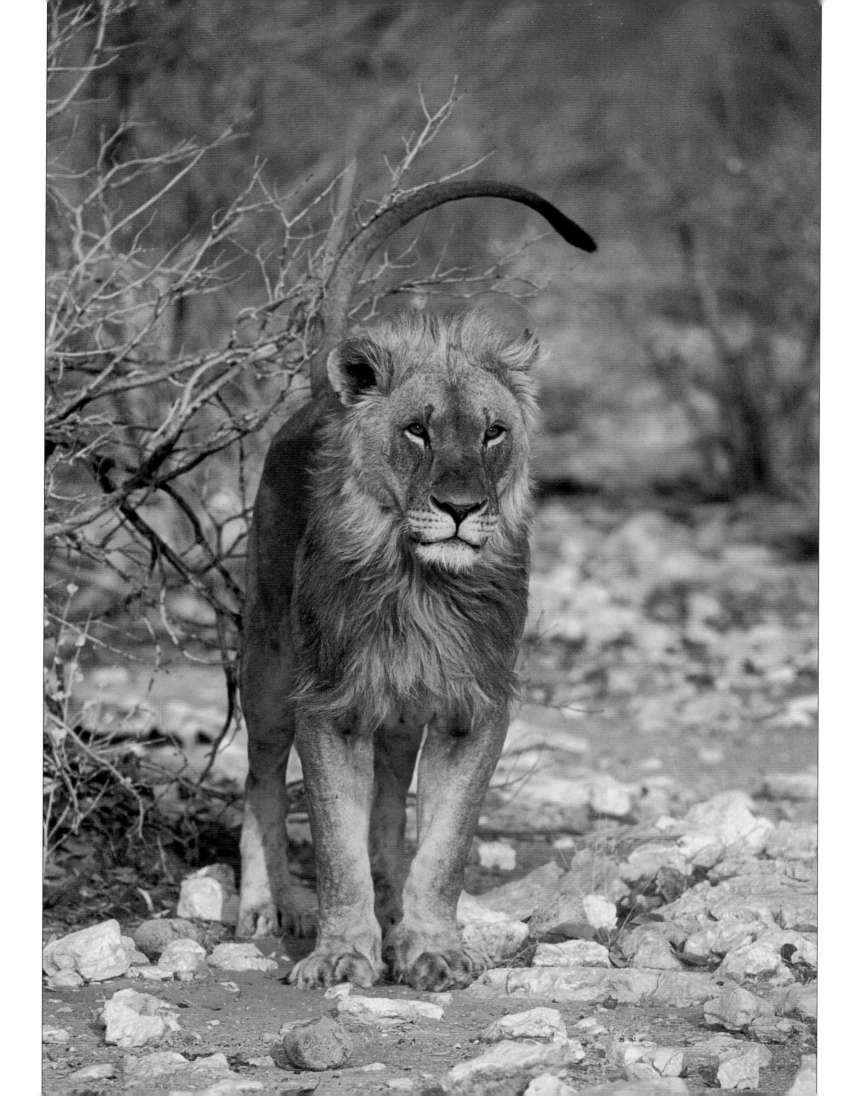

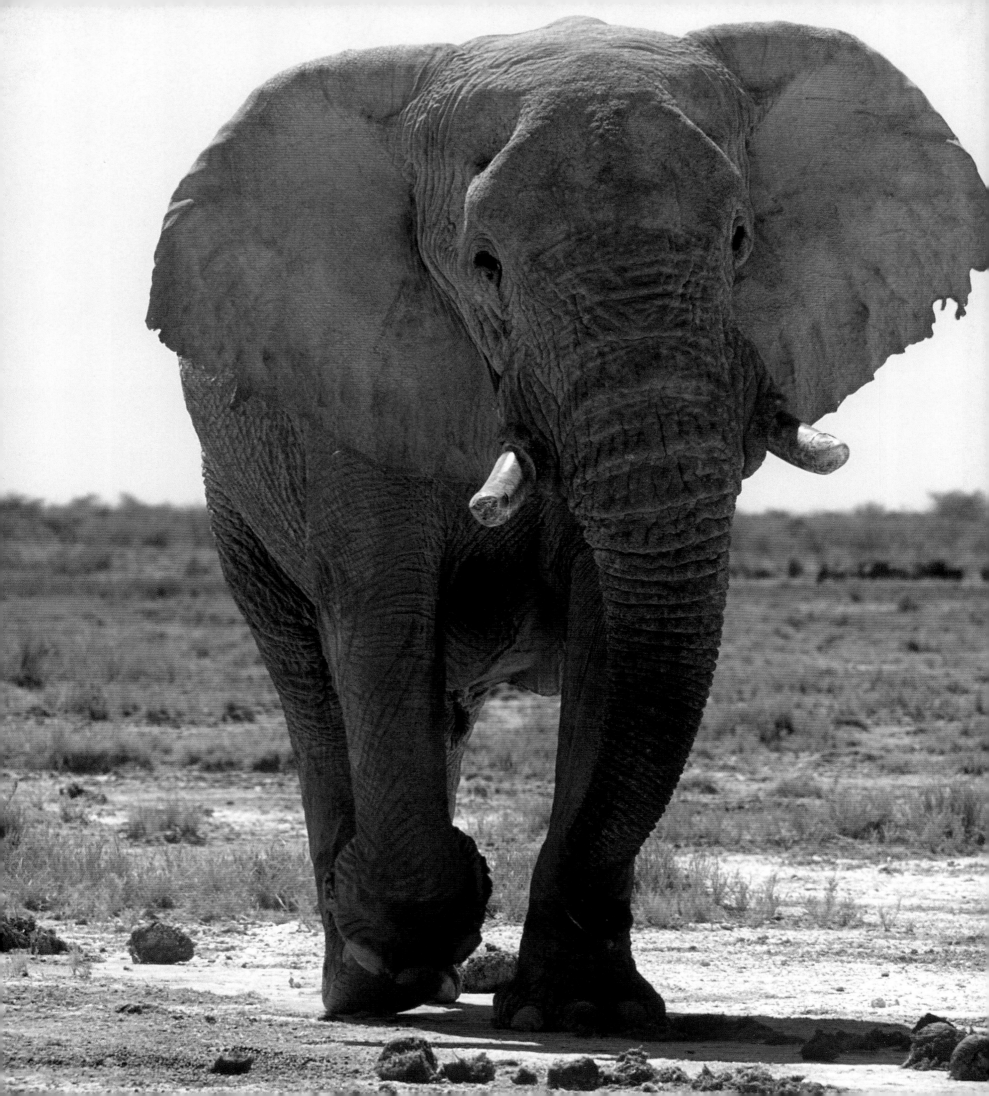

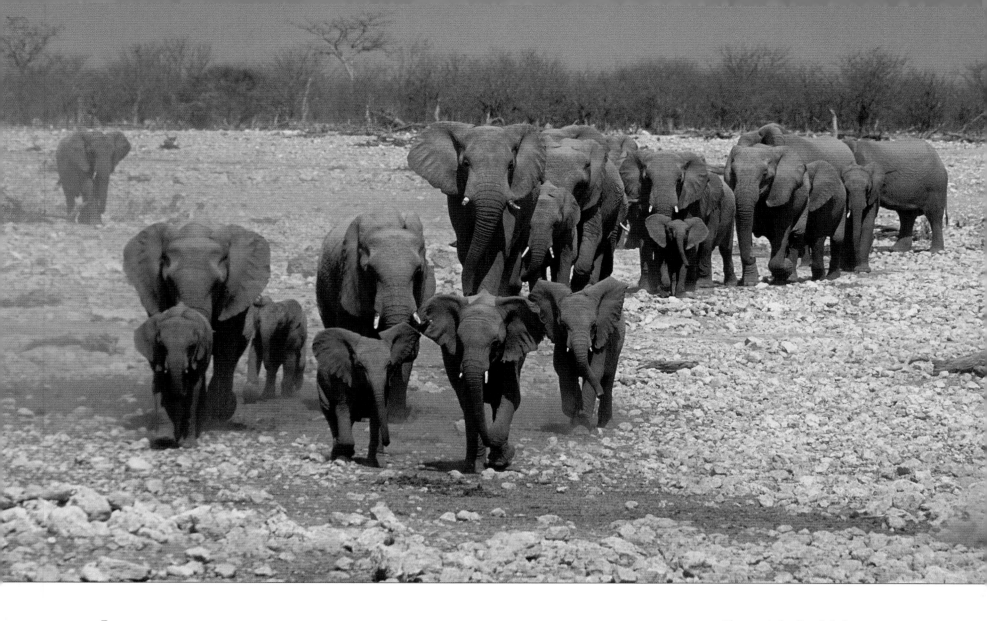

It is usually the older and bigger of the male elephants which mate with sexually receptive females. These mature males have gradually established their dominance over other bull elephants in any given area over many years. They have sparred, at first playfully, through their earlier years with each other. Later, these tests of strength become serious. Injuries and broken tusks sometimes result when the competition is evenly matched.

The oldest of all male elephants are called "big tuskers". But centuries of relentless hunting and poaching have reduced the number of these mature bull elephants whose magnificent ivory has developed with age. In the last few hundred years, tusk size has diminished. And widespread poaching during the 1980s removed most of an entire generation of potential tuskers, leaving mainly the young and those elephants with small tusks or none at all. However, the few that remain provide an impressive sight.

These big tuskers generally know it is wise to keep their distance from one another to avoid unnecessary conflict. They are experienced survivors, nearing the end of their natural lifespan. Their individual home ranges are big. Therefore, a lot of space is needed to accommodate a healthy population of these mature bull elephants. Again, size matters.

Above: A family of elephants eagerly approaching a waterhole in the dry season. One elephant can drink 225 litres of water each day - so this family could get through 4,500 litres a day.

Left: The ears of elephants usually become torn at the edges with age. They may be ripped by thorns or damaged during fights with other elephants. These ear markings are unique to each individual elephant and often prove to be helpful for identification purposes.

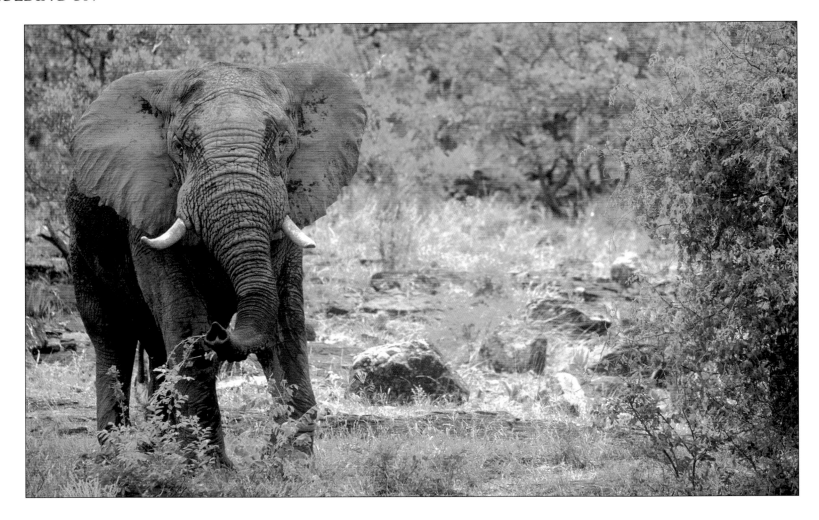

Above: This male elephant has sprayed wet mud over his body to help keep cool during an unusually hot summer period. An extensive network of blood vessels on the back of an elephant's ears also play a crucial role in temperature regulation.

Right: Two elephants resting forehead to forehead during the middle hours of the day, demonstrating their close relationship.

Kruger National Park in South Africa is one of the biggest national parks anywhere in the world. It is approximately the size of a small country such as Wales or Israel. It is undeniably big. So South Africa must be given serious credit for this achievement, together with a range of other such conservation havens that exist within its borders. But despite Kruger's size, it simply isn't big enough.

Elephants have been culled here in large numbers during recent decades as their population has increased. They have been changing the face of their landscape, as elephants naturally do - thereby putting other species in danger of becoming locally extinct as their specific habitats have been altered. In the past, long before billions of humans took over the planet, there was sufficient space for everything to move on as the natural cycles occurred again and again. But now space for wild animals is a major problem as we have imposed unnatural restrictions on their movement and behaviour. We have severely limited what was previously abundant.

So because Kruger National Park isn't really big enough for a large population of elephants plus all of the other wild animal species, the park's management has faced an agonising choice. Do you prioritise the maintenance of biodiversity? Or does your specific concern for elephant welfare prevail? This is the "headache versus heartache" question.

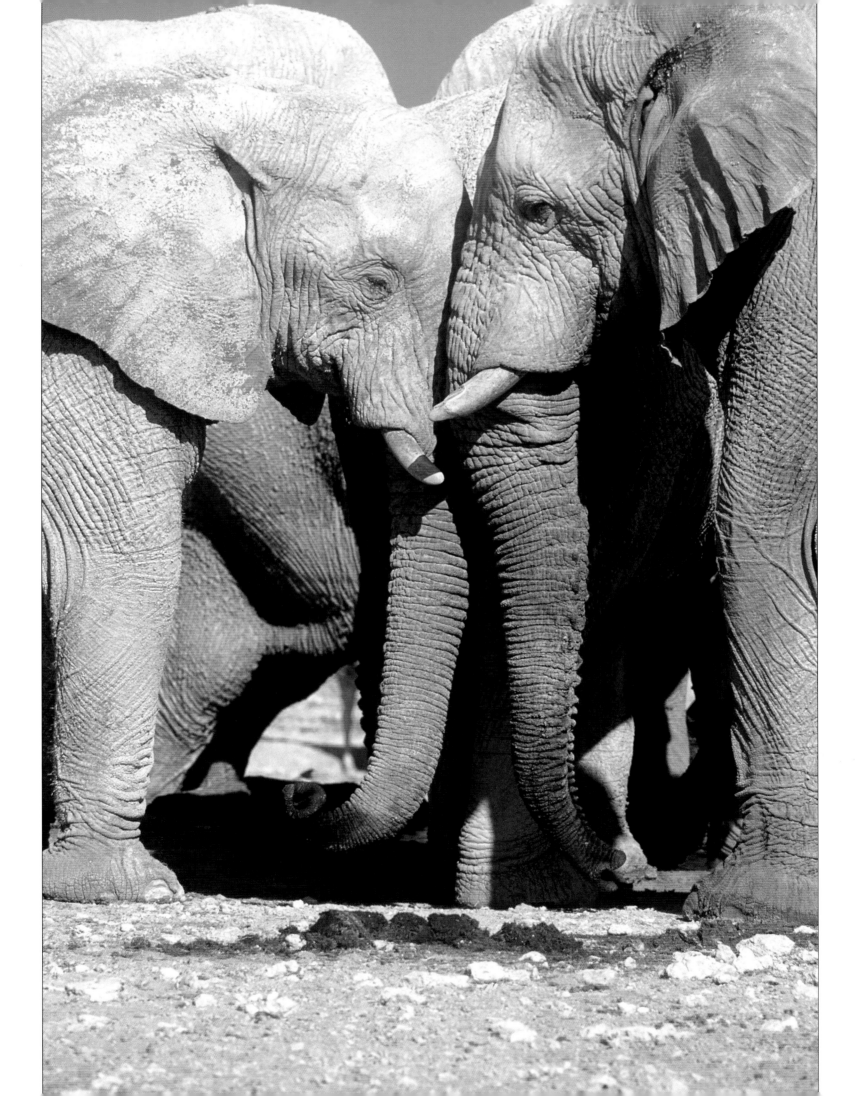

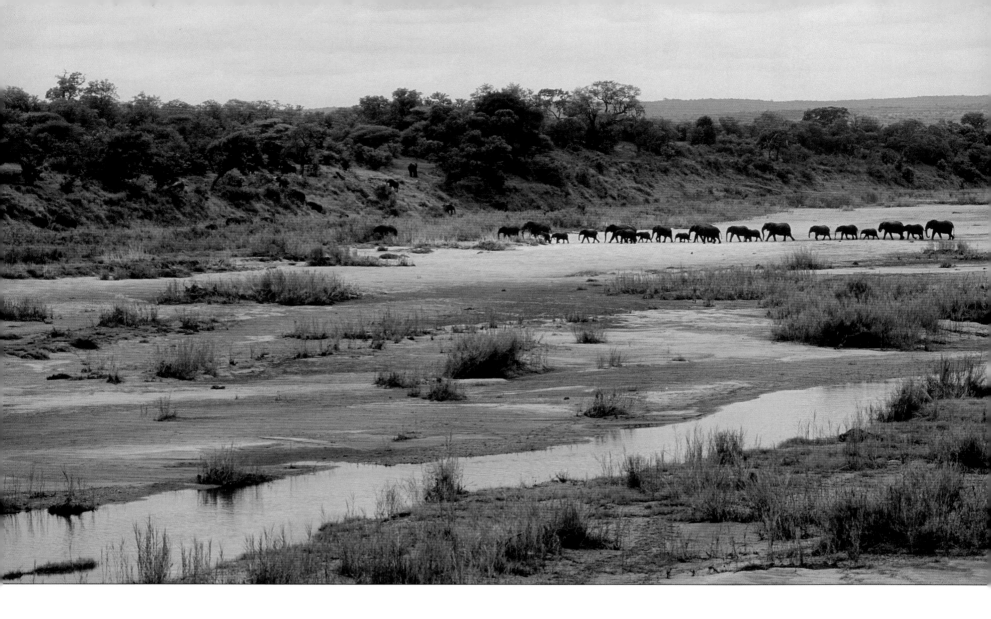

Above and right: The family of
elephants and the giraffe - large
wild animals - are dwarfed by
the huge expanse of their natural
habitats.
To repeat yet again: a lot of
space is needed for successful
conservation. Size matters.
We need to "think big".

Whether to cull or not is a real dilemma, with strong arguments on both sides of the debate. There is no doubt that elephants are highly intelligent mammals, capable of a range of emotions, demonstrating a remarkable capacity for learning and they enjoy complex social interactions. They clearly suffer from culling, even when this is done as humanely as possible.

But, on the other hand, we also appreciate the need for species diversity. We recognise that there is a duty to conserve *all* the various animals and plants living within an ecosystem. Are you failing to properly manage if you let a particular species become locally extinct?

This headache versus heartache debate is real and there is no easy answer to the dilemma - unless it is acknowledged that even such a big place as Kruger National Park is not yet big enough. By facing this basic fact - and then being willing to further enlarge Kruger - a third option becomes available, thus providing a solution to the headache versus heartache problem.

Many experts have claimed that Kruger has "too many elephants". But it is the interpretation that is crucial. Is this really an elephant problem or is it a human problem? From a rational perspective, it is surely a case of too many people taking up too much space that once belonged to elephants and other wildlife.

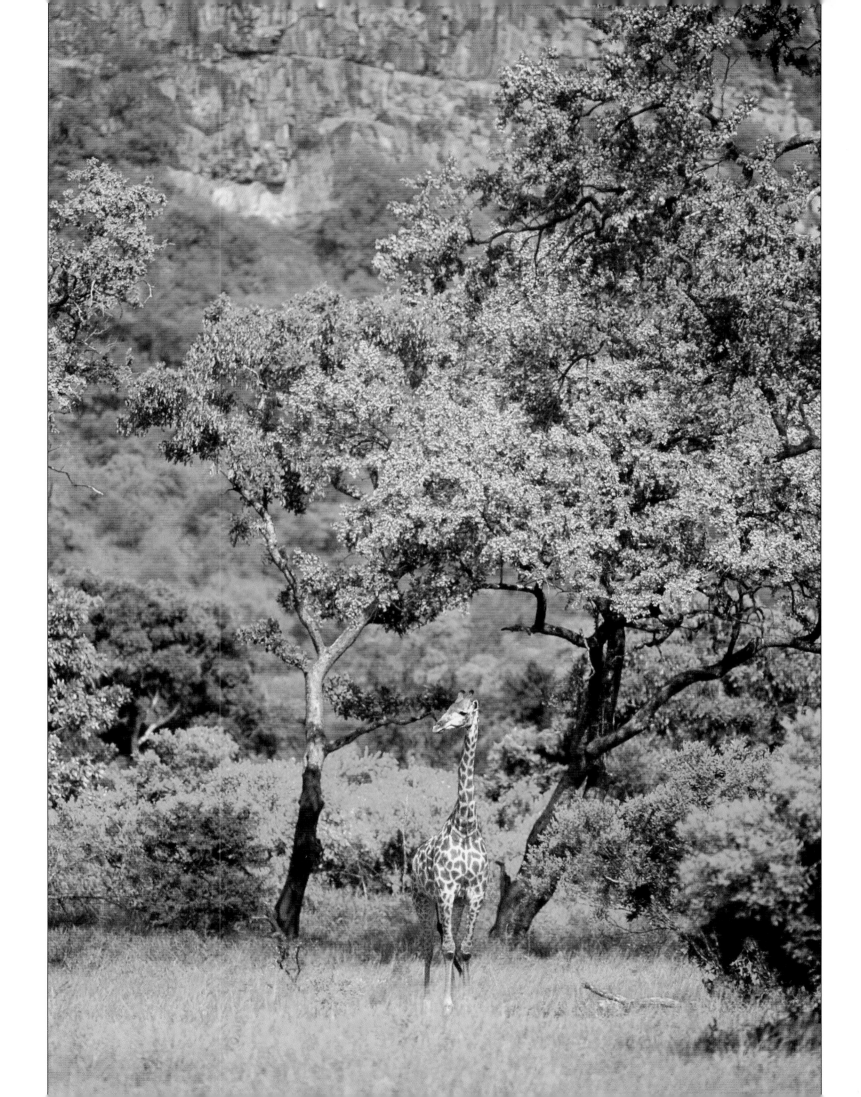

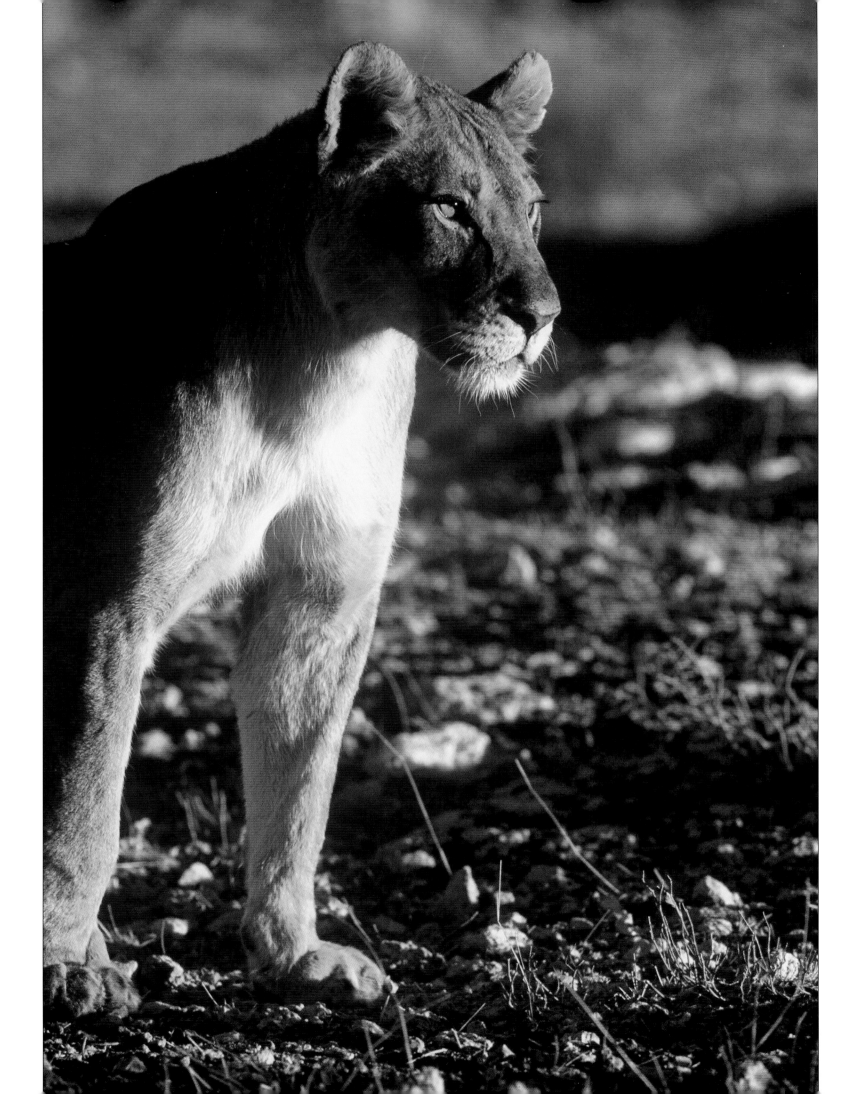

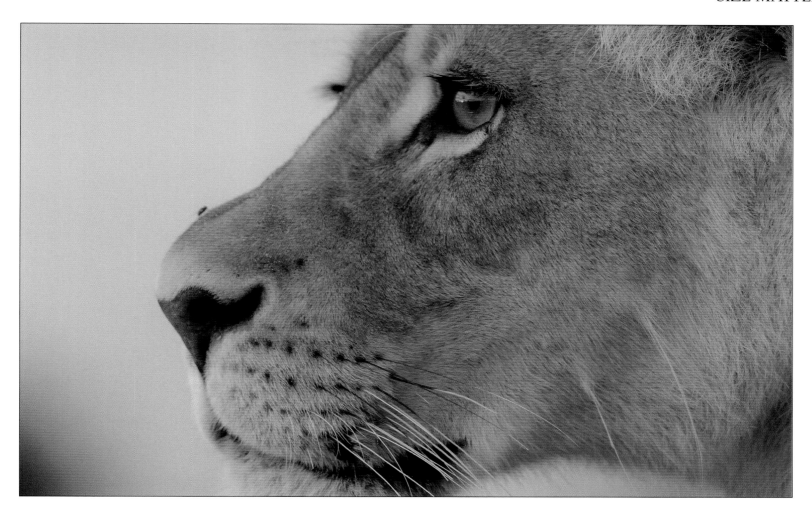

We have, at least, protected some special wild places and wildlife from the ravages of human sprawl through the concept of national parks and other nature reserves. This is a major step forward, even if it is still far from perfect.

The idea didn't always start off as a good one; rather, originally, it was based on exploitation. The "preservation" of wildlife was initially prompted by self-interest and hunting in particular. Kings, for example, wanted a plentiful supply of deer or tigers to shoot and so banned the common people from certain areas that were known to be good for wild animals. Even today, hunting is the motivation behind a number of game reserves; the only difference is that nowadays it is money that buys privilege rather than an accident of birth.

National parks came about principally for human recreation. In the USA, for example, fishing is still allowed in the national parks' system even though fish are part of the natural ecosystem; this contradicts the idea of "take memories and photographs, leaving only footprints". So-called problem animals, including number one attractions like bears and elephants, are routinely killed if they threaten the holiday calm of visitors - despite the fact that any unwanted wild animal behaviour has invariably been caused by human stupidity. So, if you feed the animals or leave food lying around (both against park rules), it is the wild animals that get punished.

Above and left: As a rule, lions will eat the most common medium-sized and large herbivores in their territory. Buffalo, wildebeest, zebra, and gemsbok are typical prey species. But lions, like all predators, are opportunists and so will eat a wide range of animals if available. They have been known to kill porcupines and tortoises. I have personally seen lions spend a lot of energy hunting warthogs - which are surprisingly quick and agile, often escaping capture.

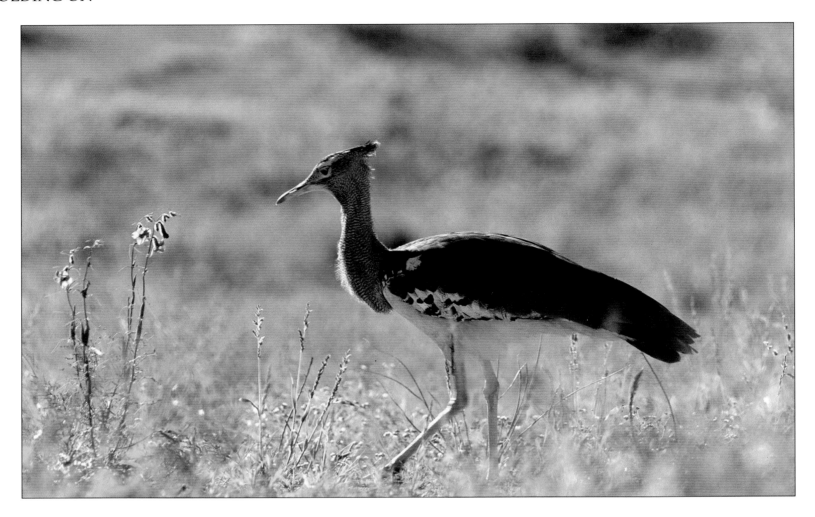

Above: The kori bustard has decreased in both range and abundance. Nowadays, it is only commonly found in large protected areas. One such place is the Kalahari.
The kori bustard spends most of its time foraging by walking and pecking on the ground - eating a wide selection of food items ranging from insects and other invertebrates to lizards, snakes, and small rodents, to seeds, berries, roots, bulbs, flowers, leaves, and grass.

It is rare that national parks and other reserves have been created from a wildlife perspective. Despite modern understanding that size matters, most nature reserves remain adequate at best. The average visitor wouldn't immediately understand that our best national parks in the world are too small, but this is often true.

Generally, birds do better than most animals because of their ability to fly. But the kori bustard is an example of a bird that really needs large areas of undisturbed natural habitat. Nowadays, it is only commonly found in national parks.

The drier western parts of South Africa's Karoo once witnessed a mass migration as spectacular as the famous wildebeest migration of Serengeti and Masai Mara. But it was caused by occasional drought, different from the regular wildebeest trek which is seasonal. Huge numbers of springbok would gather together as they moved in search of food. Millions would follow the promise of better grazing, stimulated by occasional thunderstorms bringing much-needed but patchy rainfall.

Early settlers who saw such sights reported that this mass movement of springbok would sometimes go on and on uninterrupted for up to three days, as the gazelles passed by their homesteads. Actual numbers have been argued over, but it must have been a spectacular sight and one of the wonders of nature.

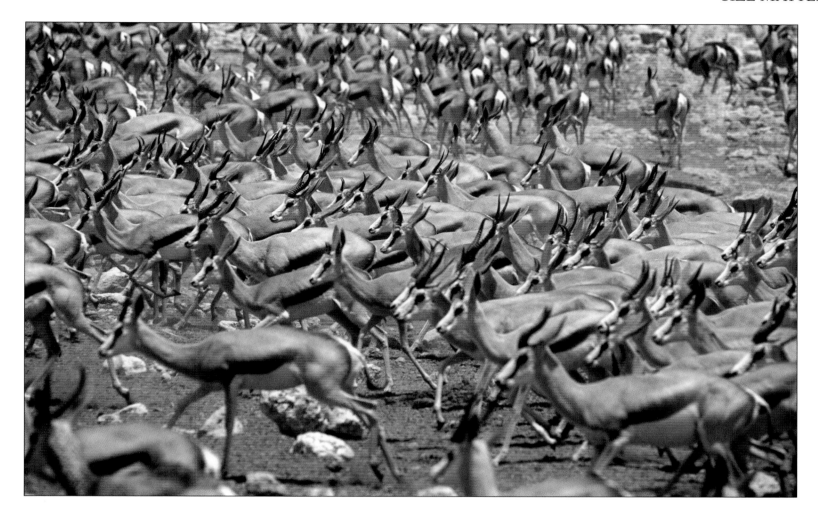

However, once again, such a migration requires a huge amount of space being available for wildlife. Today, most of the Karoo is split into numerous sheep farms - albeit often large ones - and these farms have perimeter fences, as well as internal camp fences. Some sheep farmers keep a few springbok but the fences prevent any kind of migration. The behaviour of old is now impossible whilst we occupy the land for human purposes. Even the Karoo National Park and Komsberg Wilderness Nature Reserve (the latter owned by our own organisation, featured later in this book) - both doing a better-than-average job at conserving this fascinating habitat - are nowhere near big enough to permit the historical springbok treks of yesteryear.

Indeed, the world will not again see such sights of hundreds of thousands or even millions of springbok moving in search of rain-soaked ground until the time comes, sometime in the distant future, when we humans decide to restrict the impact of our behaviour to limited areas.

There are already signs that increased thinking and caring results in millions of people becoming vegetarian. If this trend continues to spread as a worldwide pheno-menon in the decades and centuries ahead, perhaps the market for lamb might decline and eventually stop. Then, through a simple lack of demand, today's sheep farms in the Karoo might once again become a place where wild animals roam free.

Above: Large numbers of springbok were once common in the Karoo. During drought periods, they congregated into huge herds and trekked in search of rain and food.
These awesome sights are no more, but the springbok remains a suitable symbol of arid regions in southern Africa.
(I photographed these springbok at a waterhole during the dry season in Etosha National Park.)

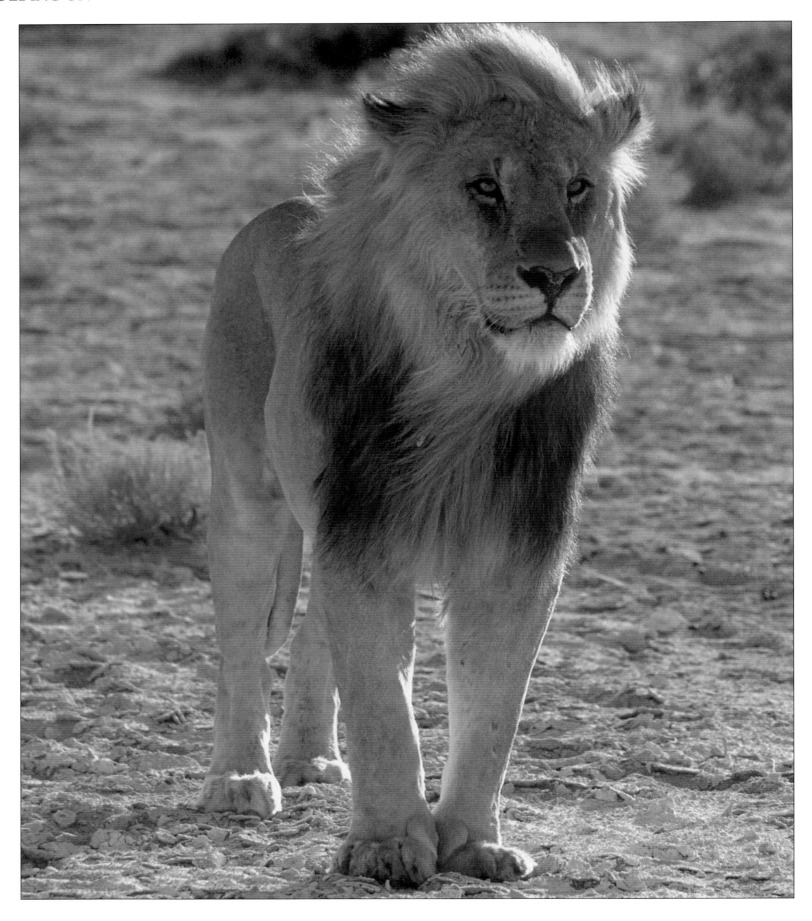

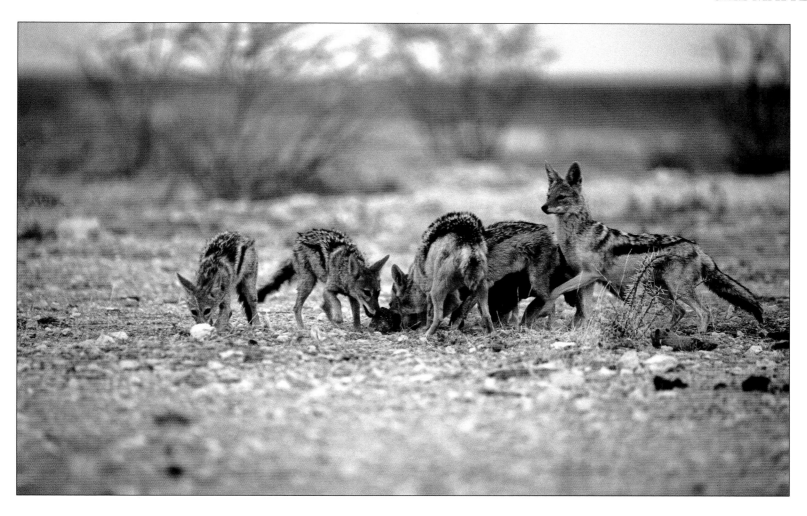

Ultimately, I believe that we humans will conclude that more space is needed for nature - and future generations will push to expand the important places like Kruger National Park still further to make them much bigger. (I have just chosen to use the word "expand" - but perhaps the correct term should be "restore" because we have already massively reduced what was once available. It is important to recognise what has already been lost.) As we develop our own potential, we will appreciate that size matters for wildlife conservation. The dawning of a greater human intelligence, backed up by humility, will one day lead us to admit that we should not dominate at the expense of other species.

I have written in one of my other books that the concept of national parks and other nature reserves is fundamentally flawed. Human beings have assumed the right to spread, exploit, and destroy. Far into the future, perhaps we will re-think our basic priorities and thereby voluntarily restrict the bulk of human activity to "human parks", allowing nature the freedom to re-colonise most of our planet. This would obviously involve humanity deciding to limit its own population and level of consumption. Wildlife would then have the chance to evolve further, as it always has done for millions of years until our recent domination. Meanwhile, of course, nature reserves are essential as a holding exercise to halt further decline.

Above: Black-backed jackal cleaning up the remains after a lion kill.

Left: Lionesses do most of the hunting within a pride. Males are heavier and more easily detected by the prey animals. As such, male lions take little part in a pride hunting. But male lions are fully capable of successfully hunting and killing even large animals such as buffalo and zebra. Nomadic males without a pride are, of course, forced to hunt for themselves.

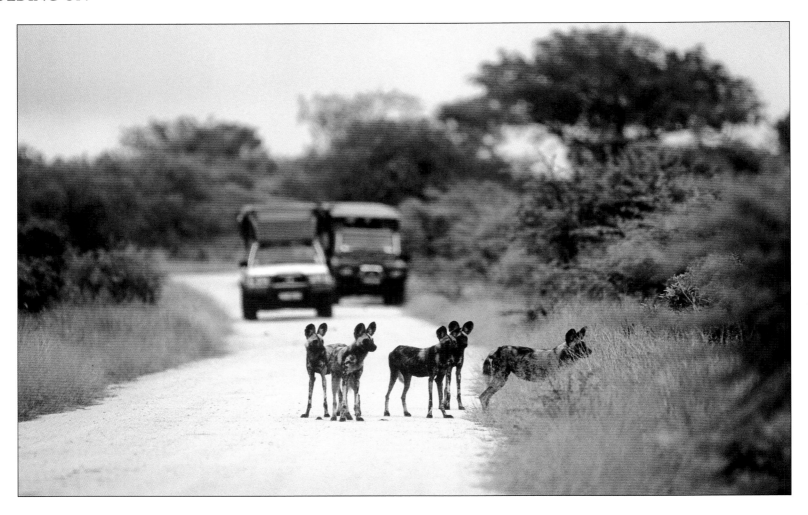

Above: A pack of five African wild dogs hunting. We followed them - actually driving in reverse ahead of them - for over an hour on this particular morning in Kruger National Park.
The wild dogs' alertness, speed, and general high energy level was incredible to witness. These are special animals that are nowadays being increasingly appreciated by visitors.

The African wild dog is endangered and numbers are still declining. It has already disappeared from 25 of the 39 countries in which it once roamed. Less than ten viable populations of 100 or more wild dogs survive in just six countries - with smaller numbers barely surviving elsewhere. The situation is grim.

African wild dogs are the most successful hunters of all the large predators. They chase down their prey relentlessly and succeed in approximately 80% of their hunting attempts. Lions, by comparison, are successful less than 30% of the time and the speedy cheetah can only boast a slightly higher success rate. So it is ironic that they are now facing extinction. But why?

The reasons are complex, but - you've guessed it - the issue of size is yet again a key factor. African wild dogs roam over huge distances. Their home ranges cover areas of between 500 sq km and 2,000 sq km. They are nomadic by nature and always on the move, apart from when they den. The African wild dogs' hunting technique is to chase after their quarry until it is exhausted and caught, so they cover much longer distances than any other predator.

It is generally accepted that an area of 10,000 sq km is the minimum size of land necessary to accommodate a viable population of wild dogs (with a minimum of nine packs). In South Africa, Kruger National Park has the only viable, naturally regulated

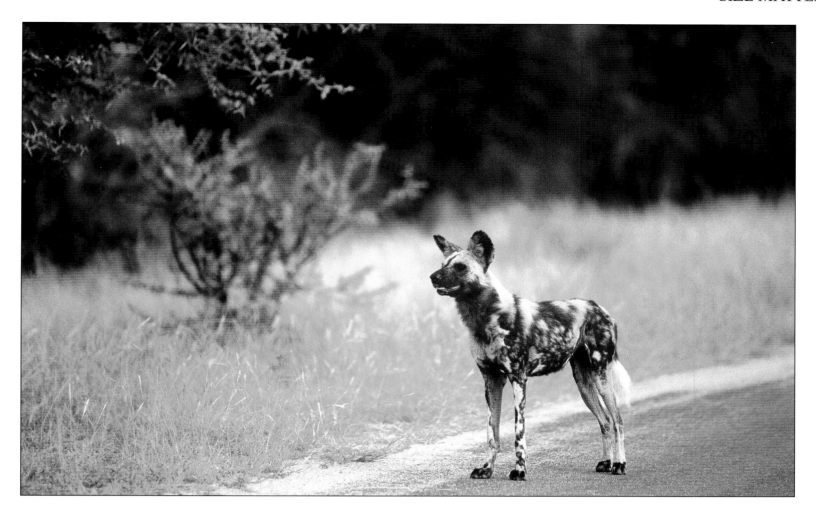

population of African wild dogs in the whole country; Kruger is 20,000 sq km in size (to repeat: about as big as Wales or Israel). Even here, the numbers of wild dogs greatly fluctuate and have decreased in recent years.

Competition with lions is another factor. Lions will kill African wild dogs whenever possible; they are bigger and their reliance on ambush provides a clear advantage. Confrontation between lions and wild dogs usually results in severe injury or death to several of the dogs. Lion predation can be responsible for up to a third of all wild dog deaths.

Spotted hyenas are also a threat because they commonly steal the African wild dogs' meal before it is consumed. This is particularly so in more open habitats. The African wild dog has a faster metabolic rate than any other mammal and so its unusually high energy requirements are crucial to survival. It consumes more meat per day than any other carnivore, allowing for size. Any loss of food can therefore be disastrous.

In recent historic times, the African wild dog has had a tough time and an undeserved bad reputation. Even the wardens and rangers of national parks and game reserves throughout Africa were shooting this amazing predator on sight until the mid 1960s.

Above: This African wild dog was having a very alert morning. Just in time, it spotted a male lion waiting to ambush the pack as it ran along the road looking for prey. We had feared the worst, thinking we might see some of the wild dogs killed. Thankfully, these endangered predators lived to hunt another day. The African wild dogs actually stood their ground and the large male lion eventually backed off. The outcome would probably have been different if the ambush had gone undetected.

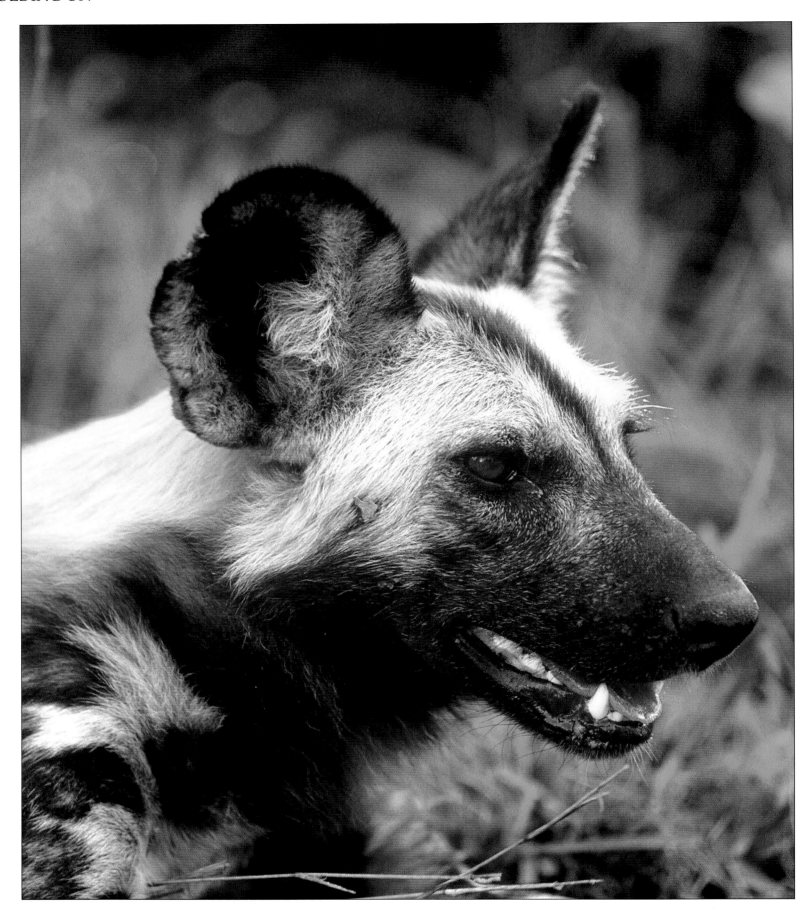

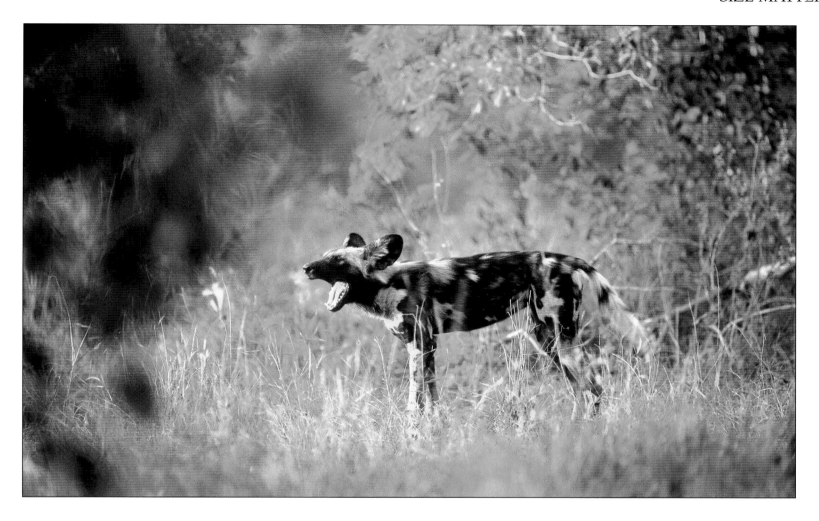

It has been misunderstood and maligned, being previously labelled as "murderous", "vermin", and "the devil's dog". Its hunting technique of chasing the prey animal until exhausted, then ripping it apart and quickly consuming the flesh, was misinterpreted as being "cruel". Other predators, by contrast, normally suffocate their prey or kill with a quick bite to the neck - which may appear less horrific to the casual human observer. The reality is that prey disembowelled by African wild dogs are killed quicker than those caught by lions.

Conservationists, not long ago, wanted the "complete extermination" of the African wild dog. Many people believed that this predator indulged in an on-going rampage of "wholesale destruction". This reputation is unwarranted. They do not kill indiscriminately or unnecessarily; like any other predator, they simply kill to eat and survive. It is also just a myth that they spread terror to other wild animals in their vicinity. One clue to this early prejudice is likely to be the fact that wild dogs hunt during the hours of daylight - whereas lions, hyenas, and leopards commonly kill their prey under the cover of darkness, unseen. Killing is a bloody affair and for many years wildlife documentary film-makers used to show the chase or ambush of predator and prey, but would shy away from showing the reality of the actual kill and act of eating, afraid that the public audience would be upset at the sight of nature in the raw.

Above and left: The wild dog is the most social of all the African predators.
One afternoon, we found a pack of wild dogs resting in the heat of the day. Later, they awoke and suddenly every individual was on its feet. They greeted one another in a high-pitched frenzy, renewing bonds in preparation for an evening hunt. Sniffing and urinating en masse as they ran around our vehicle at top speed completed this pre-hunt ritual that left us dizzy with amazement.
Close social interaction between members of the pack enhances their success as a team.

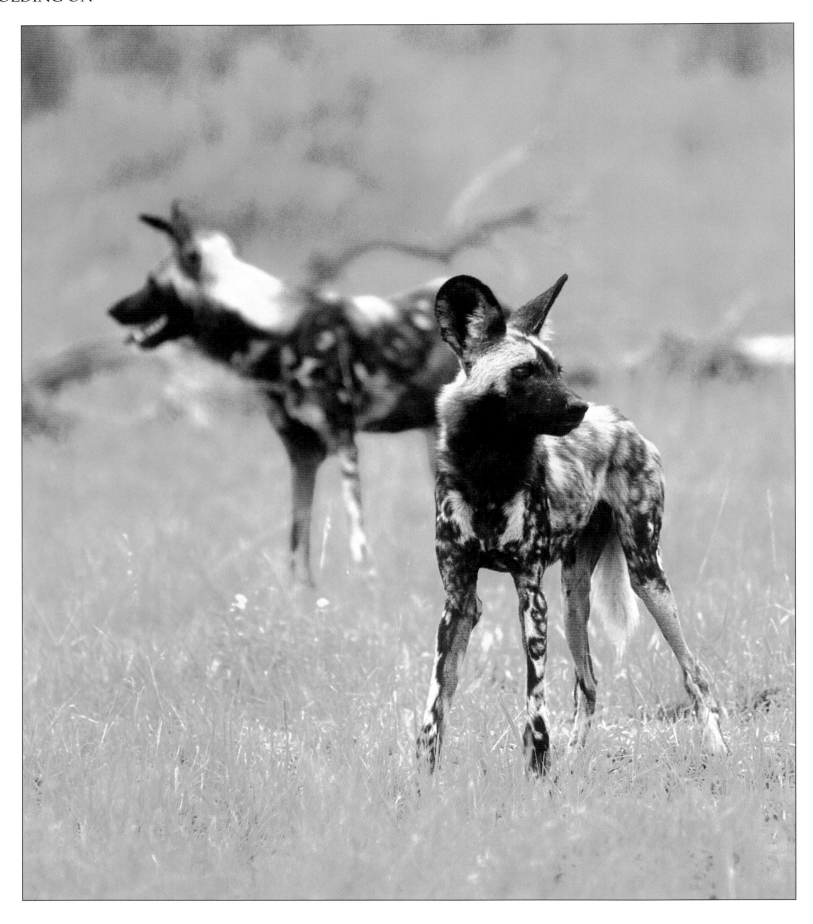

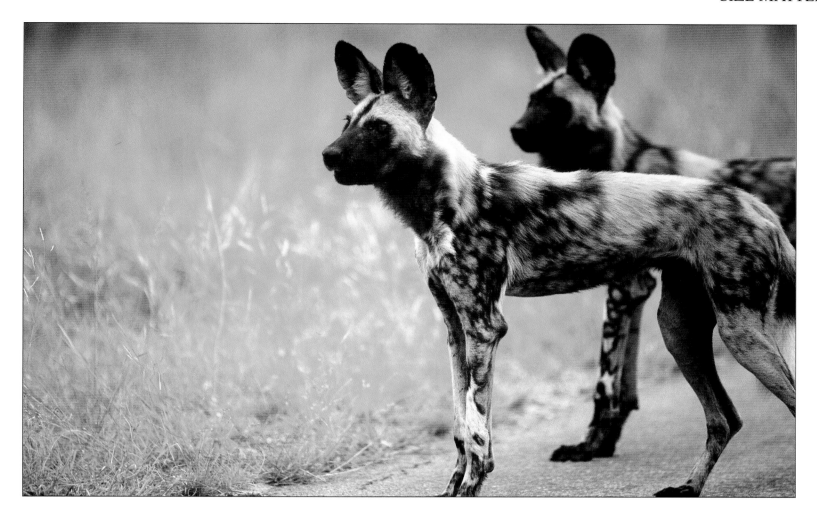

Thankfully, today, many wildlife enthusiasts have great appreciation for the African wild dog. At last, this endangered predator is starting to become highly valued. Seeing African wild dogs running along on the hunt must be one of the highlights of any safari.

Long-term, the problem of space remains the biggest challenge. A number of smaller national parks and other reserves are trying to accommodate one, two, or even three packs of wild dogs; these places must nevertheless still be relatively big. Combined together, they can form what is called a meta-population. In the case of cheetah, for example, this idea can work well. But there are far more difficulties with African wild dogs. The meta-population strategy involves moving animals artificially between reserves to mimic natural dispersal. This is important to prevent in-breeding and also (if initially successful) to remove surplus numbers that the ecosystem cannot deal with. The specific problem with wild dogs is that they are a closely-bonded pack species, constantly on the move over large areas. It is hard enough darting a single cheetah, but capturing part or all of a pack of African wild dogs is a seriously challenging job. Other problems include diseases from domestic dogs such as rabies and canine distemper.

Above and left: Each individual African wild dog has its own unique markings. These are very useful for identification, allowing an accurate picture to be built up of a population. Tourists' photographs can help in places such as Kruger. This species is also known by three other common names: the Cape hunting dog, the painted dog, or the painted wolf. The African wild dog is perhaps the most widely used and most appropriate common name. Each species only has one scientific name to avoid confusion, of course, which in this case is Lycaon pictus.

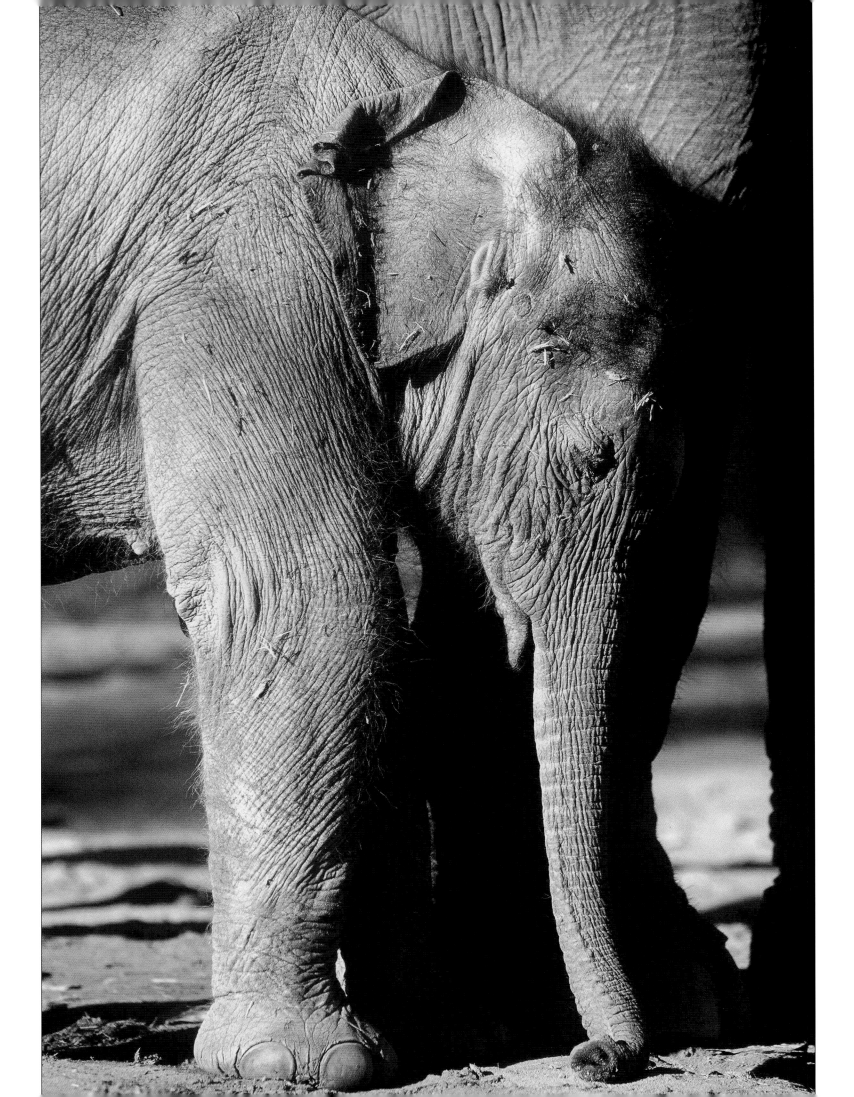

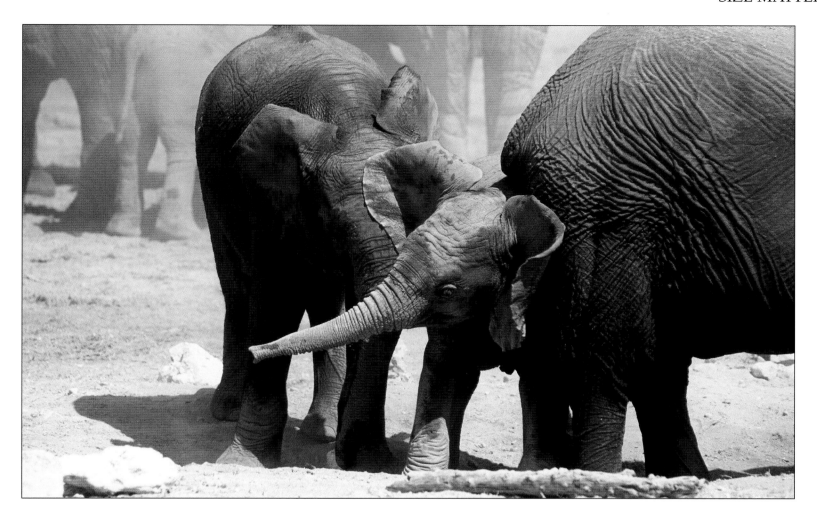

Baby elephants are born after a gestation period of 22 months, which is the longest of any species. An elephant can live up to sixty years. Elephants are capable of passing on what they have learned from one generation to another. And their size is awesome.

They need a future that is befitting to such amazing animals. For countless years we have killed their parents and grandparents for their ivory or shot them just to prove our manhood (and a few women have done likewise). More recently, we have tried to shut them in nature reserves to keep them safe.

The future of a baby elephant can never really be secure. Elephants will always face danger from each other as male challenges male - the strongest winning the right to mate and reproduce. Some babies will die an early death through fatal injury or disease. Droughts naturally happen from time to time and sometimes these will be devastating, resulting in significant deaths of both young and old. This is all natural. However, elephants surely deserve what they once enjoyed before we humans messed it up.....a future that is wild and free.

Elephants and lions are two of conservation's key species: each can be thought of as the proverbial canary in the coal mine. Some populations of the African elephant need to seasonally migrate beyond the relative safety of a national park and the problem of

Above: A baby elephant demonstrating its playfulness at a waterhole.

Left: The Asian elephant has suffered badly as a result of the increased human population in that part of the world and the massive loss of natural habitat. This newborn baby elephant was not born wild and free. Its parents provide rides to tourists who come to see the tiger in the national park and it, too, will be trained for this purpose. Almost one quarter of the surviving Asian elephants now live in captivity, usually as working animals for humans.

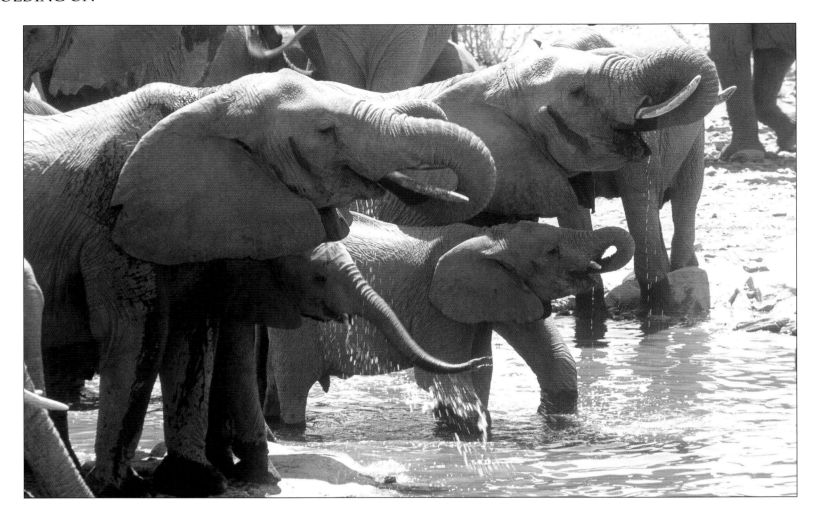

Above and right: Here are just a few fast facts about the African elephant.
An elephant's trunk can hold 17 litres or more of water.
They are only able to digest some 40% of what they eat.
Adults can charge at up to 40kph (25mph) and easily push over a vehicle.
The elephant's brain is highly convoluted, similar to that of humans.
The British Museum has on display a huge pair of tusks from an elephant that was shot on the slopes of Kilimanjaro in 1898. The left tusk once weighed in at 232lbs (105.3kg) and the right tusk at 228lbs (103.5kg).

fragmented habitat - as different from absolute space - is of major concern in these instances. Genuinely suitable corridors are needed, at very least, to safeguard seasonal movements. But the human population keeps growing and growing, competing for this all-important space.

It is understandable that villagers and farmers do not want dangerous animals walking into their daily lives. Conflict is inevitable if sufficient space for wildlife is not provided. Crops grown for human consumption get raided by elephants and other wild animals simply following migration routes that have existed for many thousands of years. Some unlucky people even get trampled to death in this clash over land.

A typical African villager, threatened by marauding elephants, doesn't share the same rosy view of wildlife as the average westerner who works in an office by day and watches television documentaries narrated by David Attenborough in the evening. So education is needed. Yes, local villagers can improve their appreciation of nature and play their part as custodians. But those who live thousands of miles away also need to re-think. People everywhere must learn to focus more on the bigger picture rather than just on their own individual wants. Realistically, this is asking a lot and unlikely to happen any time soon. But, ultimately, we have to reduce our land requirements and give back the space to our fellow species so that they can thrive.

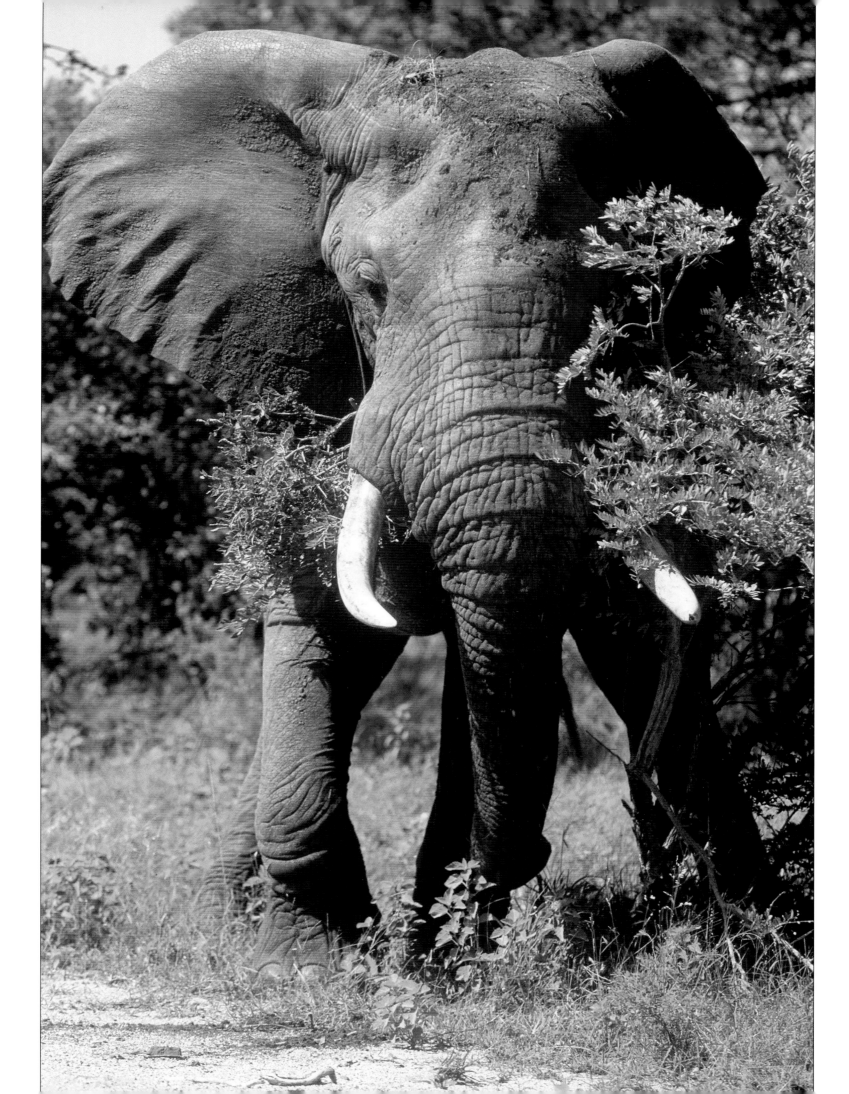

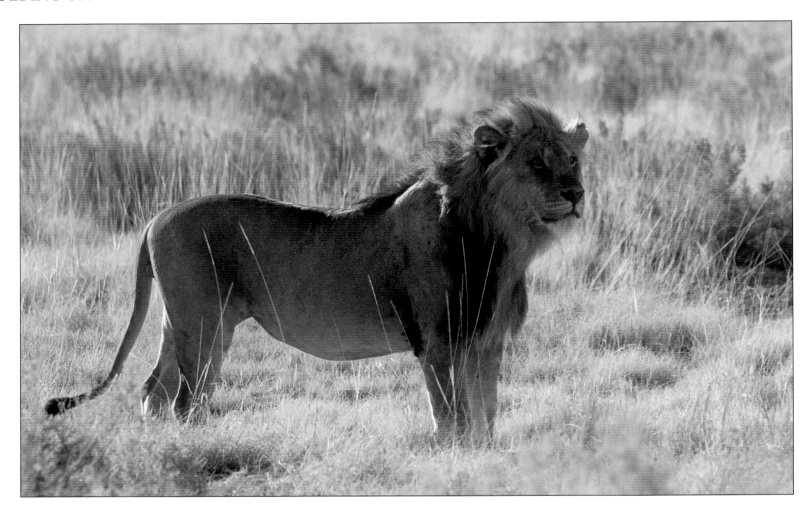

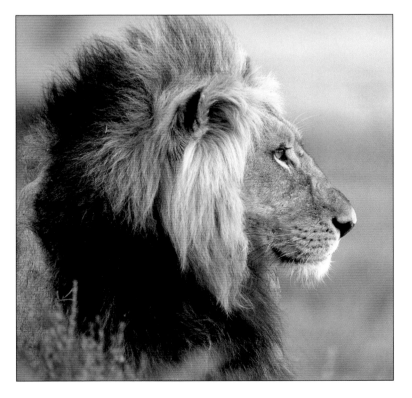

Above and left: Lions may be Africa's top predator. But they are nevertheless still subject to the rule of "size matters" when it comes to conflict situations with much bigger animals.

I have commonly witnessed elephants and rhinos pushing lions away from, say, a waterhole. There is no real competition, as an elephant's or rhino's weight/bulk is considerably greater - and they know how to use this supreme strength.

Buffalo may be relatively large - weighing up to three or four times that of even a male lion - and they do commonly displace lions, especially when the herd works together. But the buffalo is also a favourite meal and frequently preyed upon.

Despite their tall size, giraffe are very fearful of lions and, again, a common prey. They are especially cautious before bending down to drink and will spend much time looking around if they suspect lions might be nearby. The lion still has to be careful, as one kick from a giraffe can be fatal to the attacking predator.

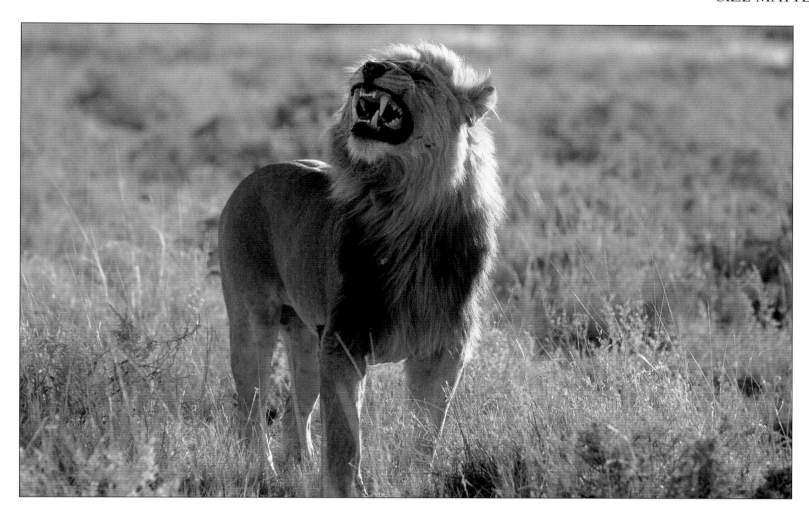

Above and right: *Territorial fights between male lions are usually short and dreadful. A lion uses both claws and teeth to good effect and these can easily inflict serious wounds on an opponent. A mature male lion's mane offers some protection to the neck from attack, but fights often result in the death of the loser or losers. There is nothing "fair" or "gentlemanly" about such contests and two lions will readily set upon a single male, one attacking from behind whilst the solitary lion tries to fend off the other in face-to-face confrontation. It is kill-or-be-killed - and winner takes all. In this savage paradise that we rightly call the wild, it is survival of the fittest. Those male lions that succeed have won the right to breed with the females and thereby pass on their genes to future generations. A large dark mane makes a male lion look more daunting. The magnificent roaring of lions - often heard in the still of night - immediately alerts other prides or males to their presence. Intruders will frequently depart as soon as they hear the roars of a resident pride, eager to avoid conflict if possible.*

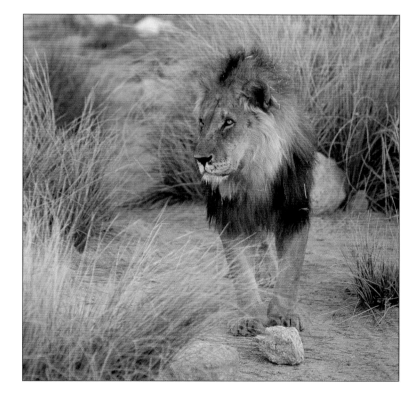

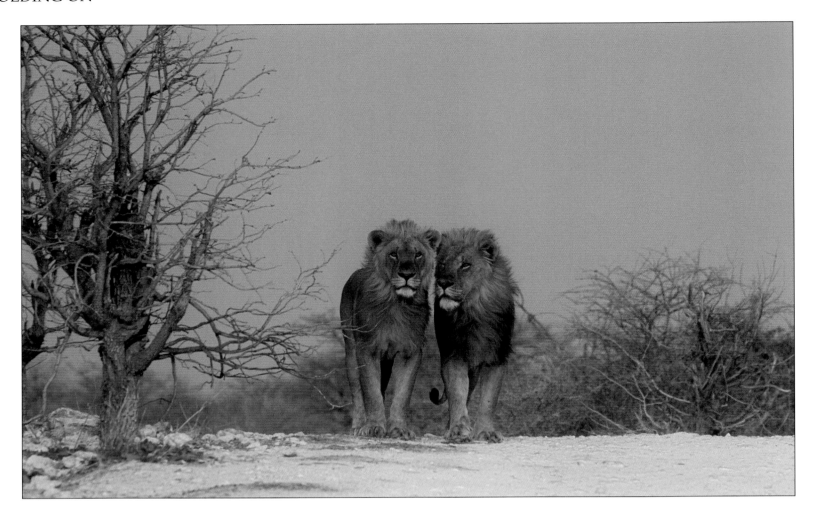

Above: I photographed these two male lions in Etosha National Park, Namibia. Namibia has one of the lowest human populations, with only 2.28 million people in 2010. However, Etosha has already been drastically reduced in size. Originally 99,526 sq km when proclaimed in 1907, it was cut to just 22,270 sq km in 1970.

Right: This male lion may not look especially ferocious, but it is nevertheless a killer. Humans and lions need their own space.

The African continent has been relatively less populated until recently, compared to other parts of the world, but this situation is rapidly changing. Many countries in Africa are now experiencing an explosion of their human populations. As a result, the coming decades spell potential danger for their wild places.

Kenya and Tanzania are the two most famous countries in East Africa for wildlife, home to the popular Serengeti and Masai Mara. When I was born in 1957, Kenya's human population was just 7 million and Tanzania's was only 9 million. By 1990, Kenya's had increased to 23.4 million and Tanzania's to 25.4 million. By 2010, they had grown much further to 40.5 million and 44.8 million respectively. (The UK's population in 2010 was 62 million - so we, as a country, can hardly claim to be leading by example.) The United Nations Population Division is predicting that Kenya will have 59 million people by 2025, 96.8 million by 2050, and a staggering 134 million by 2075. The prediction for Tanzania is 70.8 million people by 2025, 154.9 million by 2050, and 227 million by 2075. If you are overwhelmed by these figures, then I am getting through to you. Welcome to reality.

So, in the near future, a lot more people will require a lot more space - including a lot more food and other resources. The obvious question is "How much space will be left for the wildlife?"

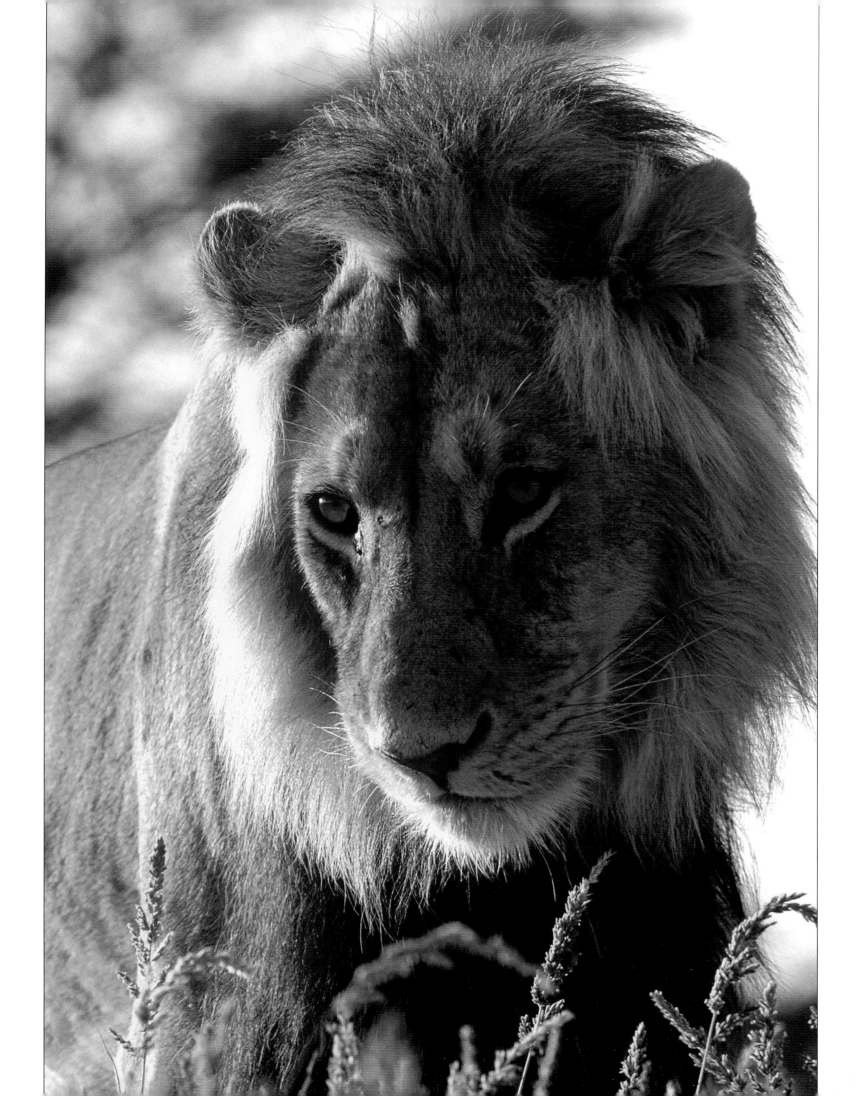

The wolves of Yellowstone

A success story

Yellowstone National Park in the United States of America was the world's first national park, established in 1872. Together with the slightly earlier setting aside of land in 1864 for what was to later become Yosemite National Park in California, this gave birth to an important concept of land-use that has become worldwide today.

Three giant volcanic eruptions have occurred in the heart of Yellowstone; these events happened 2 million years ago, 1.3 million years ago, and 630,000 years ago. This gives a clue to the many thousands of geysers, hot springs, and mud pots that are found here. Indeed, approximately half of all the world's hydrothermal features are concentrated within Yellowstone National Park.

In recent years, Yellowstone National Park has also become well-known for its successful re-introduction of wolves. This is a story worth telling.

The original wolf population was subject to indiscriminate hunting during the early years, as natural resources were exploited ad nauseam. Mountain lions were likewise slaughtered on sight at this time. In 1916, the National Park Service was formed and it assumed responsibility for Yellowstone in 1918. Predators were still seen as "vermin" and so the wholesale killing continued, albeit officially.

Attitudes began to change and a new policy was adopted in 1933, recognising that natural predators could utilise the prey species such as elk and deer. But it was too late for the wolves. They were all dead or else had left Yellowstone only to meet a similar fate beyond its borders.

A further evolution in thinking gradually took shape when a few individuals suggested that any management plan should maintain *all* biological associations and recreate them where necessary. But the dream to re-introduce wolves back to the wild of Yellowstone took over 50 years to realise.....

Right: Once shot on sight as "vermin", the wolves are now back in Yellowstone.

Far right: Old Faithful is the most famous of Yellowstone's many geysers, seen here in mid-winter. The resulting tower of steam that accompanies the eruption of hot water at this time of the year adds to the spectacular sight.

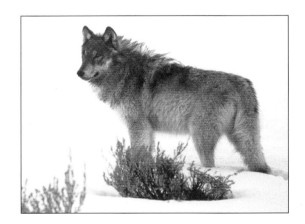

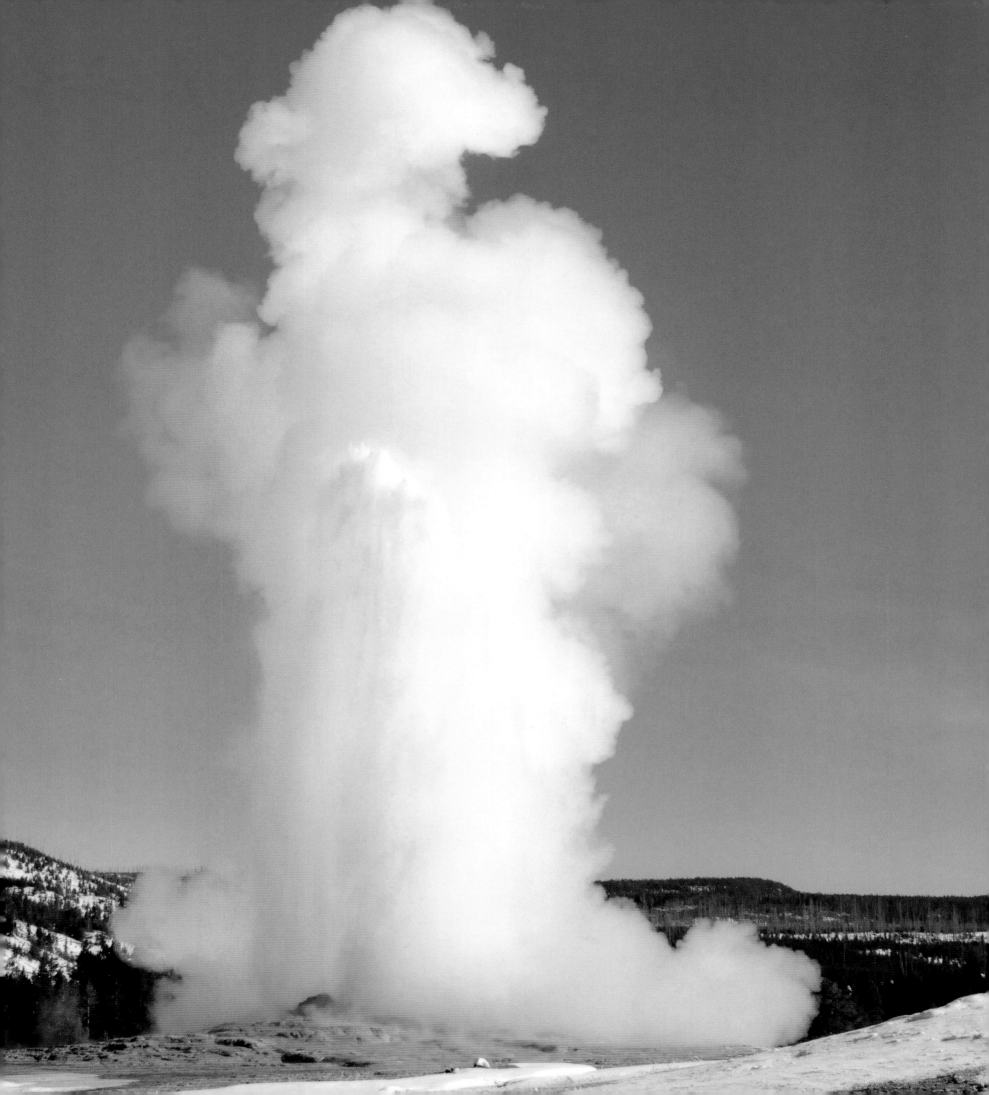

 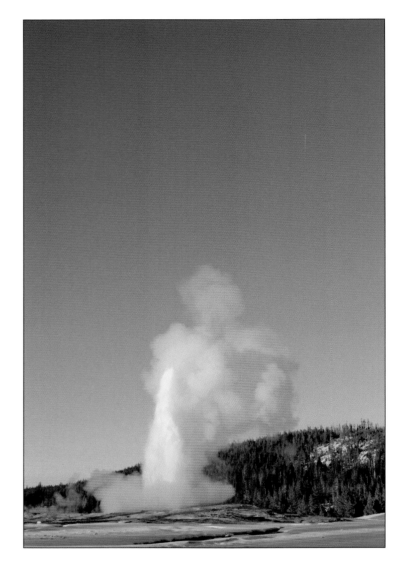

Above (left and right): *The early stages of Old Faithful erupting in the late afternoon light.*

Left: *Old Faithful Inn is an historic wooden lodge, still popular with guests from across America and around the world. We were purposely based for most of the time at the northern entrance to Yellowstone, near to Mammoth Hot Springs and the wildlife-rich Lamar Valley. The road in this northern section of Yellowstone is the only one ploughed throughout the winter months. We travelled deeper into the interior of Yellowstone to the Old Faithful area by snowcoach.*

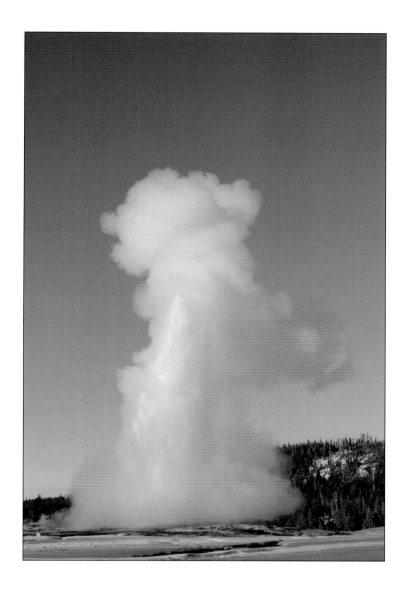
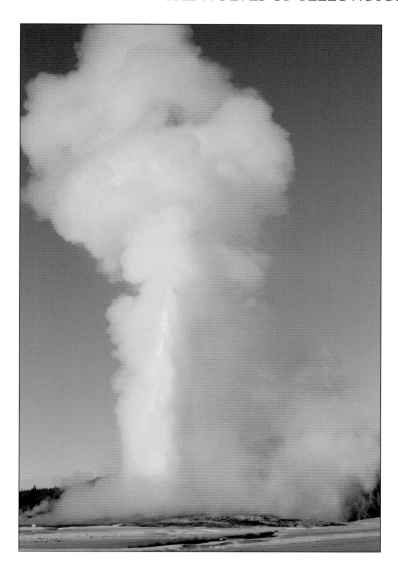

Old Faithful is the best known of Yellowstone's geysers. It erupts more frequently than any of the other big geysers, with an average interval of 91 minutes between eruptions at this present time. Between 14,000 and 32,000 litres of boiling water are thrown upwards to a height of 106-184ft. Old Faithful was immediately named by the early explorers for its consistent performance. It is Yellowstone's number one tourist attraction and has been watched by millions of visitors.

The shooting plume of boiling hot water takes 10-20 seconds to reach full height but then starts waning within a minute or so. Although the jetting itself will only reach a maximum height of 184ft, the cold winter air helps produce columns of steam that can be hundreds of feet high - adding to this impressive wonder of nature.

Castle geyser (see next page) explodes into action only twice in 24 hours; when it does, the water phase lasts 15 minutes or so and the noisy steam phase continues for a further 45 minutes. Old Faithful and Castle geyser have been repeatedly vandalised, with members of staff even being sacked for their disrespectful behaviour in recent times. Coins have been tossed into the colourful thermal pools, causing damage.

Above (left and right):
Old Faithful reaches higher and higher, with the enormous jet of boiling hot water surrounded by a mass of steam in the cold air of mid-winter.
No two eruptions are alike, with changing weather conditions being a factor - including wind, which can easily cause the huge volume of steam to obscure the actual gushing water.

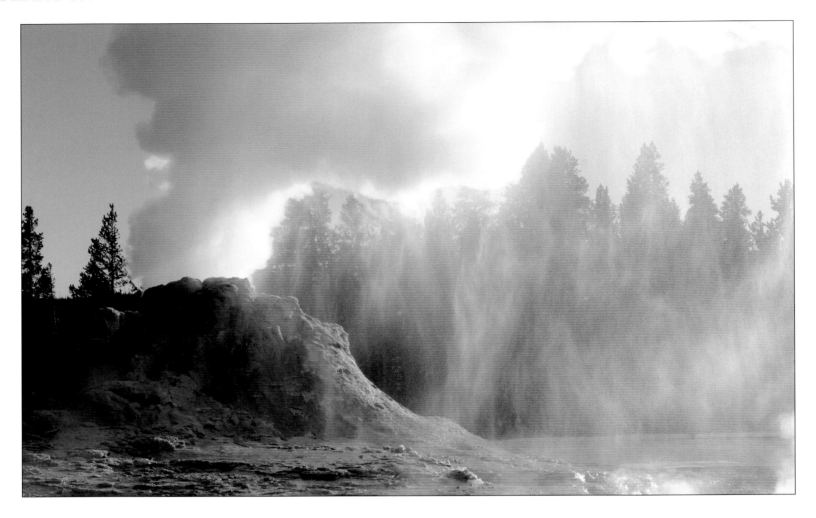

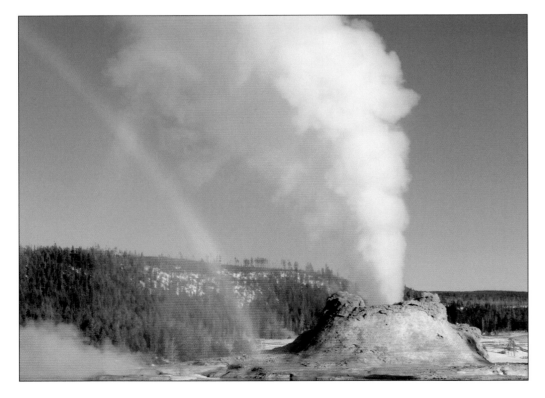

Above and left: Castle geyser erupts twice each day and is another of the famous named hydrothermal features in the upper geyser basin.

Right (top): Frosted trees, early morning, amidst the steaming earth.

Right (bottom, left): Orange spring mound is part of the Mammoth Hot Springs hydrothermal complex.

Right (bottom, right): Rocks on a river bank stained by sulphur and iron oxides, additionally coloured by bacteria and algae, provide a visual clue to the unusual geological activity of this region. Another clue is the smell of "rotten eggs".

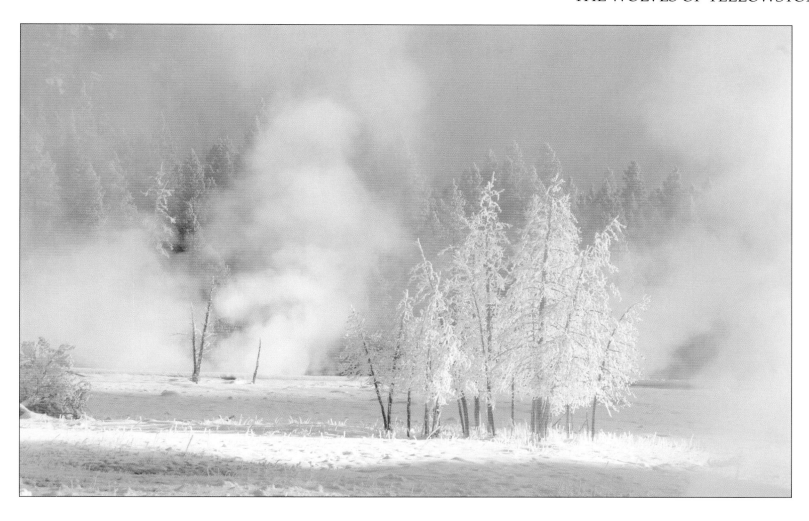

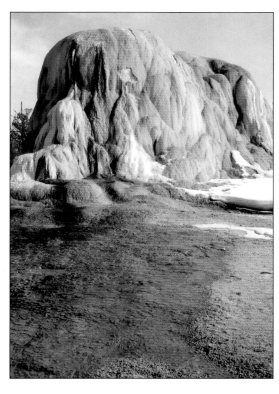

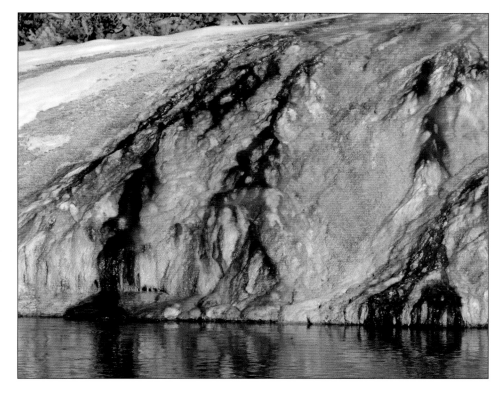

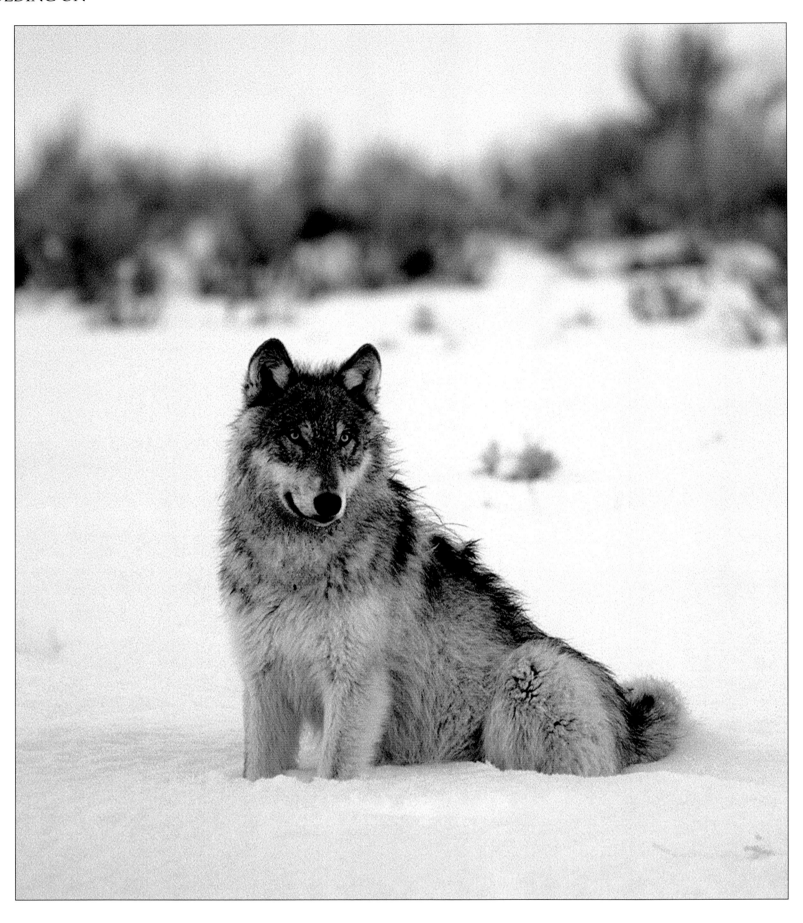

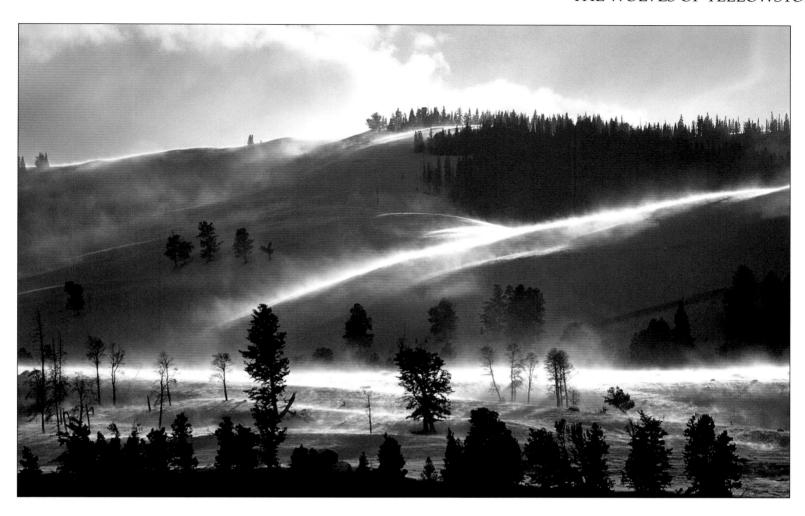

Church leaders in the Middle Ages declared that the wolf was proof that Satan walked the earth. Some Americans in recent times have labelled it "the Saddam Hussein of the animal world". Others have likewise claimed that "only a brain-dead son-of-a-bitch would favour re-introduction of wolves." Local ranchers feared for their livestock; other residents worried about the safety of their pets and even for their children's lives. The opposition to returning wolves to Yellowstone National Park was fierce.

Others believed that the wolves "could do no wrong". They are "our spiritual brothers and sisters" with "special awareness and other supernatural powers". Such naivety didn't help convince the wolf-haters, nor was it appreciated by those working hard to bring back the wolf based on ecological reasoning. The simple reality is that wolves are large predators that kill to survive, deserving of our awe and respect.

The National Park Service killed the last wolf in Yellowstone in 1926. Aldo Leopold, a pioneering conservationist, was the first person to recommend wolf re-introduction to Yellowstone back in 1944. The dream took over 50 years to realise; Leopold died in 1948. The Endangered Species Act became law in 1973, mandating the restoration of endangered wild animals to their natural habitats; this included the wolf. Despite a law prompting responsibility for preparing plans to bring the wolves back, government

Above: A cold winter's day in the Lamar Valley, with a bitter wind chill.
A serious photographic trip to Yellowstone during the winter usually involves many hours standing outside in freezing conditions, sometimes from dawn 'til dusk, looking and waiting for any special opportunity.

Left: A wild wolf, photographed on the first day of my first trip to Yellowstone! A wolf pack had killed an elk nearby. After eating, the wolves began to disperse. Fortunately, I predicted the direction of their movement and was rewarded when one wolf came towards me.

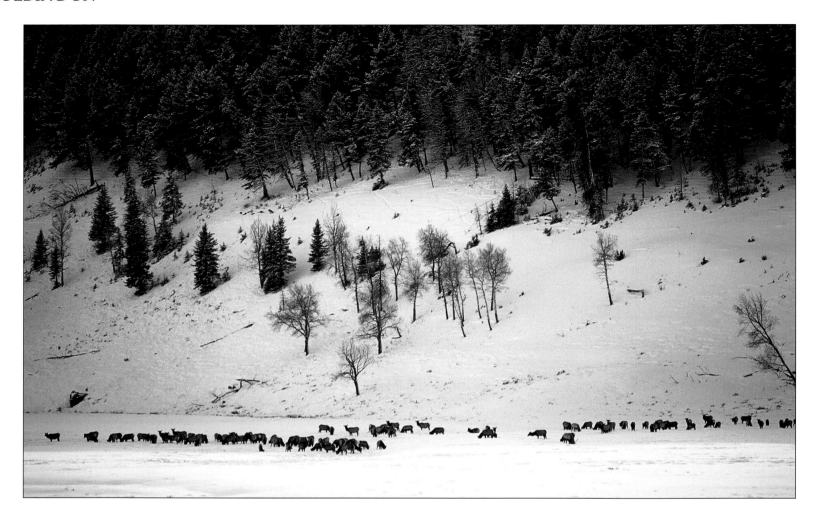

authorities were at first understandably timid, aware of the powerful livestock industry and political reality. Plans to re-introduce wolves to Yellowstone National Park at last began to take shape in the 1980s, with one Montana politician immediately claiming "There'll be a dead kid within a year!"

Most visitors to Yellowstone liked the idea, however, favouring it by a six-to-one ratio. Even local state opinion showed a majority support to bring back the wolves. But the authorities still decided to stall and requested a study on the potential impact of wolf restoration. When the findings suggested that wolves would help check the over-abundance of elk and bison, another study was called for. Previously, some leaders in the National Park Service had lost their jobs when their pro-wolf advocacy offended powerful political groups.

A breakthrough came when the director of the National Park Service, William Mott, suggested that the single most important action that conservation groups could take would be to develop a fund to compensate local ranchers for any loss of livestock killed by wolves. By 1992, Defenders of Wildlife had set up a $100,000 fund to pay for such verified losses.

Meanwhile, another battle had been raging - this time between pro-wolf groups. Purists argued that wolves would eventually move southwards from Glacier National

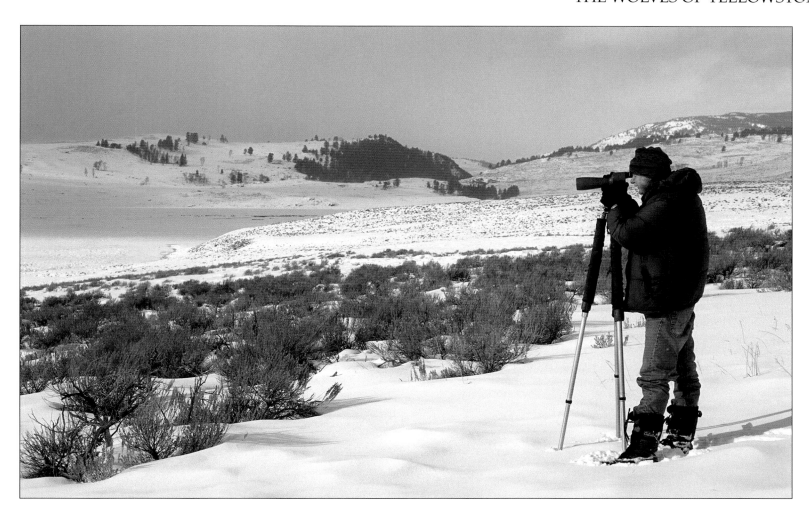

Park to naturally recolonise other wild areas including Yellowstone. They wanted nothing to do with the capture and translocation, radio collaring and possible ear tagging of the wild wolves. Pragmatists argued that the wolves needed a helping hand to speed up the restoration process, rather than waiting patiently for 40 or 50 years for it to perhaps happen naturally; they also wanted the whole operation to be carefully monitored. The pragmatists eventually won the argument and detailed plans were made to translocate surplus wolves from Canada to Yellowstone. The long wait was nearly over.....

The first 14 wolves arrived in Yellowstone National Park during January 1995. Three acclimatisation pens had been erected to hold three packs of wolves for the first 10 weeks, with the aim of breaking any homing instinct. This method is known as a soft-release, as different from a hard-release where animals are set free immediately on arrival. But the years of controversy had one final twist. A last-minute legal challenge by the American Farm Bureau Federation was still being considered by the courts. Although it sounds crazy, Yellowstone staff were initially forbidden to let the wolves out of their shipping crates into the acclimatisation enclosures; they feared the crates might become coffins. At last, in the middle of the night on 14th January 1995, the legal wrangling was over and the doors of the shipping containers were opened.

Above: A keen wolf-watcher.

Left (above): A pack of wolves waits just below the tree line with a large herd of elk in the Lamar Valley floor below. Look closely, at one third of the way across from the left (underneath the dense tree area), and you will see the resting wolves as tiny dots. They unsuccessfully attempted a kill as the light was fading.

Left (below): Bald eagles over-winter in Yellowstone because some rivers here remain unfrozen due to the heat from the thermal features, allowing the eagles to catch fish.

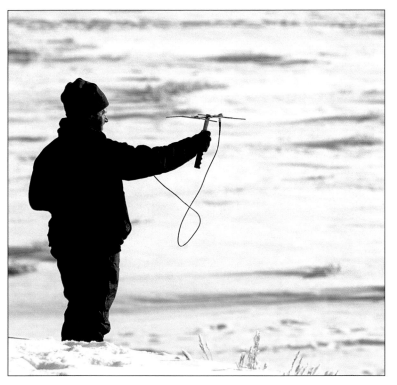

Above and left: Initially, every wolf re-introduced to Yellowstone was fitted with a radio collar, each having a unique frequency. This allowed detailed information to be gathered, vital to assessing the success or failure of the project.

Since the early years, some 35% to 40% of the population have been given radio collars so that long-term research information can be gathered. This involves darting the wolves from a helicopter, usually during the deep winter snow of January/February when it is harder for them to quickly flee. Once tranquilised, a collar is fitted; the animal is also given a basic health check, with blood samples taken.

Radio tracking is done from the ground and from the air, allowing movements of the various packs and individuals to be carefully followed. Yellowstone is a big place and some wolves travel long distances.

(If you haven't already done so, spot the volunteer - also pictured left, close-up - radio tracking in the winter landscape above.)

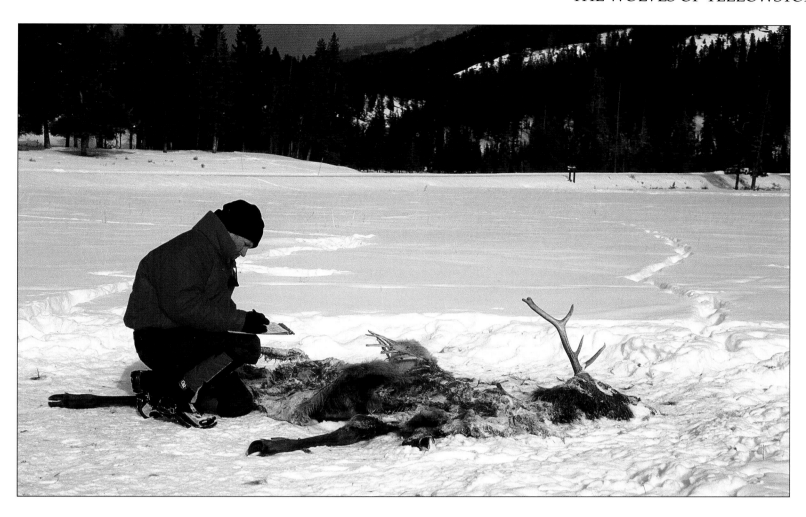

Above and right: A volunteer examines the remains of an elk, killed by wolves. Biological samples are taken, helping to gauge the animal's age. This volunteer, usefully but coincidentally, was a carpenter by trade! (For any reader who may not immediately understand my last comment, he's using a saw to obtain the sample.)

Since the wolves have returned to Yellowstone, the elk population has approximately halved in numbers. Various factors including drought, harsh winters, hunting by humans, as well as wolf kills, have all contributed to this decline. Before wolves were re-introduced, people were complaining there were too many elk and that this high number was damaging the ecosystem. Now the debate is "Are there too few?"

Many elk congregate in the Lamar Valley and other parts of the northern range of Yellowstone during the winter months. This area is famous for its winter wolf viewing. Research has shown that wolves make more successful elk kills - their favourite prey species - during late winter than early winter. This is probably explained by deeper snow favouring the wolves during a hunt, combined with the declining condition of the elk as the winter progresses. By comparison, 25% to 35% fewer elk are killed in summer.

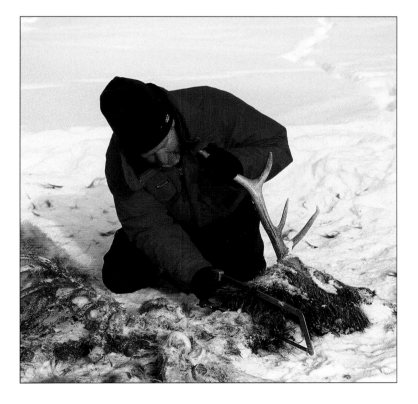

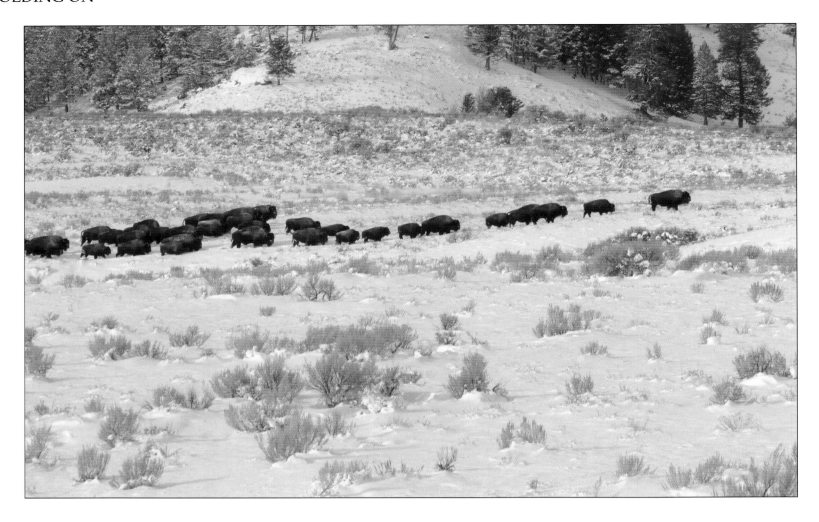

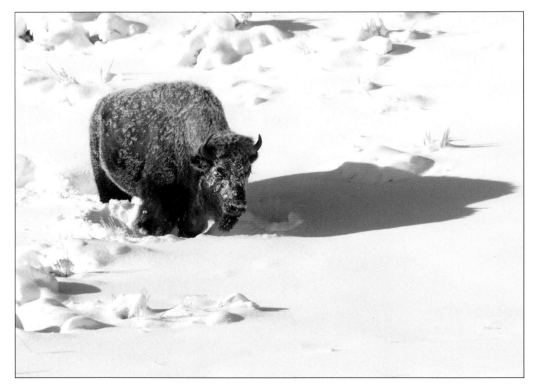

Above: Yellowstone was crucial to the bison's survival.

Left: It is harder for bison to move about in deep snow and they use up more energy.

Right (above): A herd of bison on the move in search of grazing.

Right (below): The bison has a large head and powerful neck, allowing it to push snow off the grasses and sedges before eating. This "snowplough" effect is important to their survival in winter, when bison are in constant need of food and deep snow might otherwise lead to starvation.

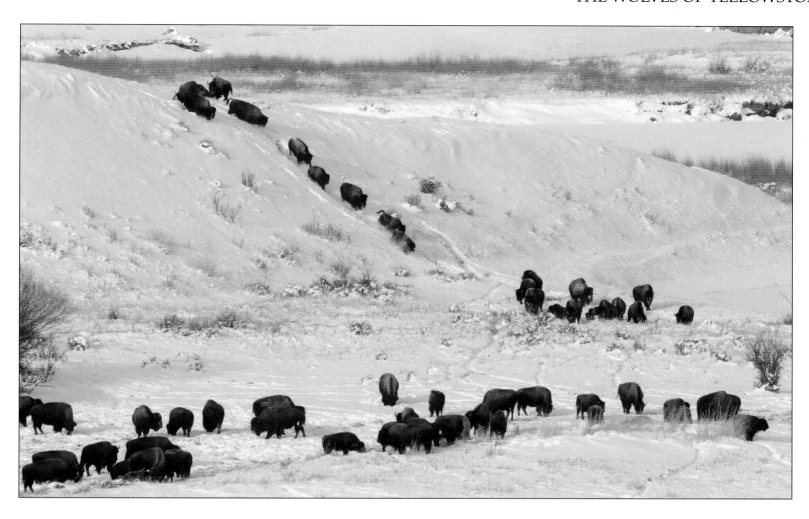

Bison are historically famous as a prairie species, where they existed in great numbers on the vast open spaces. They were all but eliminated by European settlement, with Native Americans earlier reducing numbers and causing local extinctions. By 1902, less than 25 bison survived in the wild. Pelican Valley, in the central region of Yellowstone, played a crucial role in their continued existence.

Numbers have thankfully recovered and Yellowstone today typically has more than 3,000 of these large beasts. The mass slaughter of bison in the mid to late 1800s must not be forgotten. It is estimated that between 30 to 60 million bison once roamed free in North America.

The bison may at first glance appear to be a massive and cumbersome creature, slow to move about. Many visitors to Yellowstone mistakenly think of bison in this way. People often get too close to the bison, ignoring National Park Service warnings that they can be dangerous, perhaps over-eagerly wanting to pose next to these symbolic American animals for a photograph. Every year, a number of visitors find themselves in danger - with injury a possible outcome, as frightening incidents suddenly develop. Bison are surprisingly agile and can suddenly charge up to 30mph (48kph). They will react defensively if provoked. I have reliably heard of at least two shocking incidents where a father tried to place his child on the back of a bison.

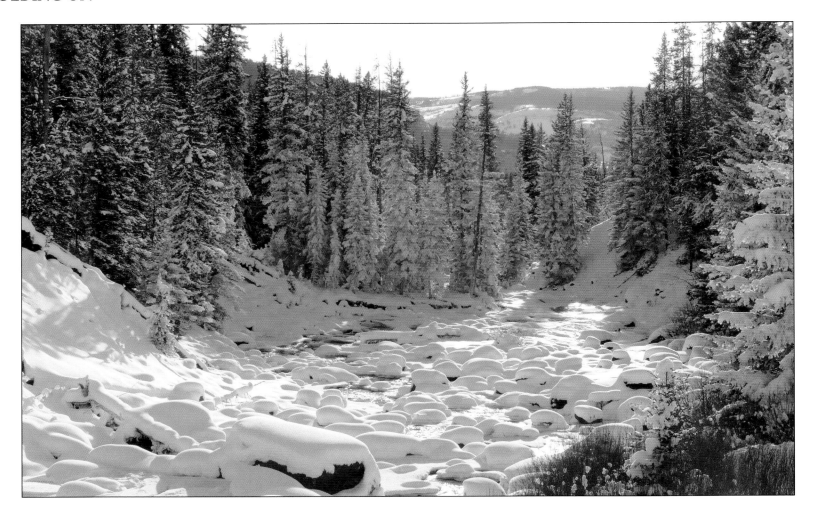

Above: A picture-postcard scene of a Yellowstone river in winter.

Right: On my second trip to Yellowstone, the temperature was -40°C during the first few days, described by the American weather forecasters as "frigid" conditions. On my previous visit, I had experienced -25°Cwhich was cold enough. The benefit was even better photographic opportunities. This frosted tree and stream in the Lamar Valley was a beautiful sight. Another advantage of visiting Yellowstone in winter is that you avoid the horrendous crowds of summer.

Security was tight during the wolf re-introduction phase, as anti-wolf feelings were still at boiling point. Armed officers were always nearby for the transporting of the wolves from Canada to Yellowstone. Then, whilst the wolves were in the acclimatisation enclosures, specially trained security rangers were always watching - albeit just out of sight of the wolves, so the new arrivals did not get too familiar with humans.

In late March 1995, these first wolves were given their full freedom of Yellowstone. A second batch of wolves was translocated in the spring of 1996. The packs settled into their new environment, each marking out a territory. Thousands of visitors watched in fascination. As long as people stayed on the roads, the wolves didn't seem bothered and they carried on their normal behaviour. The dream had become a reality.

Outside the national park, the hatred and fear continued. Some parents wouldn't let their children wait alone just by the house for the school bus. Many believed that the only good wolf was a dead wolf. And, of course, those who over-romanticised the wolf saying they "could do no harm" were quickly proved wrong. In January 1996, wolf #3 wandered beyond Yellowstone and attacked a sheep. It was quickly recaptured and re-released some 60 miles away in central Yellowstone. But, by the beginning of February, #3 had returned to the same ranch beyond the park's boundary and another sheep was attacked. According to regulations, the wolf had been given a chance and

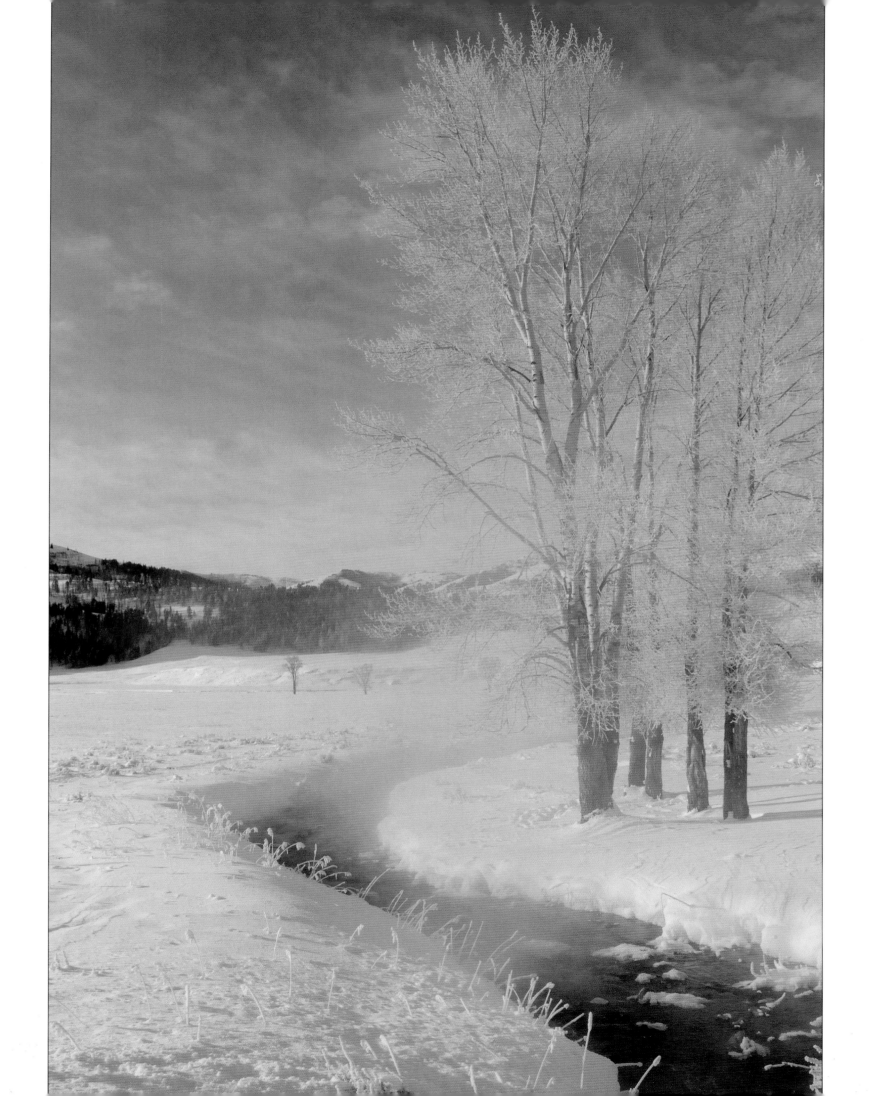

Above: *Early morning in the Lamar Valley, with the temperature barely rising from an overnight low of -40°C. These sub-zero conditions yet again produced a wonderful sight of frosted trees in the snow.*

the decision was taken to remove it from the project. Wolf #3 was therefore shot by an Agricultural Department's Animal Damage Control Program officer.

Much earlier, in April 1995, just weeks after being released, wolf #10 was illegally shot by a local man. He claimed in court that he thought it was a feral dog, but few believed this. To some local people, he was a hero. To others, the shooter was a murderer. The courts found him guilty of the federal offence of killing an endangered species and the man was sentenced to six months in jail plus the loss of hunting privileges for two years. More than 30 wolves have since been killed illegally.

Despite individual tragedies, the wolves of Yellowstone have flourished. During the first five years, their population grew by up to 50% a year. Wolf numbers peaked in 2003 at 174 but have since significantly declined. My second visit to Yellowstone coincided with the 15th anniversary of the wolf re-introduction and in January 2010 there were 96 wolves surviving, largely as 14 packs. Disease - including parvovirus, distemper, and mange - has been a major factor in the recent decline. Wolf numbers seem unlikely to increase again to the heady days of the late 1990s and early 2000s when visitors to the northern range of Yellowstone were treated to an abundance of wolves. That said, places like the Lamar Valley remain special and offer relatively easy viewing of wolves in the wild.

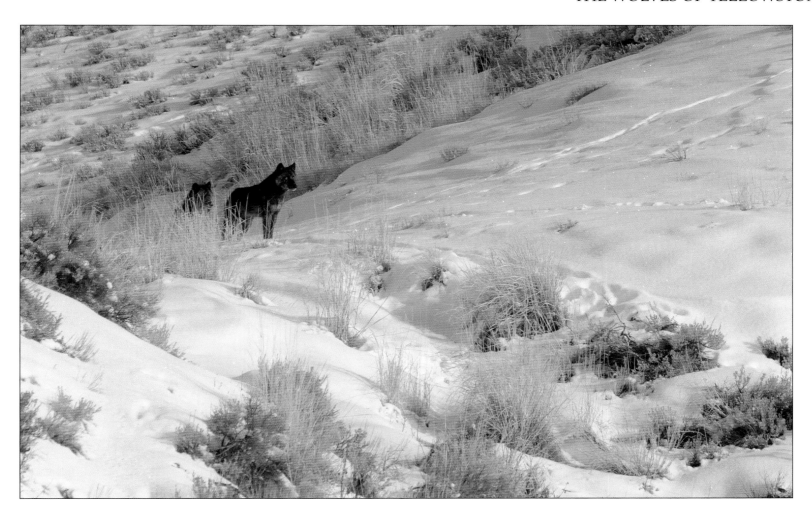

Above: I took this photographic image of these black wolves on the last day of my second trip to Yellowstone. As with my first ever sighting on the first day of my first trip (see pages 54 & 55), I anticipated where the wolves would appear and we waited with great expectancy. These wolves were part of the famous Druid Peak pack, but the coming weeks would see their final demise. (So this and the photograph on page 78 are among the last published images of this much-loved wolf pack.)

Right: An organised tour of wolf watchers. Fieldscopes are very useful, capable of magnification up to x75 (compared to binoculars which are typically x10). The wolves are often far away but nevertheless clearly observable with this equipment.

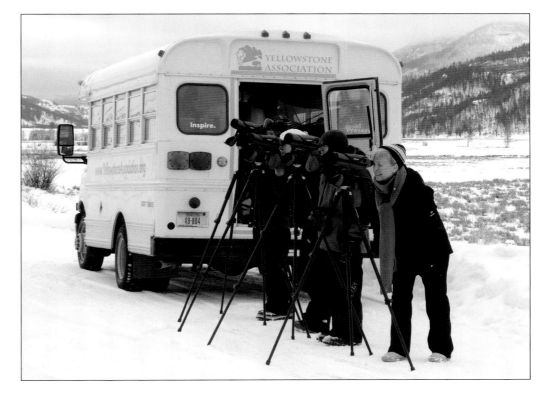

Above: Dead lodgepole pine trees left standing from the widespread fires of 1988. Many people feared for Yellowstone's future after these seemingly devastating fires, which happen only rarely every hundred years or so, but much regeneration has since taken place as nature's cycles continue to turn.

Left: Snowmobiles are a controversial subject in Yellowstone. One of the U.S. National Park Service's aims is to provide recreation - but snowmobiles are noisy, polluting, and dangerous. A range of local businesses, however, depend on this winter trade and insisted on their rights. By 2010, an uneasy compromise of "organised tours only" had been reached - reducing the dangerous aspect somewhat.
Fishing is also permitted in Yellowstone and other American national parks, yet surely fish are also wild creatures worthy of sanctuary?

Right: Yellowstone's Grand Canyon in mid-winter. This is a view from Artist Point of the Lower Falls and Yellowstone River. Millions of visitors have stood here (usually in summer), struck by the overwhelming sense of vastness - some hopefully with gratitude that such wilderness has been protected.

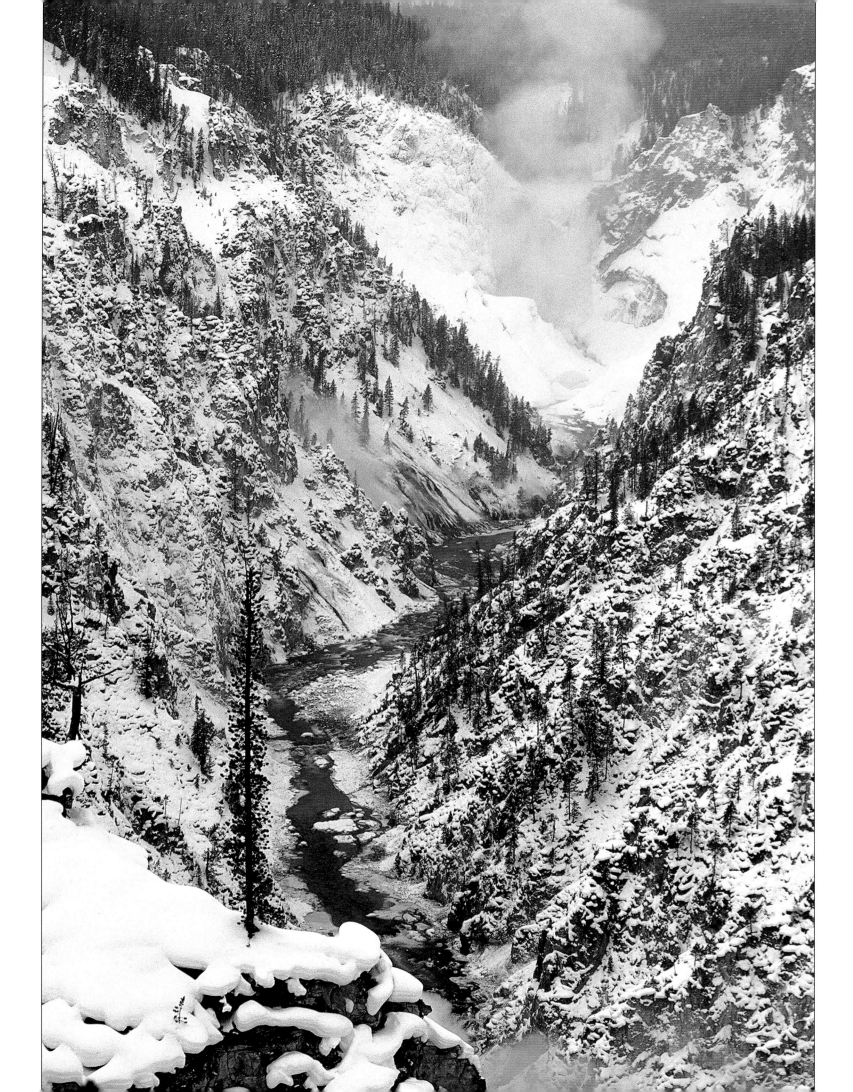

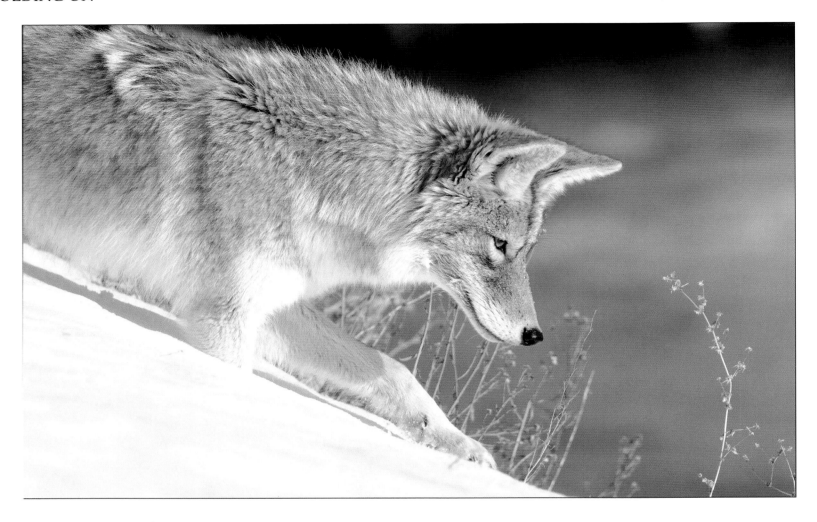

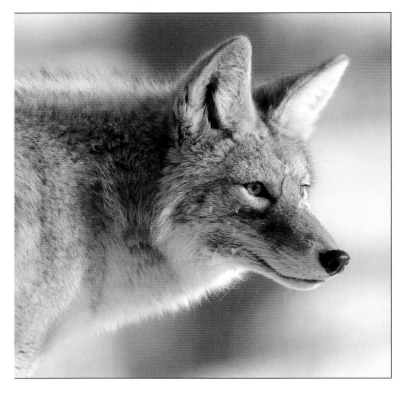

Above and left: *The coyote is the North American equivalent of Africa's black-backed jackal. It is seen here hunting mice and voles, listening out for them as they burrow underneath the snow.*

Prior to wolf restoration, Yellowstone supported one of the densest coyote populations anywhere; this situation was undoubtedly artificial. Coyotes are masterful at adapting and exploiting a range of opportunities. Since the wolves have come back, coyote numbers have dropped by 50% in Yellowstone's northern range.

Coyotes usually gather at a kill site shortly after the wolves begin feeding. They initially keep their distance in this risky business of scavenging a meal, but will quickly move in if the wolves give them half a chance. Nevertheless, wolves have frequently killed them on carcasses as well as at den sites.

Coyotes may have declined since the wolves have reclaimed the "top dog" role in Yellowstone, but this in turn has resulted in an increase of red foxes - now not so persecuted by an excessively large number of coyotes.

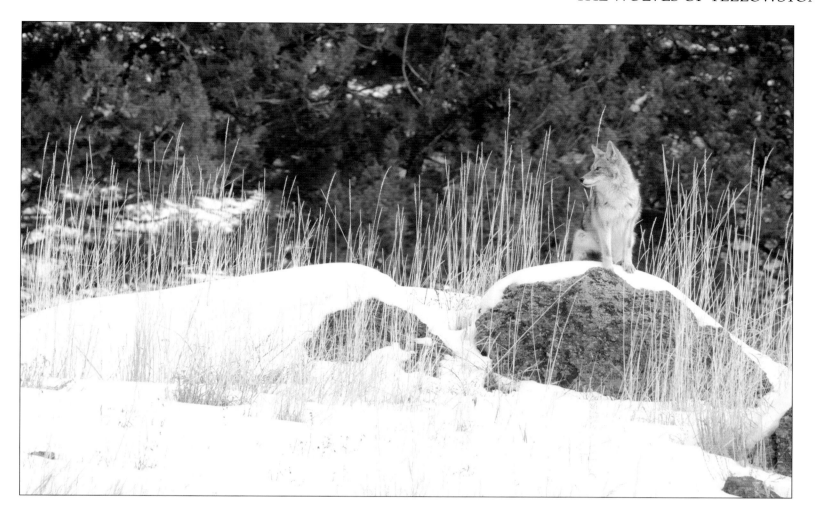

Above and right: Sitting atop a boulder high up on a ridge gives the coyote an advantageous lookout point while it rests, as wolves are now a major threat to life.

A surprisingly large number of visitors to Yellowstone think they may be seeing a grey-coloured wolf whereas they are actually looking at a coyote. This confusion is understandable, as the two species are similar in appearance - size being the main obvious difference. Along the road leading to the Lamar Valley, experienced wolf watchers are usually on hand to help guide and educate the average visitor who may be in doubt. When one or more wolves in a pack are black in colour, there is no ambiguity about identification.

It is important that visitors do not give food to animals such as coyotes because they can quickly become habituated to this "easy" lifestyle. Invariably such wild animals become an increasing risk to human safety and park rangers end up shooting them - even though people are actually at fault and have caused the problem.

A yearling male wolf was shot in the Old Faithful area in May 2009 because it had associated visitors with getting food, with several repeat incidents having been reported.

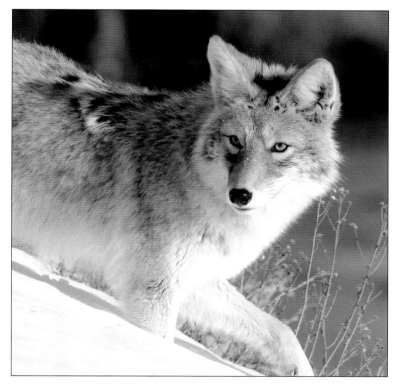

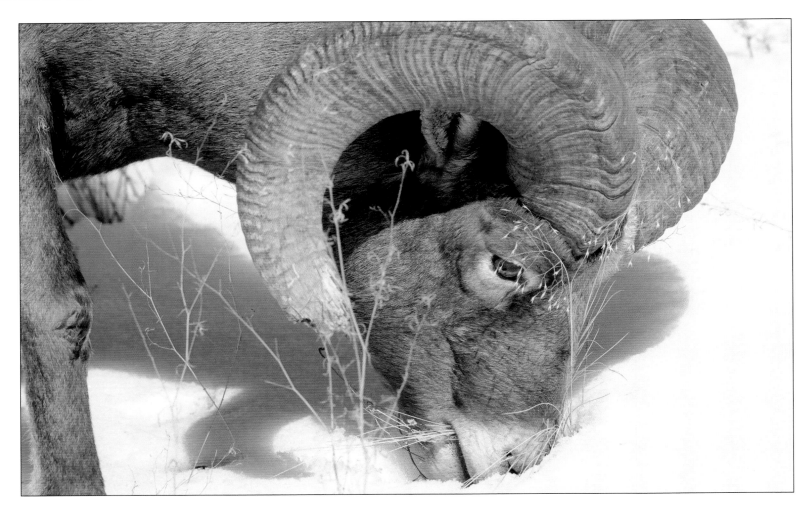

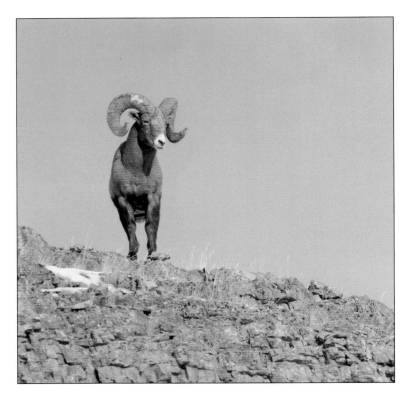

Above and left: *Bighorn sheep are yet another example of what was almost lost. Millions of bighorns once graced the western parts of the USA. By 1900, only a few hundred remained.*

Today, Yellowstone's resident bighorn sheep in the northern range number between 150 and 225 animals. Since the wolves have returned, there have only been a couple of cases of bighorn sheep being predated. Their special agility on steep slopes affords them good protection. And they also keep watch for any sign of danger. The bighorn (left), for example, had spotted a coyote and was keeping it in sight as it trotted past.

During the rutting season, the rams repeatedly butt heads as they spar to assert dominance - the winner getting the prize of mating with the females. Frequent clashes often result in horns becoming broken or "broomed" at the ends (as you can see in the images above and on the opposite right-hand page). It is the older males which have the most spectacular headgear for which these sheep are named.

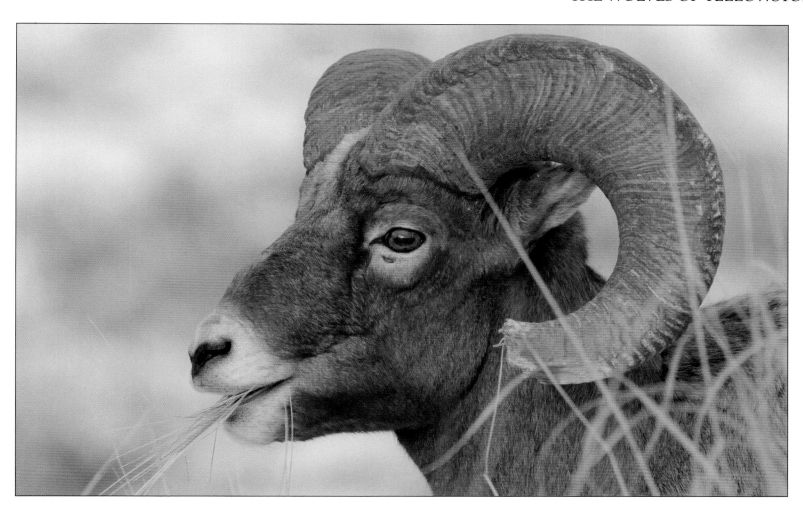

Above and right: *Visitors usually seem delighted at seeing bighorn sheep with their large, curved horns and some of the older males seem relatively unbothered when they are turned into celebrities with dozens of cameras clicking away.*

There are several points from the north entrance to the far end of the Lamar Valley where you are likely to encounter this fascinating species, including the steep cliffs above Gardner River not long after entering the park before reaching Mammoth Hot Springs.

Bighorn sheep are mixed feeders, both grazing grasses and browsing bushes. They are reasonably bulky animals, with males weighing up to and sometimes exceeding 135kg.

In Yellowstone, it is the Rocky Mountain bighorn sheep you will see. Two further sub-species with similar self-explanatory names are found to the west: the Sierra Nevada bighorn sheep (formerly known as the California bighorn sheep) and the desert bighorn sheep.

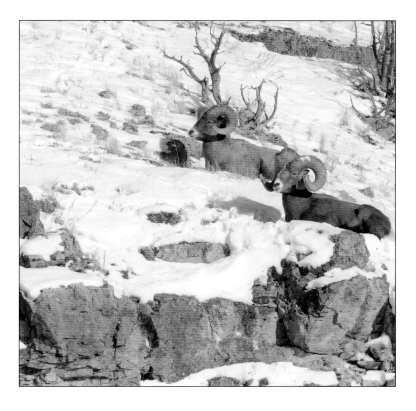

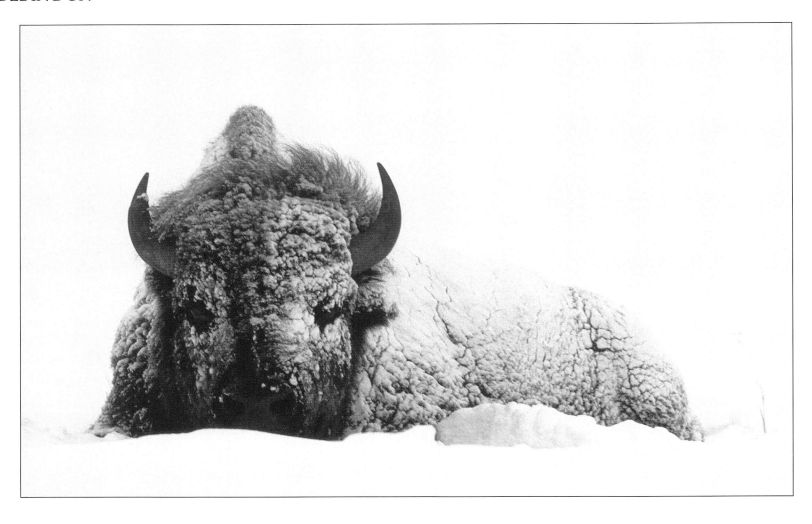

Above: I photographed this bison in the early morning after a snow storm.

Left: Fresh snow and grasses.

Right: Another picturesque scene in the Lamar Valley. Day after day, I looked for a bison or another wild animal to move into the right position to make this view complete. My efforts and persistency were eventually rewarded.
During my second visit to Yellowstone at the same time of the year, the river was completely frozen over due to unusually cold conditions.

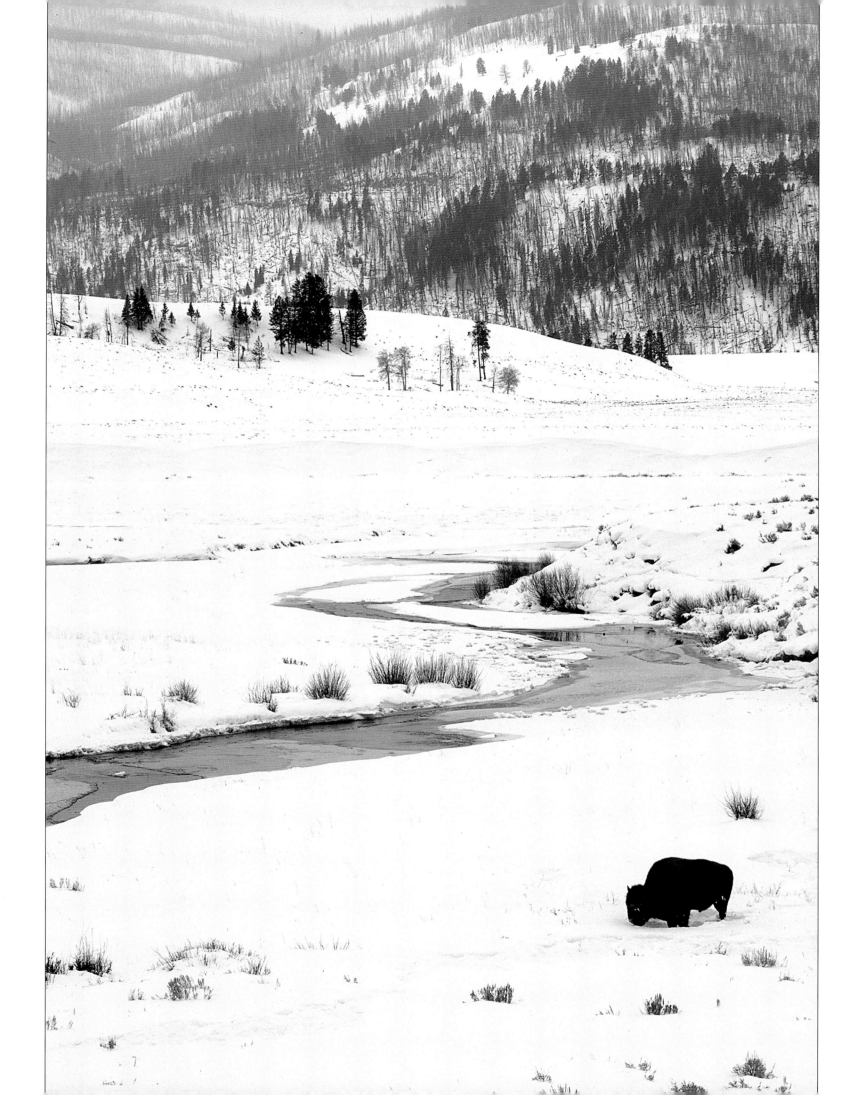

Above: *Alladale Lodge in early winter. The estate's remote location is well-chosen and scenically attractive.*

Wolves in the Scottish Highlands?

Paul Lister has a dream. He wants to bring wolves back to the Scottish Highlands as part of a re-wilding process. And by buying the 23,000 acre Alladale estate, he has already put his money where his mouth is - unlike many people who seem to be content with merely talking the talk.

Paul Lister inherited a fortune from his father, Noel Lister, who sold his share of the MFI furniture business in 1985. Paul was inspired by the remaining wildlife in the Carpathian mountains of Eastern Europe and by successful private game reserves in South Africa. He bought Alladale in 2003 with the aim of restoring the native Caledonian forest and re-introducing bears, lynx, and European elk - as well as wolves - to the Scottish Highlands, north of Inverness. A public relations firm was hired to promote the dream and a number of national newspaper articles plus television documentaries quickly followed. But was the idea "howling mad"?

Scottish ramblers were soon up in arms. They had fought hard against a lack of walking access through large hunting estates, usually owned by mega-rich Englishmen, eventually winning the Land Reform (Scotland) Act 2003 that requires landowners to

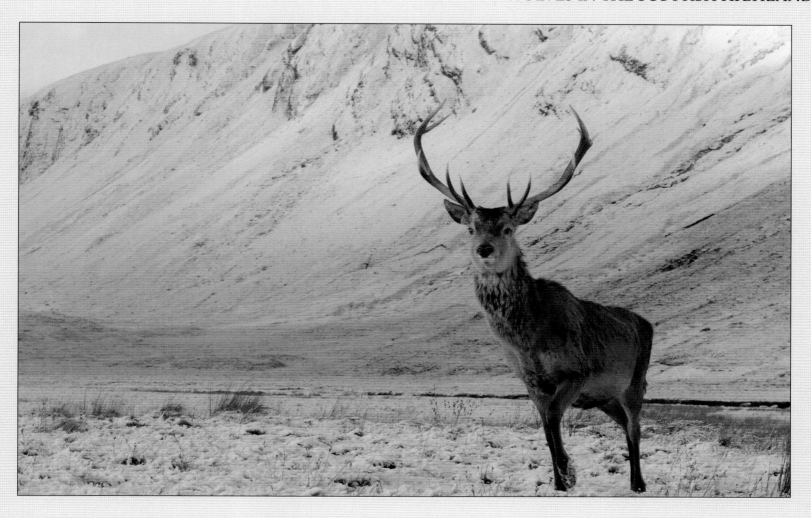

Above: The red deer is seen as a problem animal in the Highlands. The breeding of this trophy animal is encouraged by many hunting estates, yet an overpopulation of red deer is devastating the native trees. As in the case of Yellowstone, the re-introduction of wolves would put a major predator back into the natural equation. Alladale continues to offer deer stalking to rich clients, albeit with the aim of keeping numbers in check.

Left: Some have dismissed Paul Lister as just "a nutter with money" but this isn't true. It is creditable that he is using his inherited wealth to do something worthwhile. Everyone goes through a learning curve and Paul has undoubtedly now learned that bringing back wolves isn't an easy thing to try to do. The future outcome of Alladale will probably boil down to whether he is a fighter or a quitter.

Above: Paul Lister has been fortunate to have inherited two excellent professional deer stalkers who were already working at Alladale: Innes and Poppy. Both men have been convinced by the conservation vision, seeing it in action for themselves during a trip to South Africa. Here, Innes is looking for a suitable deer for his guest to shoot.

I am personally opposed to shooting for sport and would argue that if culling is absolutely necessary, for whatever reason, then it should be done by professionals. Others, of course, argue that hunting brings in much-needed finance.

maintain free access everywhere apart from gardens and other specified areas. They were horrified at plans to erect a high electrified fence around the Alladale estate for the purpose of keeping wolves. Ironically, many who loved being outdoors became vehemently opposed. For example, the Mountaineering Council of Scotland has officially stated its objections. But is this just another example of "me, me, me" coming from people who can't "think big"? Why can't ramblers share the Highlands' expanse with wolves and other native wildlife long-since persecuted?

Others have expressed their professional opinion that Alladale is too small, saying that a minimum size of 50,000 acres is required for free-ranging wolves; still others believe that 250,000 acres is needed for just two wolf packs. It looks as if one or more owners of neighbouring estates would have to share Paul Lister's dream, yet many seem to have been initially upset by his impulsive approach - although perhaps, with time, this situation may change.

My own opinion is that Paul Lister should be applauded. He is right: we should be re-wilding remote areas of Scotland. But despite his worthy vision, Paul lacks the necessary skills himself to realise the dream and so is dependent upon others around him to make all the pieces of the jigsaw puzzle come together. Almost 10 years on, there are still no immediate plans to bring wolves back to Alladale.....

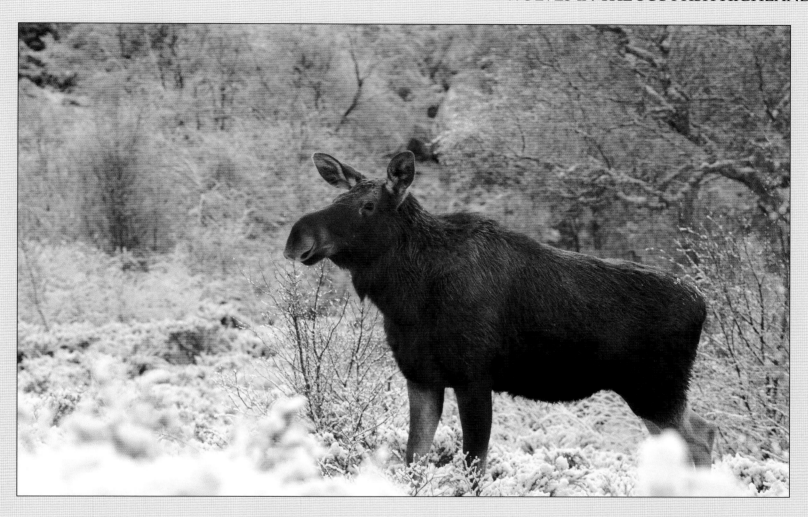

Above: One of the two European elk (or moose) bought from a Scandinavian farmer and kept in an enclosure at Alladale. This initiative, however, must not be confused with an authentic re-introduction to the wild.....because it isn't. The animals are kept with a zoo licence, artificially fed every day, and have a wooden shelter for protection.

Right: These wild boar are likewise kept in an enclosure and artificially fed. Academic research has been done into their usefulness for breaking up bracken and other dense vegetation to aid tree regeneration. My understanding is that this idea is not as straightforward as first imagined.

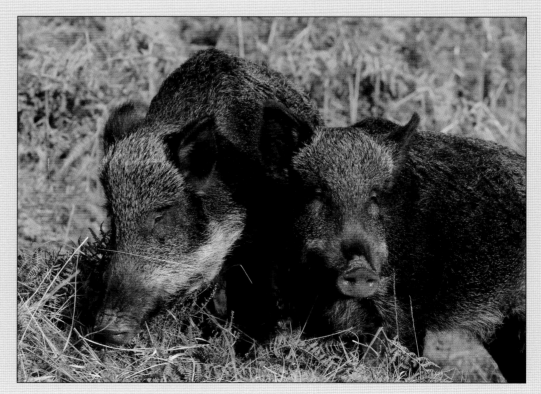

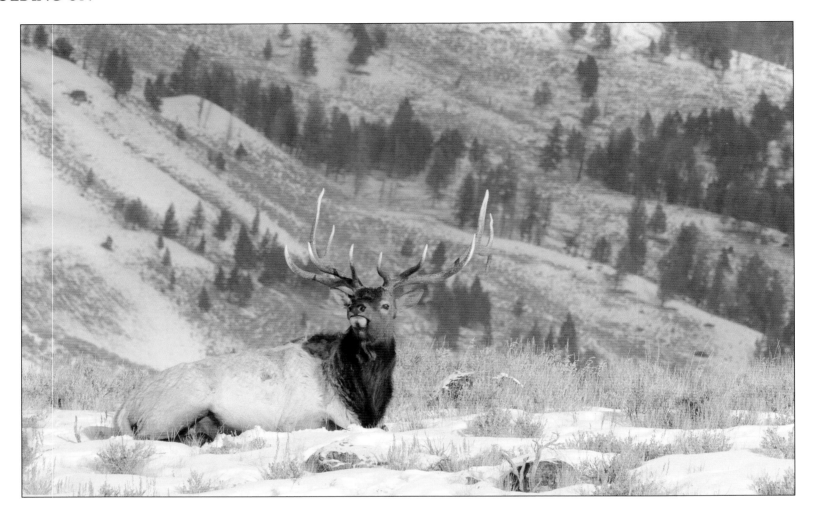

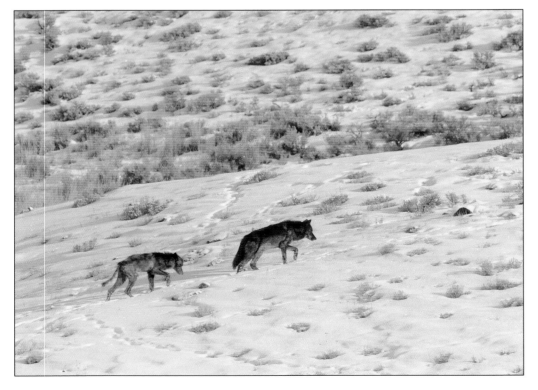

Above: *A majestic bull elk in the wilds of Yellowstone.*

Left: *Mange has badly affected the wolf following behind, as well as other members of the Druid Peak pack. Wolves with mange are susceptible to dying of cold during the bitter winter months. Mange is a parasitic infestation, causing the host animal's fur to fall out. A healthy, well-fed adult wolf can usually withstand mange but a number of Yellowstone's wolves have nevertheless died from this disease.*

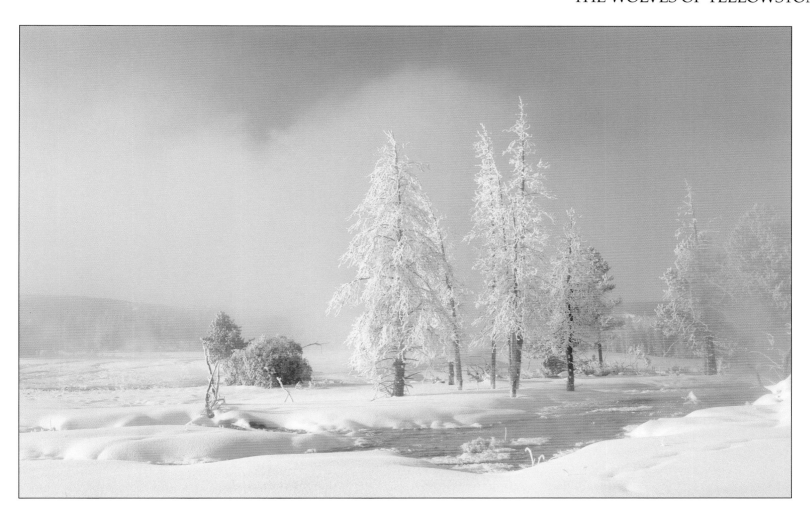

Above: The winter wonderland of Yellowstone can be stunningly beautiful for visitors prepared to brave the freezing cold weather. If you are planning a trip, pack suitable clothing and footwear.

Right: Two wolves on the move in the Lamar Valley early one morning. Travelling through thick snow is a challenge for any animal, but wolves seem to manage it better than most and it is at this time of the year that they are most successful in hunting elk.

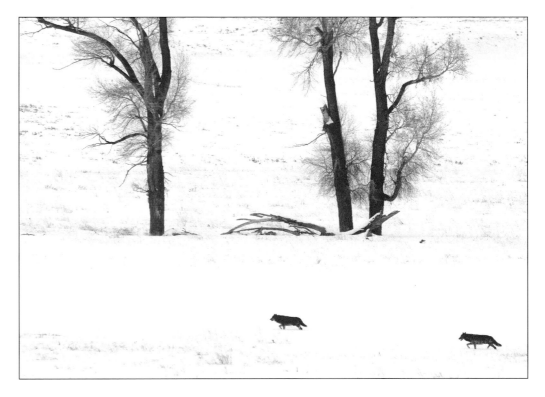

79

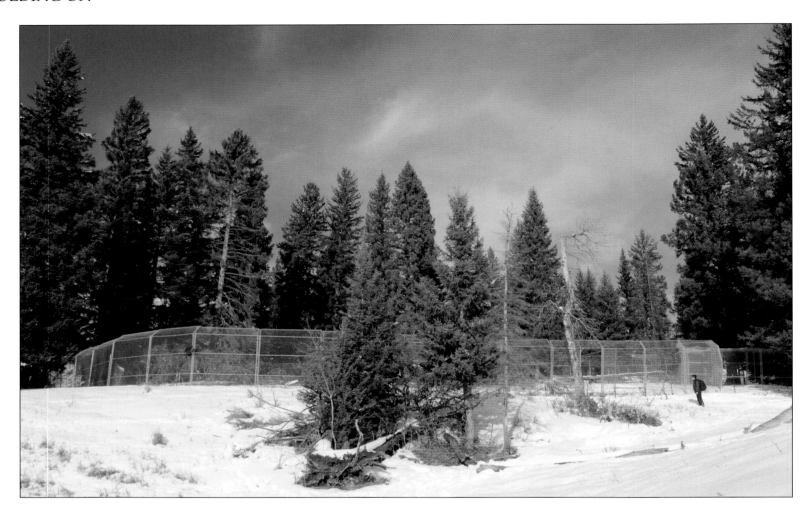

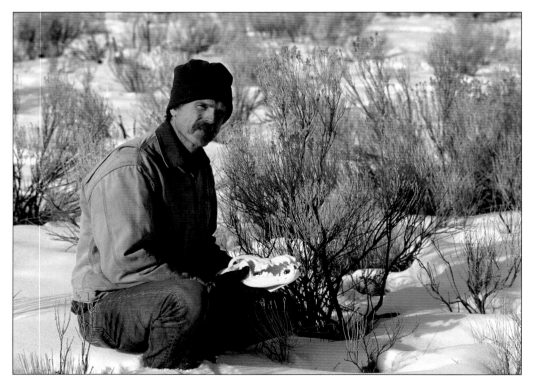

Above: One of the original acclimatisation enclosures from 1995 is still standing.

Left: Doug Smith was involved at the re-introduction stage as a biologist and later as project leader of Yellowstone's wolf programme.
The skull Doug is holding is that of #27. This female wolf was legally shot by staff after killing sheep outside the park on two separate occasions. Yellowstone is a big place, but #27 simply didn't understand the human concept of artificial boundaries. Wild and free, she paid the ultimate price for just being a wolf.

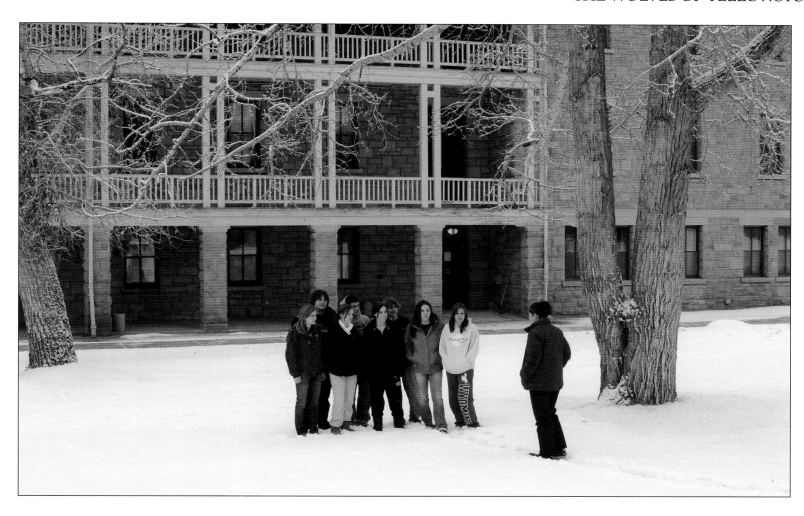

Yellowstone is a success story. This was the world's first national park, leading the way for others to follow. Wolves were initially wiped out during the early days, but a re-think has now led to their re-introduction after many years of acrimonious debate. So what next?

A major consideration for a better future must be to extend the northern borders of Yellowstone National Park - or, at least, afford proper protection to wildlife that wanders beyond these park boundaries. Originally, the main purpose of safeguarding Yellowstone was to preserve its geysers and other hydrothermal wonders; little or no thought was given to seasonal movements of the wildlife.

Elk and bison head northwards during the cold winter months, seeking lower elevations in response to accumulating snow and crusting of the snow pack. When they remain in the northern range of Yellowstone, they are obviously safe and this multitude of wildlife provides great viewing for visitors. But when they venture further north, beyond Yellowstone's borders, they are likely to be killed. One third of the wider northern range ecosystem currently lies outside of the park boundaries on other public lands and privately-owned properties.

Elk hunters claim their right to bear arms and indulge their recreational shooting interests. Although quotas are regulated by the Montana state authorities, shooters

Above: Becky talking to a group of students at Mammoth. I had initially planned to photograph them being educated by a member of staff from the wolf project, but quickly abandoned this idea when I saw the biologist had lost their attention and was boring the students to sleep. Becky and I talked with the young people afterwards, easily able to inspire them. Education provides a chance to change any remaining prejudice among the local population through the next generation, but this is easier said than done. It is not enough to merely present students with biological facts.

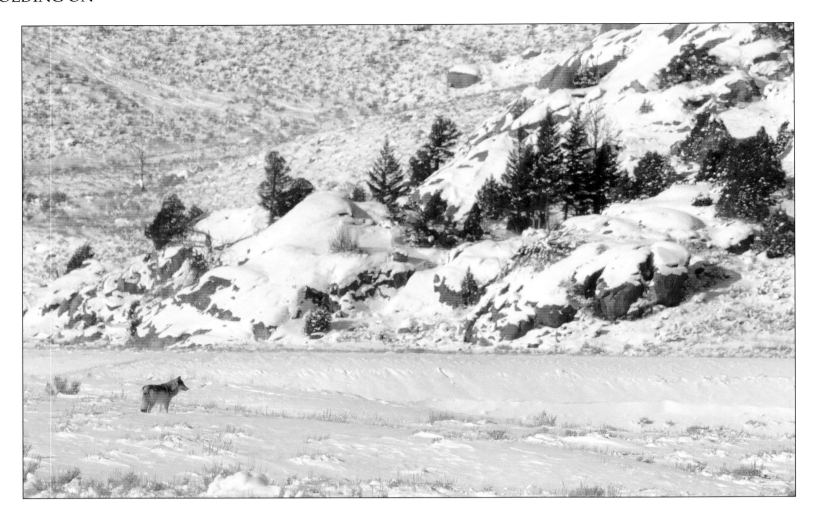

Above: *This picture says it all: the wolf has been successfully returned to the wilderness of Yellowstone National Park.*

Right: *Old Faithful erupts as the last light of the day begins to fade.*

nevertheless kill a lot of elk. This includes about 10% of the Yellowstone elk herd every year. Now that elk are no longer overpopulated in the national park, the hunters' "rights" must surely now be questioned.

Bison are seen by Montana's Department of Livestock as a risk to cattle ranchers. Yellowstone's bison are infected by the bacteria which causes brucellosis, probably contracted way back in the early 1900s when domestic cattle were kept in the park to provide meat and milk for visitors. Even though there has never been a single case of Yellowstone's bison transmitting brucellosis to cattle, the possible consequences are considered too high to ignore by the livestock producers and state authorities. Up to half of Yellowstone's bison have migrated beyond the park during severe winters. In 2008, a staggering 1,730 were slaughtered out of an estimated population of 3,662.

On 5th May 2011, the U.S. Fish and Wildlife Service delisted the wolf from its endangered status in the Northern Rocky Mountains. The state of Wyoming remains aggressive to wolves and - outside a very limited area - currently allows them to be shot on sight. The states of Montana and Idaho allow "regulated" hunting of wolves, with Montana proposing a "harvest" quota of up to 220 wolves for the 2011 season. Many people living outside Yellowstone's borders still hate wolves and some of these will kill them, legally or not, given half a chance. The story continues.....

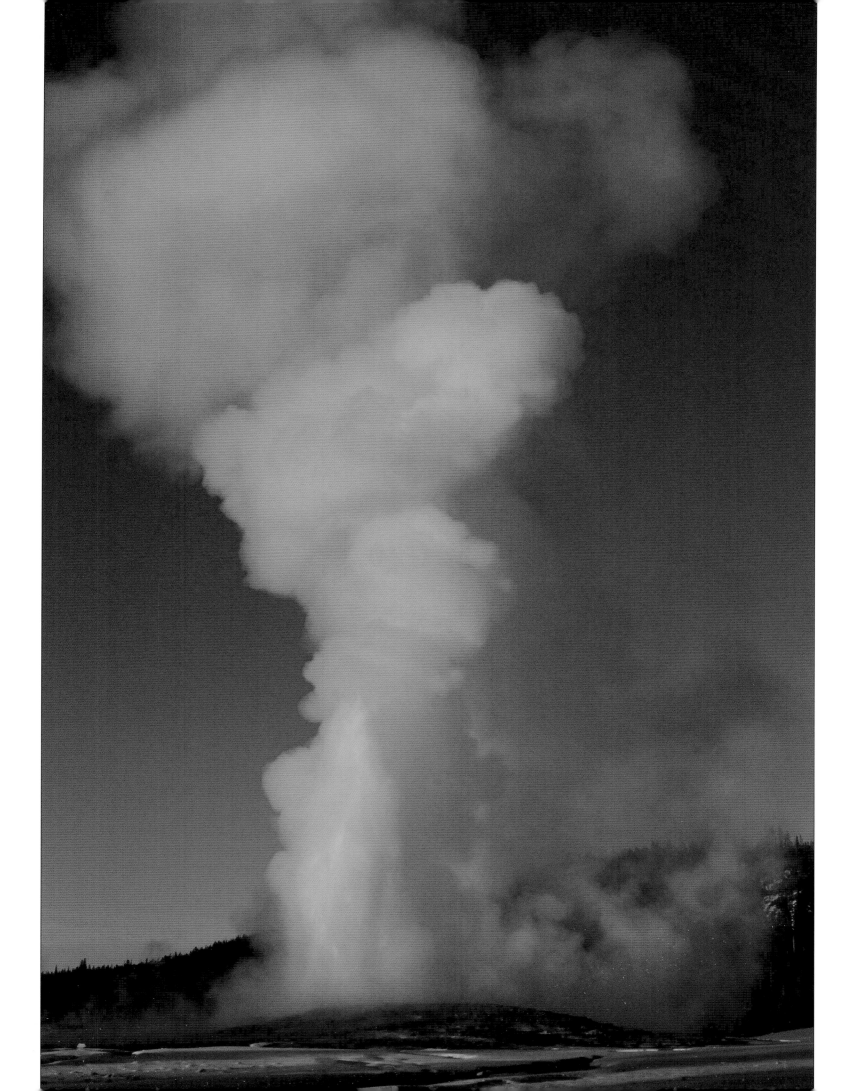

Tigers & rhinos
Why are they still endangered.....
...after 50 years of conservation effort?

In my third book, *What Will It Take? A Deeper Approach To Nature Conservation* published in 1999, I wrote "For every 100 rhinos living in the early 1970s, only three remain today - a terrible decline of 97%." The tiger's plight is just as bad. Why? Why are these wildlife mega-stars still endangered after 50 years of conservation effort? This is a big question that cannot be ignored.

We can generally classify professional conservationists as working in four categories: government organisations, non-government organisations (NGOs), businesses, and academic research institutions.

Almost everyone likes to criticise governments and in lots of ways this is justified; governments can and should do better. That said, the national parks system in many countries must be praised. Tanzania, Kenya, and South Africa are all examples where government is setting aside quite a lot of land for nature. The United States of America is another example - and of course has the honour of Yellowstone being the world's first national park.

My own country, the UK, has a few national parks - but in many ways they are a joke. As a child, I grew up in the Lake District which is justifiably our most famous national park. The lakes, mountains, valleys, and mountain tarns are picturesque and this landscape is very green due to high rainfall. Many people visit the Lake District, enjoying the walking and views on offer. But this national park is not really natural. The Lake District is full of domestic sheep! The sheep admittedly keep the fells well grazed, preserving a certain look that we have all become used to over the years. However, if this multitude of sheep was removed and a range of native wild animals re-introduced, the habitat would change significantly. Then, perhaps visitors might commonly see golden eagles flying overhead. And where are the wolves and bears, etc that once roamed wild? The Lake District is, after all, supposedly a "national park" ...different from Hyde Park or Regents Park in the centre of London!

Right and far right: The tiger is a magnificent large cat and truly awe-inspiring. It has been wiped out from much of its former range and is now endangered, barely holding on.

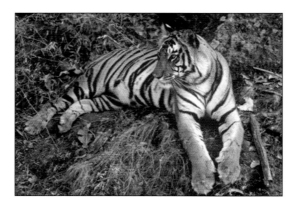

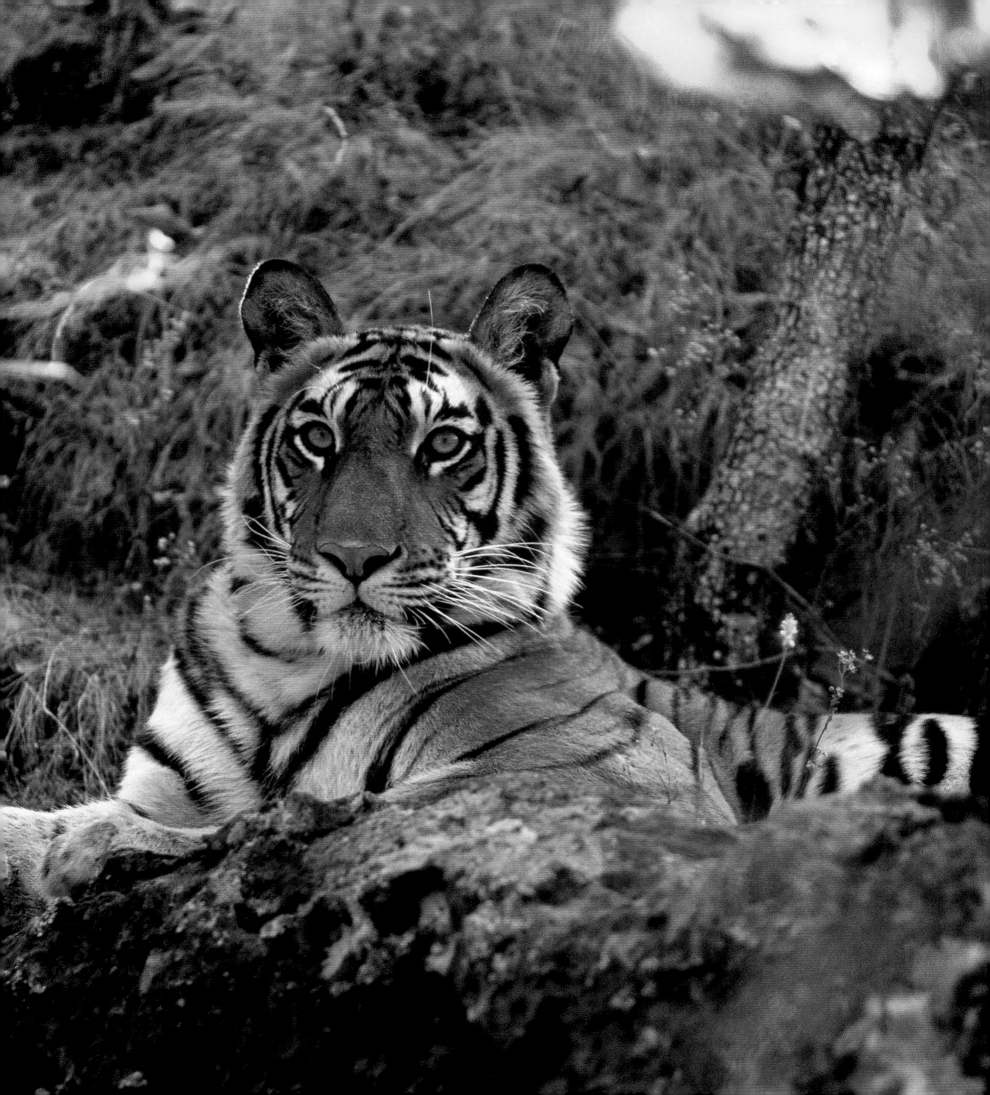

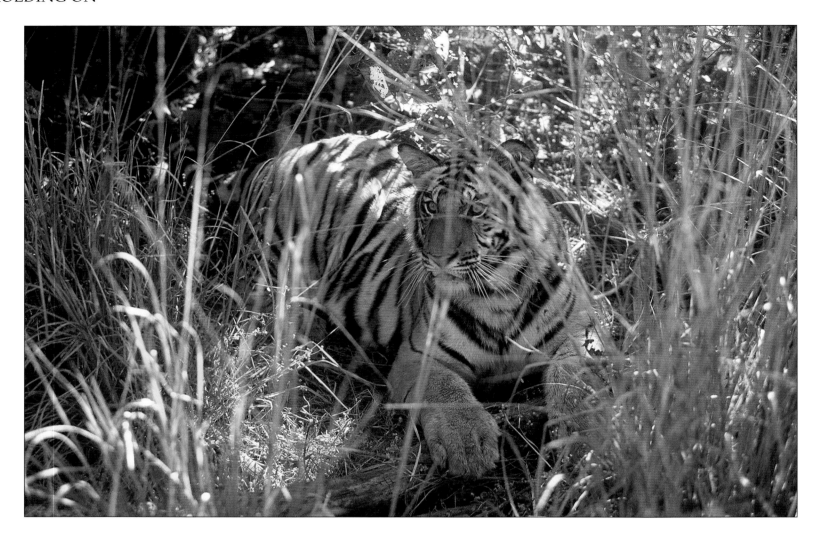

Above: The tiger was once common. Numbers were initially reduced through hunting by royalty for sport. Meanwhile human overpopulation shot up, massively decreasing the tiger's forest habitat. Finally, the modern scourge of poaching has reduced the few that remained. Is the tiger now doomed?

Right: Thankfully, we were alone when this tiger appeared from the dense jungle and I took this photographic image (also used on the front cover). So often there is a swarm of jeeps carrying lots of noisy tourists when a tiger is seen.

Politicians and government officials are skillful at watching their own backs. We all know that politicians usually have one eye on the next general election and that staff in the various departments think they have a job for life if they keep within the guidelines. Whereas this "play-it-safe" mentality might restrict an entrepreneurial attitude, it nevertheless often assures a reasonable degree of accountability and reliance on facts. Many governments, of course, also suffer from corruption and apathy; this is well-known and understood.

However, thank goodness for governments because of the worldwide system of national parks. And the many smaller reserves as well, run by regional government authorities. Collectively, a lot of space is being conserved for our wildlife.

Businesses also get quite a lot of unfair criticism: "A bunch of greedy businessmen raping Mother Earth" sums up the attitude of many greenies. But if you start to look carefully, a number of businessmen and businesswomen are also making a difference. South Africa is the most obvious example as that country has many good cases of rich individuals and companies starting their own private nature reserves - a huge and costly undertaking. And farmers, too, sometimes convert some or all of their land to benefit wild animals. Indeed, it was a few conservation-minded farmers who saved

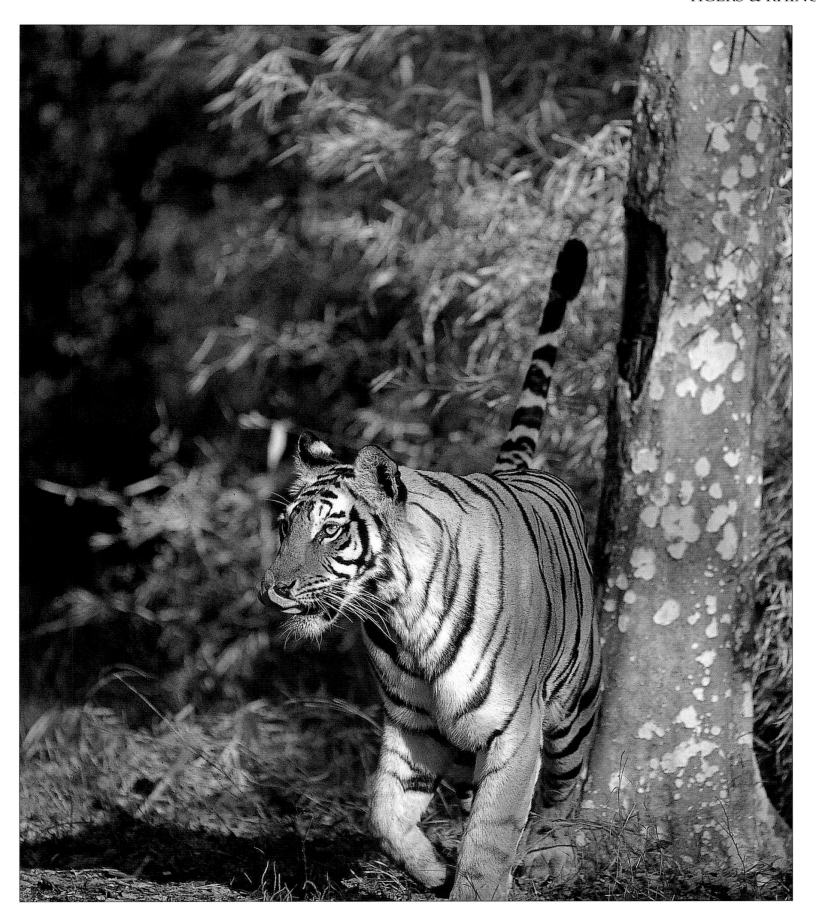

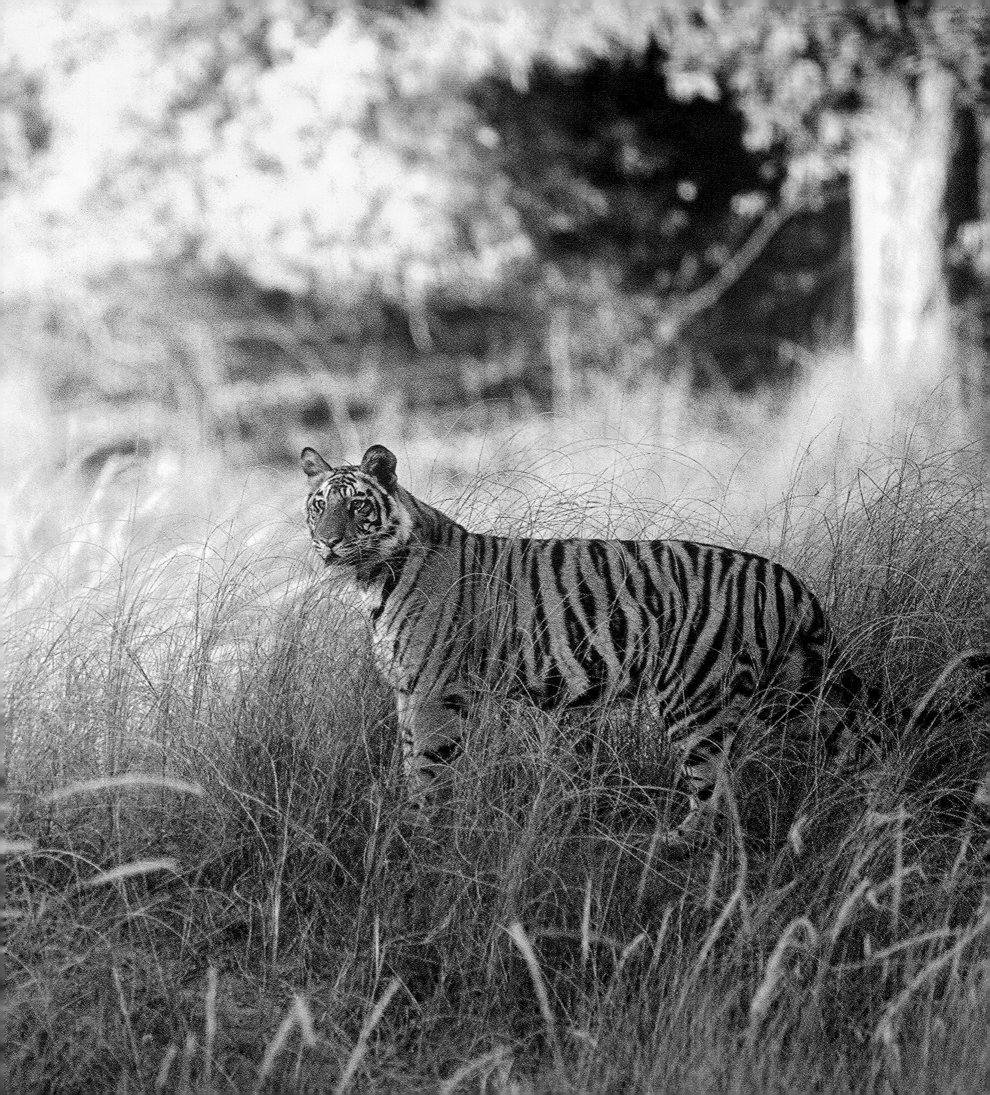

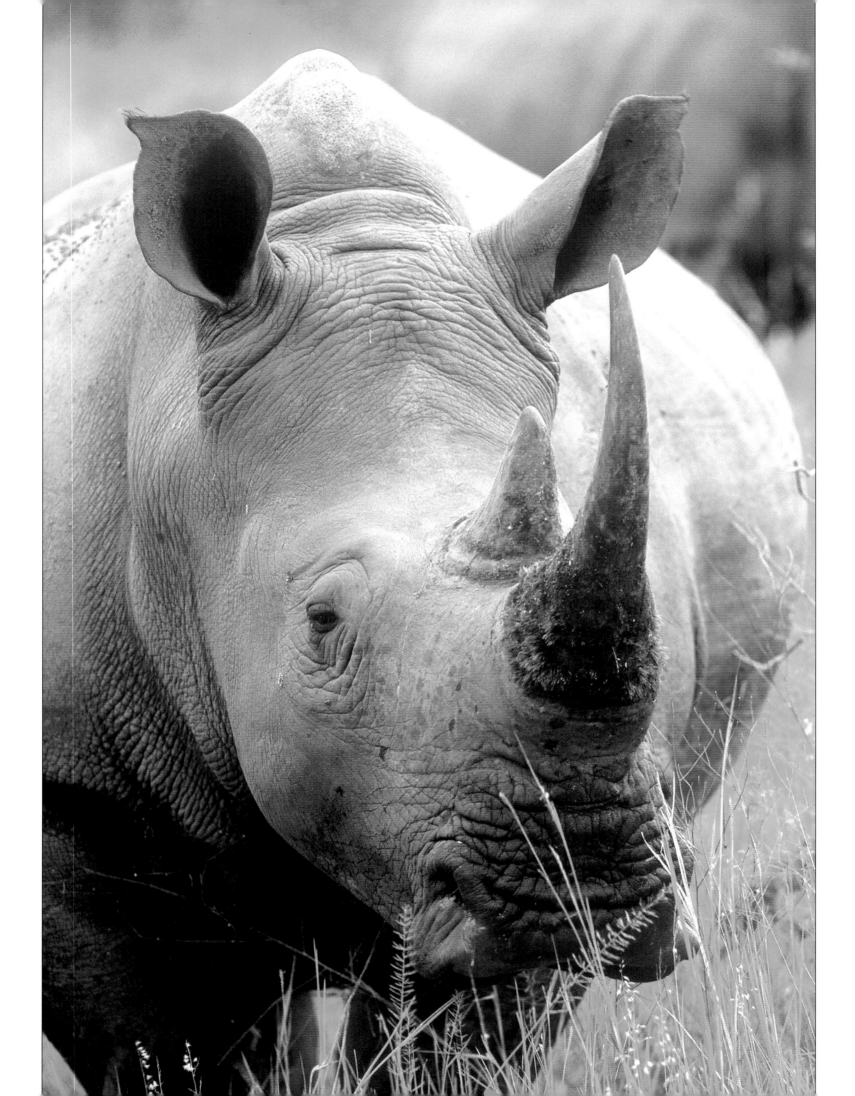

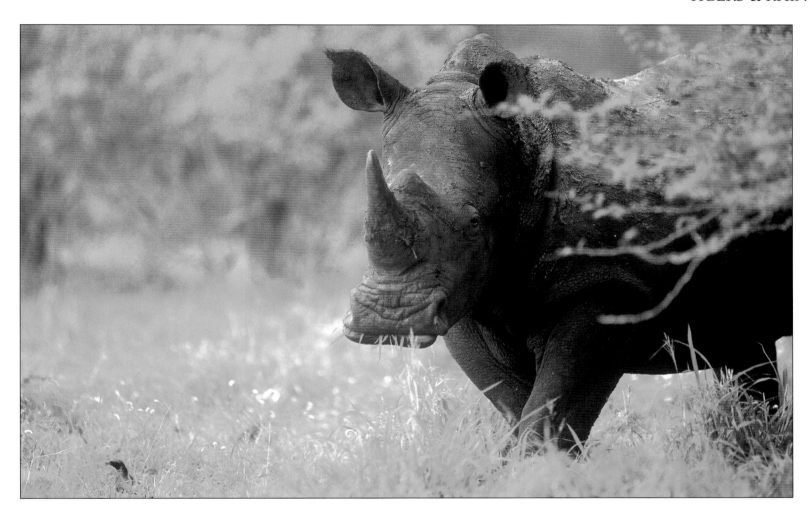

the black wildebeest in South Africa from going extinct in the late 1800s (as we will briefly see in the next chapter).

Academic researchers are often, frankly, just academic researchers. Nowadays, most do little that is constructive, preoccupied with the survival of their own careers as they chase the next grant. Some work for government departments, others for NGOs; a few get employed by businessmen who are keen to enlist an expert or two when they first start their own nature reserve. Many researchers stay cocooned within universities and other academic institutions.

Knowledge is unquestionably important, but we are already highly knowledgeable. What we surely need now is the wisdom to apply our existing knowledge to practical situations that urgently require change, not more research of dubious benefit. So, with a few exceptions, I am with those Australian outback farmers who think of academic researchers as "shiny bums". (They spend too much time sitting behind their computers or desks.) And, continuing this straightforwardness, it should be honestly acknowledged that researchers collectively use up a lot of available funding for conservation that could be better used. (Incidentally, I trained as a biologist.)

So, finally, we get to the non-government organisations. In the UK, the general public usually refer to these NGOs as charities. WWF, the RSPB, and Friends of the

Above: White rhinos are easily identified by their wide-lipped mouth, which is well adapted for eating large amounts of grass.

Left: A rhino's horn is this animal's defensive weapon against attack. Yet human superstition and greed nowadays make the rhino's horn a likely death warrant.

Previous pages: A tiger appears in the beautiful meadows of Bandhavgarh National Park. We were thrilled that I managed to capture this image to be included here.

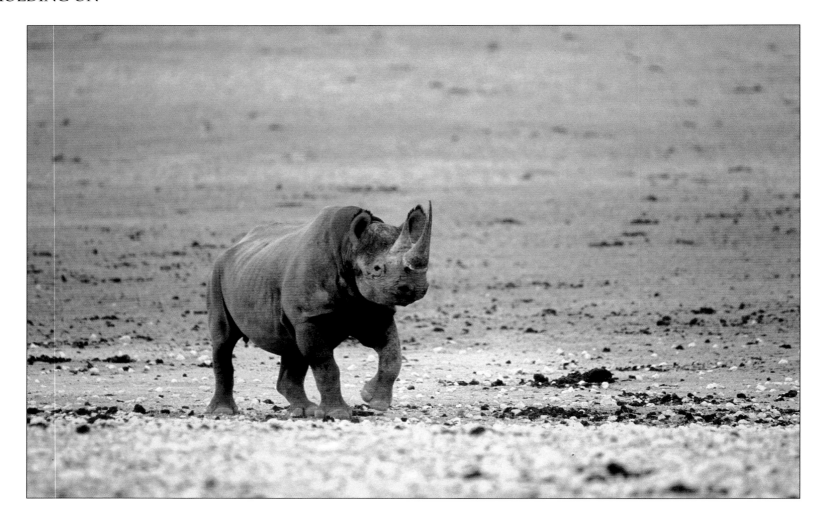

Above: *The black rhino is more aggressive and bad-tempered than the white rhino, although it is also a shy animal. It is easily identified by its hooked lip, which allows the browsing of trees and bushes.*

Etosha National Park in Namibia is one of the best places to see the endangered black rhino. Ngorongoro Crater in Tanzania is an excellent destination within East Africa, although black rhino numbers are fewer here.

Earth are well-known examples. Some NGOs are very specialised in their goals, perhaps aiming to preserve badgers or else looking after their local reserves.

NGOs pride themselves on having a special status that is relatively free from government bureaucracy and political pressure. This is supposed to encourage innovation and the freedom to act appropriately and quickly. NGOs like to think they can show government a thing or two and believe they are ethically ahead of businesses. These organisations have worthwhile aims which the public support, usually believing they are "the good guys". This is the theory.

I have had decades of international experience seeing what NGOs do and don't do. This has been in the wildlife conservation area, of course, but I have also been practically involved with humanitarian aid for 25 years, working in countries such as Sudan and Ethiopia. Sadly, the reality often falls well short of the promise or claims. Unlike governments, NGOs are relatively unaccountable. Members of the public continue to support them with regular donations regardless of success or failure. After all, "They care!" If, for example, there is a new surge of tiger or rhino poaching, the NGOs launch a fresh appeal for funds and the money comes pouring in. How many letters or emails are written by past or present donors questioning what has happened to the huge amount of money already given? How many people have even asked the

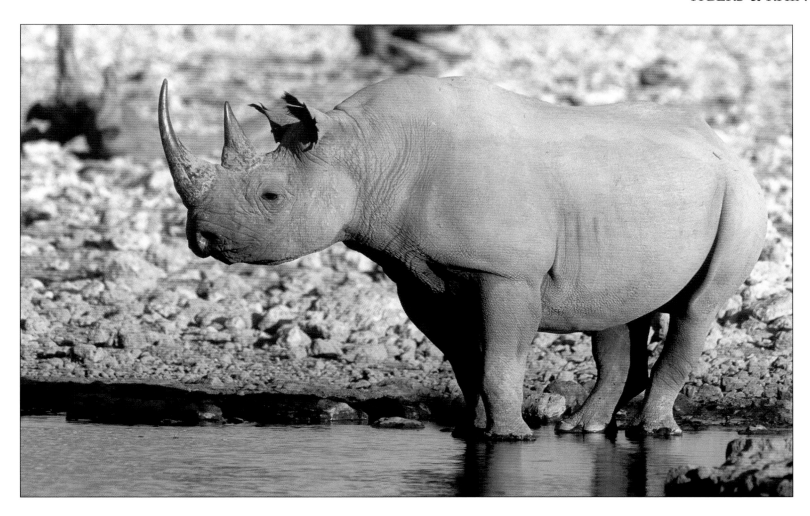

question "Why are tigers and rhinos still endangered after 50 years of conservation effort?" Would businesses still be in business if they likewise failed to deliver in such a spectacular way?!

The makers of a British television documentary made an excellent point when they set up a spoof charity for the day, calling themselves "Daylight Robbery". Members of the public generously put money into their collecting tins, seemingly not bothering to think or question. The following response didn't arouse suspicion either: "Thank you. We'll use your money to help our mates escape from prison!" Indeed, some people gave money a second time when these words were said - and even congratulated the spoof Daylight Robbery fundraisers when they then added "That will help us buy a ladder or rope to get them over the walls!"

I am the director of The Wildlife For All Trust, a British registered charity that is proud to be different. During our second-stage interviews, I used to ask groups of candidates: "Why are tigers and rhinos still endangered after 50 years of conservation effort?" Some of the interviewees were graduates of zoology or conservation courses; others already had experience. Yet hardly anyone was able to answer this simple question. They had never asked themselves what was going wrong, or heard the matter discussed.

Above: Etosha is graced with a a range of superb waterholes. One of the best strategies is to wait patiently by one of these waterholes for animals to come to drink - especially during the hot, drier months. This particular black rhino came for water at Rietfontein during late afternoon; other visitors had already left for camp.

Left: *The langur monkey is a common resident of the forests where tigers exist. It mostly eats the leaves of trees, as well as fruit and flowers. Langurs are quite wasteful feeders, but spotted and sambar deer are aware of this and often gather below to eat the dropped leaves or fruit which would normally have been beyond their reach.*

This close association between species, all possible prey of both the tiger and leopard, has developed further with regard to alarm calling. Perched in a commanding position high up in the trees, langur monkeys can easily keep watch for the approach of a dangerous predator. When they make an alarm call, spotted deer and sambar are immediately alerted and often join in with their own alarm calls. Despite this forest security system, tigers still make sufficient successful hunts.

As a photographer, there have been many times when I wished I had the vantage point of the langur monkeys. They could see something, possibly a tiger, whereas we could see nothing at ground level.

The common name of langur monkey is derived from the Sanskrit word langulin, which means "one having a long tail". As the long tail suggests, langurs are more arboreal in habit than rhesus monkeys and bonnet macaques.

A variety of species share the forests of India - ranging from langur monkeys to spotted deer and sambar, barasingha or swamp deer to nilgai or blue bulls, Indian wild dogs and jackal to sloth bears, marsh crocodiles to jungle cats. I have been fortunate to see them all and more. But without the tiger, India's wildlife would seem lacking. If India and the rest of the world allow the tigers to become extinct in the wild, it will be a sad reflection on us - supposedly the planet's most intelligent animal.

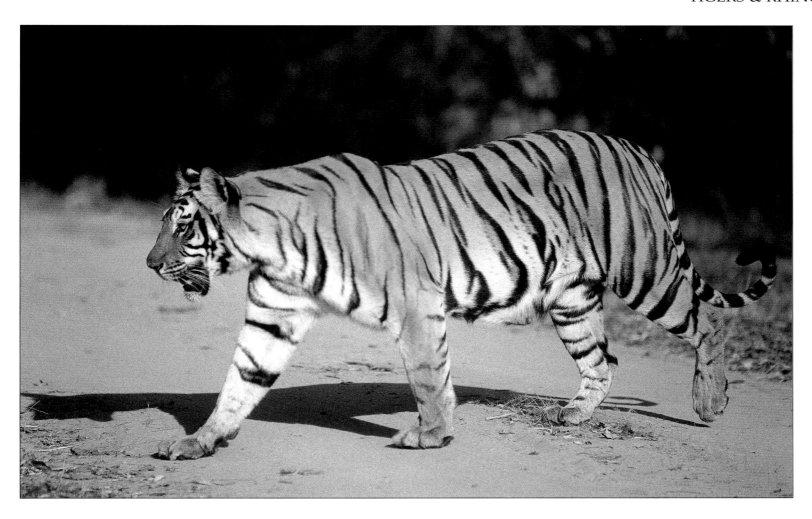

In fact, many interviewees didn't even register the real question. They tried to answer as if it was just "Why are tigers and rhinos endangered?" - conveniently overlooking the all-important "...after 50 years of conservation effort" bit.

So, what has gone wrong? Let's look in more detail at the NGOs, starting off with how the donors' money is actually spent. Many staff in the majority of charity organisations nowadays get paid. And they pay themselves a higher wage than many imagine. Do your own investigations to find out how much a typical charity director is paid each year and how much the total staff budget adds up to; you will probably be surprised. Add to this all the office and administration costs, plus miscellaneous expense accounts. And the questionable fundraising costs, including the hiring of separate businesses that of course take their share. I hope that you're starting to get the idea.

After this come the actual project expenses. But what do the charities really do? How do they specifically go about saving the endangered tiger and rhinos? Education is part of any solution and, conveniently, this often uses up a lot of the budget. But, in the UK, aren't we already sufficiently aware of the problems? Shouldn't these charities be putting most of their educational efforts towards changing the mindset of people living elsewhere in the world, specifically those who use the tiger parts and rhino horns?

Above: The tiger is a big animal. It is an agile, fast, and strong killer capable of taking large prey species such as sambar deer (up to 202kg), barasingha (180kg), and nilgai (240kg). Some tigers, such as the famous Genghis of Ranthambhore in the 1980s, charge through the water of lakes to chase down their prey. A tiger's stripes help camouflage its large body amongst the nearby vegetation, concealing the predator's approach before it launches itself full stretch at its target.

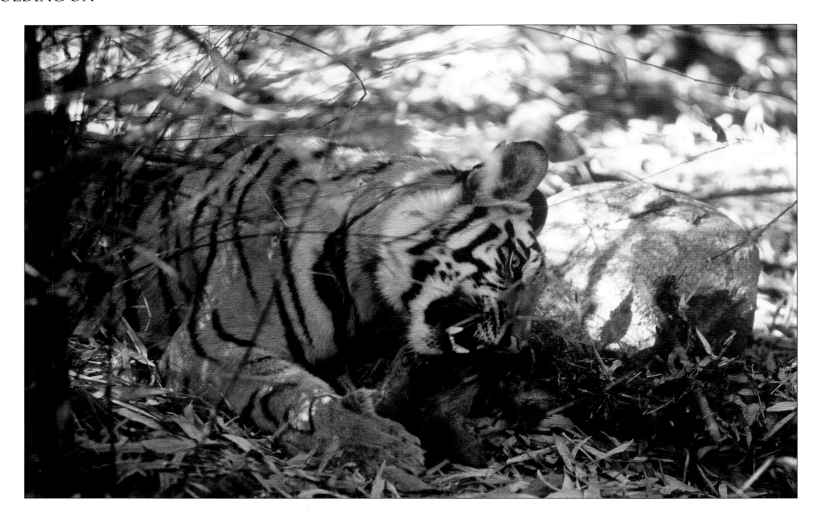

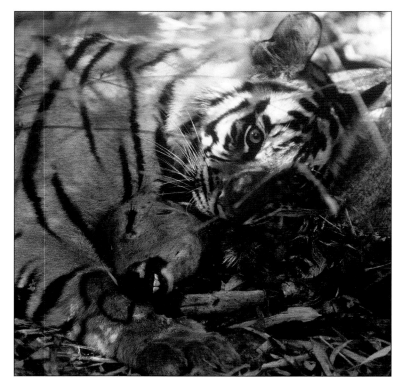

Above and left: There is a clear relationship between the number of available prey animals, such as spotted deer, and the number of tigers that can be supported in a reserve or national park. It is therefore important to protect the deer species as well as the tiger itself, together with the forest trees which provide food for the deer. Poaching of tigers, deer and other prey species, or illegal woodcutting is all detrimental to the interconnected ecosystem.

Right: The spotted deer or chital is a common prey species of the tiger and one of the most beautiful deer species in the world. If you hear the alarm call of a spotted deer, a tiger may be close by.

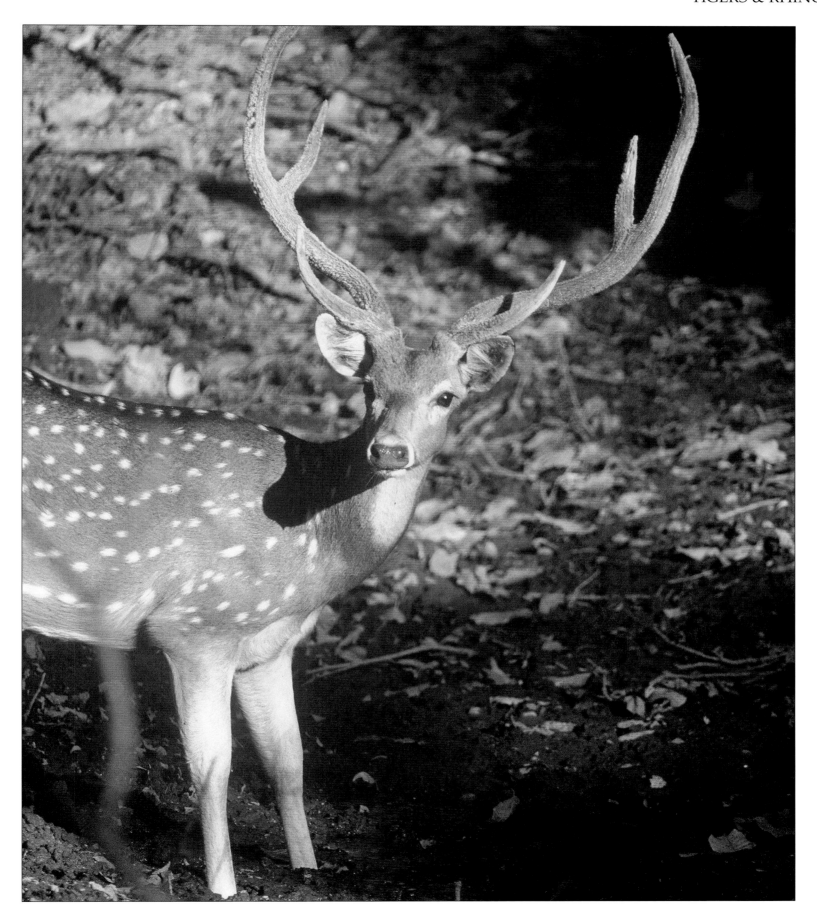

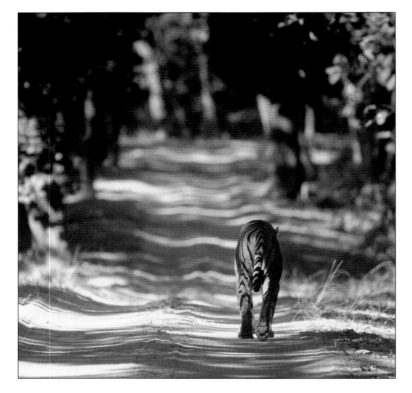

Above: *A government census taking place in Bandhavgarh during January 2006.*

Left: *For many years the Indian authorities have been exaggerating tiger numbers using the method of counting pugmarks. Based on the mistaken belief that every individual tiger can be identified by its unique footprints, reserve staff copy the outline of pugmarks onto glass, transfer these to paper, and then compare all the drawings within an area.*

To demonstrate this method was flawed, Indian biologist Ullas Karanth got 33 tracings from 4 captive tigers. Six experienced Project Tiger staff (including a field director) examined the footprints and estimated that the marks were made by between 6 and 23 different tigers; nobody could even sort out all of a single tiger's pugmarks correctly. Many people, including myself in one of my previous books, have pointed out that this method of "counting" tigers is useless. Yet it is still used and conveniently overestimates the actual number of tigers that remain in the wild.

A more accurate way of assessment is to compare photographs from camera traps as each tiger has unique stripe markings.

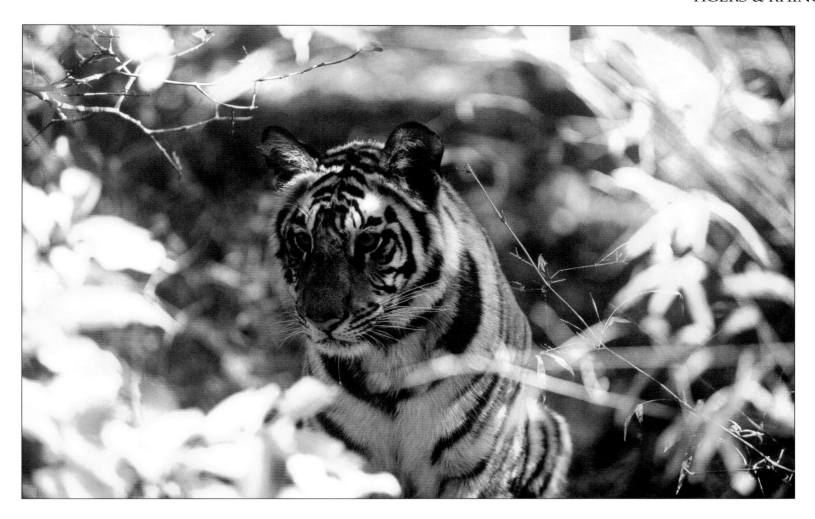

Above: Tigers and people simply don't mix. With 1.2 billion people now in India, much of the tiger's forest habitat has been destroyed or seriously encroached upon. (And the human population in India is expected to grow by another half a billion people by 2050!) There is mass exploitation of the forests and illegal killing of the wildlife.

Right: Parliament House, New Delhi, India. Indira Gandhi as Prime Minister took bold decisions from the late 1960s until her assassination in 1984 to help protect India's wildlife, including the tiger. With her death, India's forests and wild animals lost their political saviour. Her son, Rajiv Gandhi, was then elected but he focused more on environmental pollution than on wildlife conservation, following an international trend. In 1991, Rajiv Gandhi was also assassinated.
The governments of India that followed through the 1990s and 2000s effectively failed the tiger and poaching became rampant again. Once more, tiger numbers dropped alarmingly.

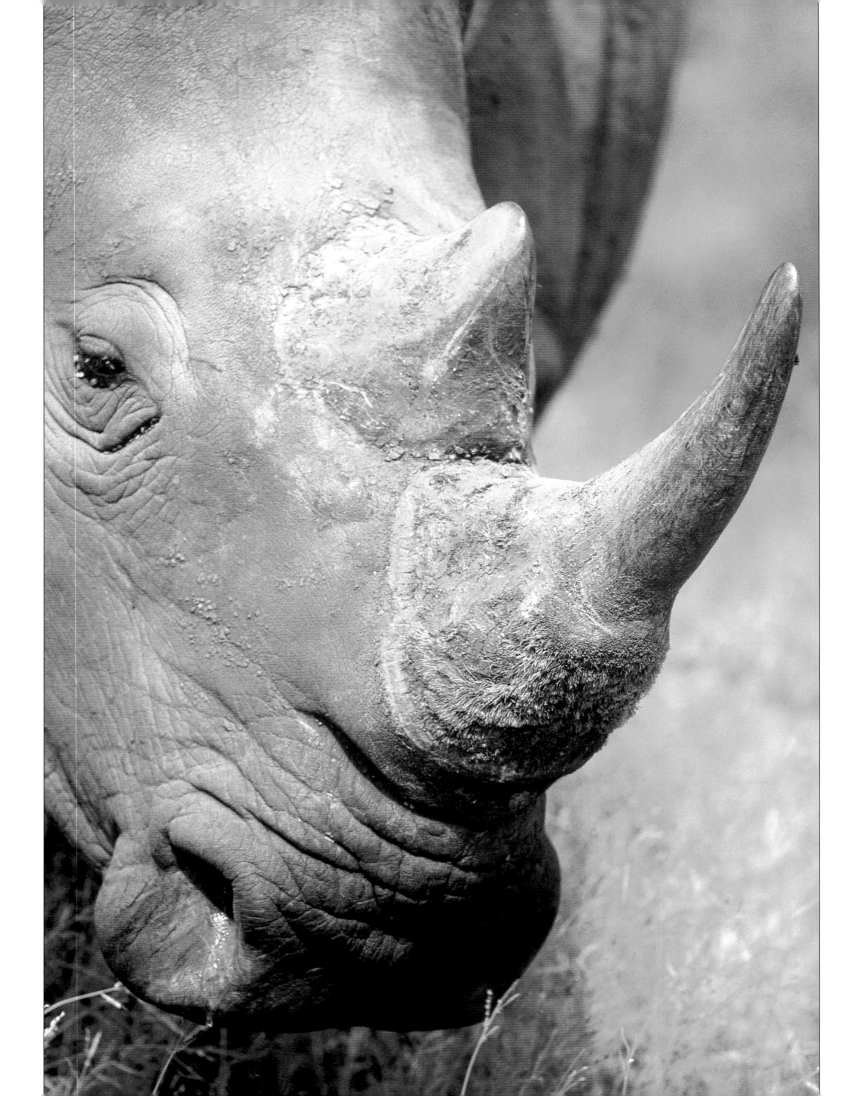

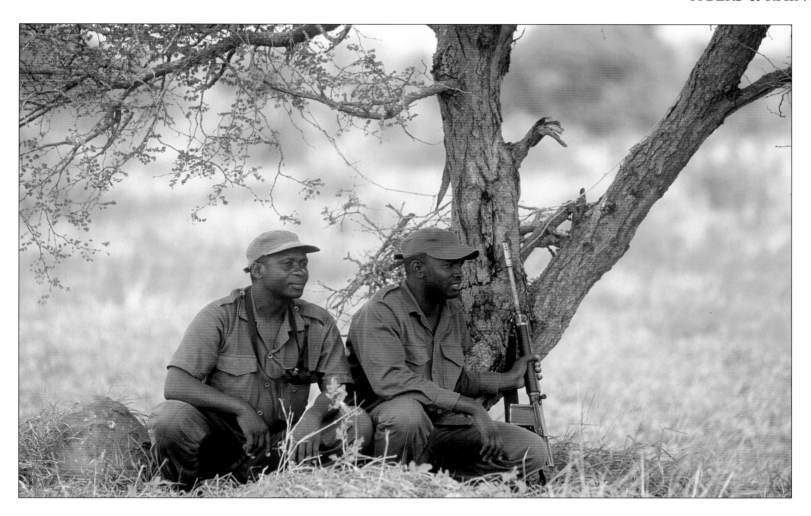

Or is this just too difficult, compared to sitting in a comfortable office in Surrey or elsewhere? How many British conservationists actually work in Yemen, for example, where we know a lot of poached rhino horn is used to make handles for ornamental daggers - a place where Arabic is the language with many ancient dialects and fewer people speaking any English than in most Arab countries? Isn't it crucially important to focus attention where it is most needed?

We all know about these wild animals being poached and of the need for anti-poaching squads. However, you would be surprised by how many times I have seen the on-the-ground reality where the anti-poaching staff are blatantly ill-equipped. They lack bullets for their rifles. Their communication equipment is non-existent or doesn't work. They don't even have basic repair kits for their bicycles or enough fuel or spare parts for their vehicles. And yet the staff at head office always seem to have the latest computers and plenty of money to attend the next international conference to talk still more about the problems.

I am not saying that these conservationists don't care, because they do, at least to some degree (albeit buried beneath a pile of excuses). However, I am certainly questioning their effectiveness and efficiency - their basic ability to correctly prioritise what most needs to be done and then to put these top concerns into action. Are these self-appointed

***Above:** Guards on anti-poaching duty wait silently under a tree in Kruger National Park.*

***Left:** Rhino horn is used in traditional Chinese medicine to treat a wide range of ailments from headache and fever, to vomiting and arthritis. It is also used to make handles for ornamental daggers in Yemen, known as jambiyas, carried by men as status symbols. One importer was bringing in 3,000kg of horn each year representing the deaths of perhaps 1,000 rhino. Another trader imported 36,000kg of horn in 16 years - a further 12,000 dead rhinos.*

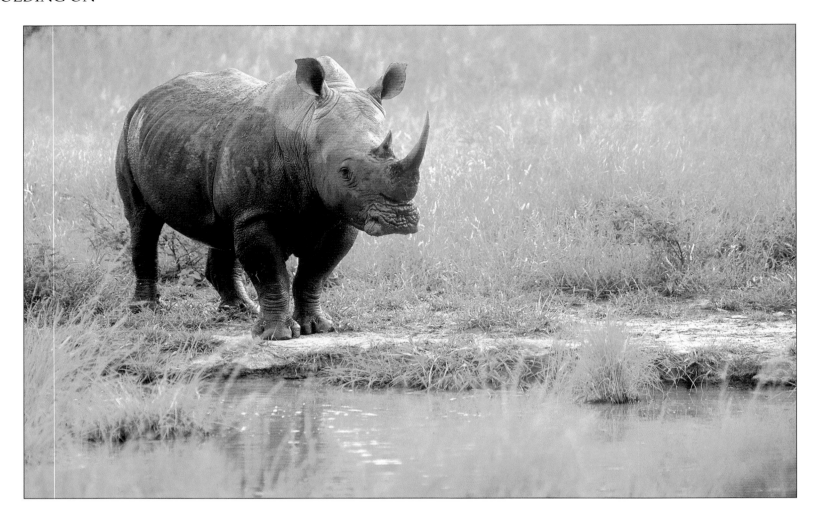

Above: There are five different rhino species: the white rhino of Africa (pictured above), the black rhino (also of Africa), the Indian one-horned rhino (of northeast India and Nepal), the Sumatran rhino (of Malaysia, Borneo, and Sumatra), and the Javan rhino (of Indonesia). There are just 200 to 275 Sumatran rhino left. In October 2011, WWF and the International Rhino Foundation announced the extinction of the Javan rhino sub-species in Vietnam, leaving less than 44 surviving Javan rhinos in Indonesia's Ujung Kulon National Park. No resignations or dismissals were announced.....

conservationists actually doing what is really necessary, or just conveniently choosing what to do and not do according to their own personal limitations? Is all the clever-sounding jargon about "grants" and "conservation partners" just a smoke screen for doing less than their best, whilst getting reasonably well paid and able to fool themselves that they're doing something useful? Wouldn't any salesman or manager in a business have been sacked long ago if there had been a 97% fall in profits?

After decades of abysmal decline, numbers of white rhino and black rhino started to slightly increase over a few short years up to 2007. This was effectively due to the good work by government-run places such as Kruger National Park in South Africa and Etosha National Park in Namibia, together with a number of private nature reserves in South Africa. Indeed, South Africa conserves 93% of all southern white rhino. These animals have a high monetary value and any surplus rhinos are sold to private nature reserves, with the owners willing to invest. But because the demand for rhino horn remains high - after 50 years of alleged education and other efforts by NGOs - this minor upturn is being undone. South Africa began seeing a rise in poaching during 2008, with at least 83 rhinos killed. It got worse in 2009 when 122 rhinos were poached. And in 2010, the situation became shocking with 333 rhinos killed by organised gangs

- including 146 lost from the Kruger National Park population. As I finish this book, it has just been announced that a further 448 rhinos have been slaughtered during 2011. And these figures are from just one country, which has the best track record of all for breeding rhino in the wild during recent times.

Alarm bells sounded in the 1960s about the tiger facing extinction, with several crisis warnings since. In 2000, the United Nations Convention on Trade in Endangered Species published a report saying that tiger poaching was accelerating and that officials and conservation groups were refusing to face up to the problem. The report concluded that "an essential first step in solving any problem is to face up to its existence." I am not a fan of the various United Nations organisations, as they talk the talk at considerable expense, but it is worth repeating their shocking words yet again: "an essential first step in solving any problem is to face up to its existence." These words were written after 40 years of international conservation effort to help save the tiger. They went on to criticise WWF's office in India which "has apparently been so absorbed in recent years with its own problems that it has failed to motivate stronger action from public authorities." I know this to be true because I have repeatedly seen it for myself, in the years before 2000 and since.

Above: Rhinos, being so big, have some difficulty regulating their body temperature. A fondness for bathing and wallowing in mud helps keep them cool. Dried mud provides protection for their hairless skin against the burning sun. The mud also acts as a barrier to biting insects that might transfer disease.

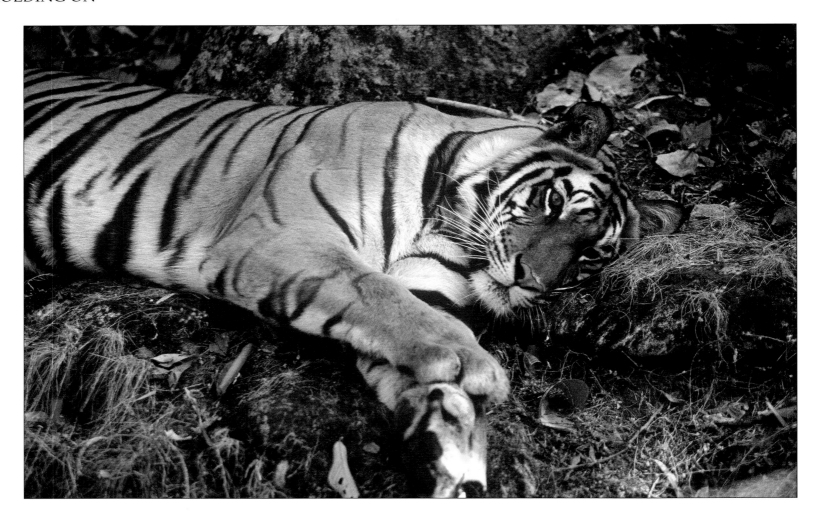

Above: There has been much fashionable talk of allowing tribal people and other forest dwellers to share the tiger's habitat in some romanticised peaceful co-existence. Such an idea is silly. The people are greedy and untrustworthy. Most want their slice of the materialistic cake, as quickly and easily as possible, with little effort.

To save the tiger, suitable reserves have to be made inviolate. The environmental lobbyists need to shake off their complacency and "clever" ideas - and wake up to the harsh reality of human selfishness.

By the beginning of 2005, the tiger crisis had become a farce when it was obvious that all of the tigers had disappeared from Sariska National Park in Rajasthan, India. For several months ridiculous excuses were made, such as "the tigers are hiding" and "they have migrated but will come back". The denial, by those who should have known better, was at its most blatant.

Under pressure, the Prime Minister of India eventually acted and sent in the Central Bureau of Investigation (CBI) to find out what had happened. Despite lacking previous wildlife experience, the CBI rapidly investigated and produced an excellent report. In stark contrast to some organisations, their conclusions were blunt and accurate.

Fateh Singh Rathore recently died on 1st March 2011, aged 72. Many years before, under the no-nonsense political leadership of Indira Gandhi, Fateh Singh took charge of the Ranthambhore tiger reserve in Rajasthan. In 1976, he negotiated the resettlement of 13 villages containing some 10,000 families from inside Ranthambhore to a new village outside. He inspired dedication amongst many forest guards and urged them to perform their duty well. The tigers subsequently flourished, seen by countless tourists from all over India and from many countries throughout the world. At this special time in the 1980s, the tigers of Ranthambhore became famous.

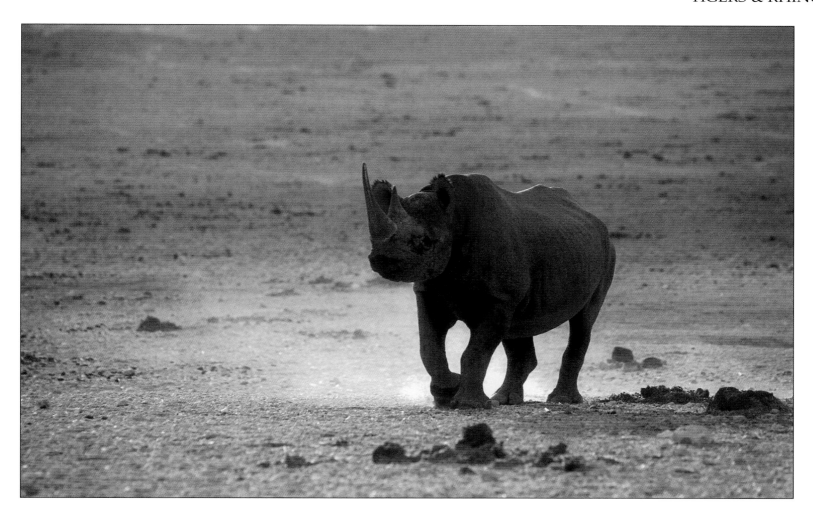

Fateh Singh's efforts were not popular with everyone. In 1981 he was ambushed, beaten unconscious, and left for dead by villagers who were illegally cutting wood and grazing cattle in the reserve. By 1988, he had been sacked as warden of Ranthambhore and transferred to a desk job in Jaipur after challenging a rich and influential man caught shooting wild boar.

When I met Fateh Singh Rathore shortly after this time, he never claimed to have been an angel - but he was obviously and genuinely intent on saving the tiger from the ravages of over a billion people in his country. In typical flamboyant style, Fateh Singh bluntly told me that "99.999% of my people are liars and cheats"; he briefly paused, then added "and they should be six foot under." During the early years, at various conferences, Fateh Singh had warned the international conservation organisations against complacency, saying that the tiger was far from safe. In those days, Project Tiger was considered to be the flagship of the conservation movement - a rare success story. Valmik Thapar, who worked closely with Fateh Singh regarding him as his mentor, honestly admitted to me that even he had wondered if Fateh was going too far during those times - until later, when the predicted cracks started to appear.

Valmik Thapar has done much more than most to try to save the tiger in India. He has written a number of books, informed the public about tigers through presenting

Above: The black rhino has poor eyesight, but compensates with a good sense of hearing and smell. The horn is used for breaking branches to get at food, as well as a weapon. Historically, the black rhino had a much greater geographical range than the white rhino - not least because the latter requires a plentiful supply of grass to eat.

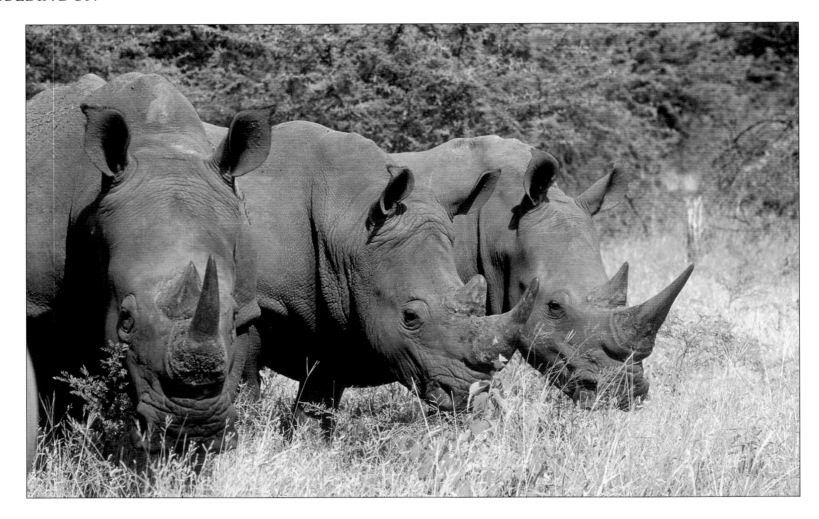

Above: White rhinos are the most sociable of all the rhino species. Groups of females with their young were once common many years ago before rhino numbers crashed.

Right: Oxpeckers are commonly seen riding along on a rhino. Not only do these birds clean ticks from the rhino's hide, nose, and ears, they also act as an early warning system - raising the alarm and flying off at any sign of danger.

wildlife documentaries, and he has used his position to influence policy makers up to the highest level. Furthermore, he co-founded an NGO working with villagers around Ranthambhore to help alleviate their poverty and in doing so win support for the tiger and its natural forest. And, in his own words, he has failed.

Valmik says so himself: "I established the Ranthambhore Foundation in 1988 to try and find peace and harmony amongst people, tigers, and the forests. I was idealistic and believed there was a way. In the 1990s, Ranthambhore Foundation focused on various issues including dairy development, increasing milk yields, enhancing income generation of women through handicrafts and agro-forestry. But they all failed. All my work in creating Ranthambhore Foundation and trying to do something to integrate man, nature, and tigers failed. The Ranthambhore Foundation is a failure. I gave it up in the [late] 1990s."

He continues: "I accept failure fully. I am the first one who shouts to all that I have failed in my life. My life's mission was to make sure that tigers could be saved. I believed I could do it. I met the Prime Minister, the present one, the last one and the one before that, the leader of the opposition and various MPs."

I discussed my own scepticism about people and NGOs with Valmik Thapar in January 1994 at Ranthambhore and later at his home in Delhi, several years before he

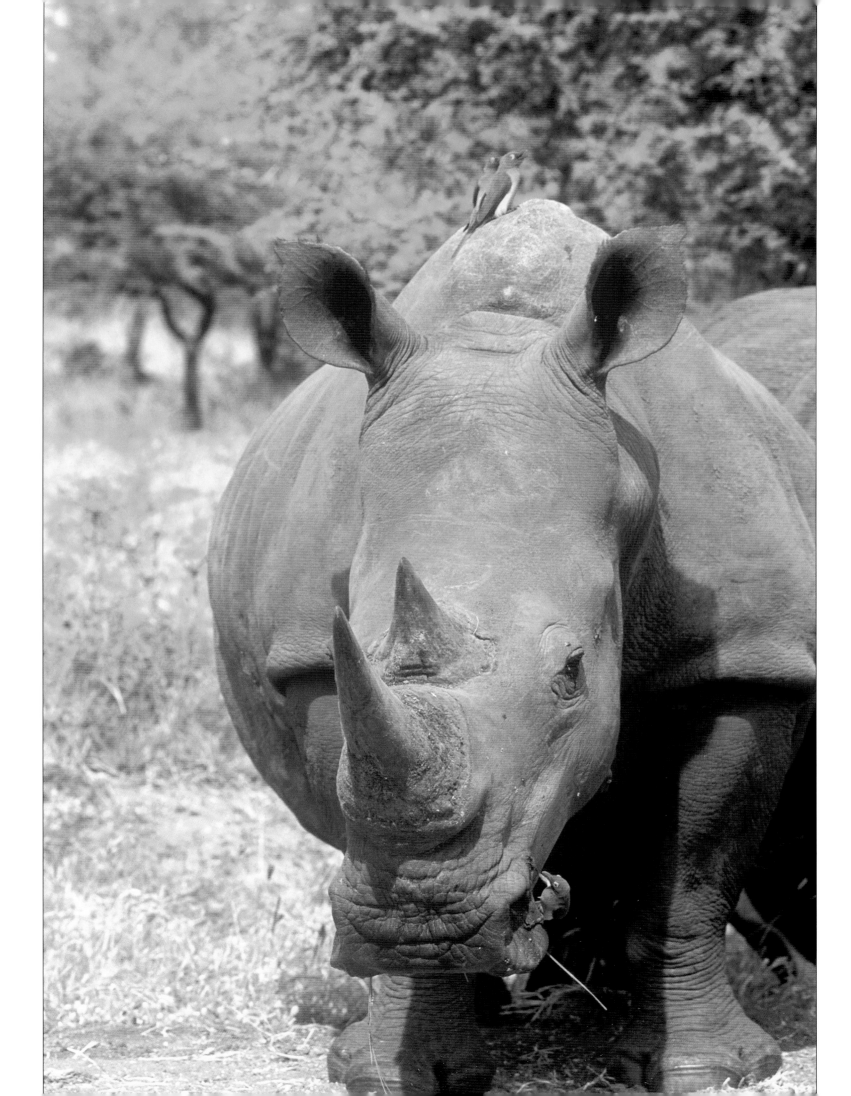

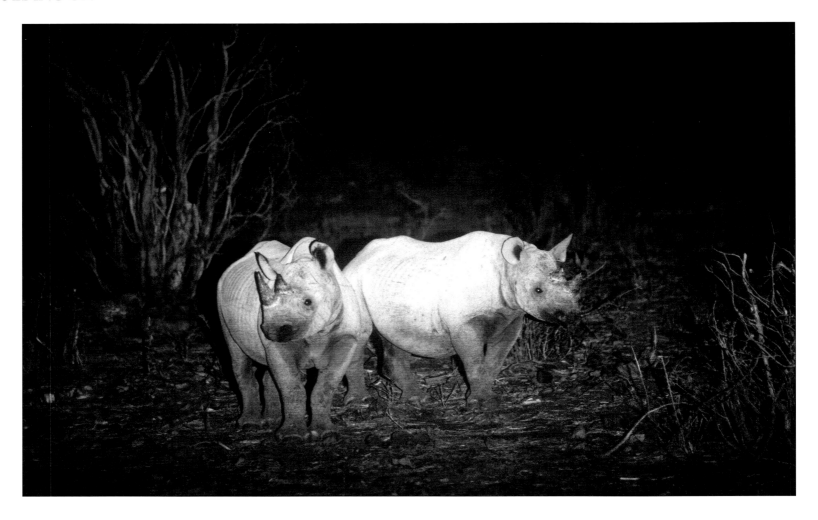

Above: One of the special attractions of Etosha National Park is its floodlit waterholes at the edges of the rest camps. Okaukuejo and Halali are the best, both likely to guarantee rhino sightings at night. Indeed, it is not unusual for several black rhino to appear at a similar time of the night.

fully faced the harsh reality himself. Nevertheless, we would both insist there is a solution. Once again using Valmik's words: "If you want delivery and good governance, you have to select selfless people devoted to the cause."

Where is a similar level of self-honesty from all the other individual conservationists, NGOs, and governments? It isn't anywhere to be seen. Self-honesty is like Monty Python's proverbial Norwegian blue parrot: it is no more, gone, expired; it has become deceased.

Today's average shallow-thinking environmentalist is lacking. Image has replaced the need to be truly capable. Saying the right words has been substituted for having authentic human values such as integrity and wisdom. Psychological avoidance is the norm, yet is ignored. There is safety in numbers if you don't rock the boat, neatly negating the need to "be just and fear not" (Carlisle United's motto, originally from Shakespeare). So, not surprisingly, endangered wild animals such as the tiger and rhinos remain in serious peril.

The fundamental problem is the "me, me, me" mentality. The most blatant acts of selfishness are recognised as such, but the majority of this normalised "me, first" or self-orientated behaviour is almost universally accepted and so goes unchallenged. Multiply it by 7 billion people and wildlife has a serious problem. What happens when

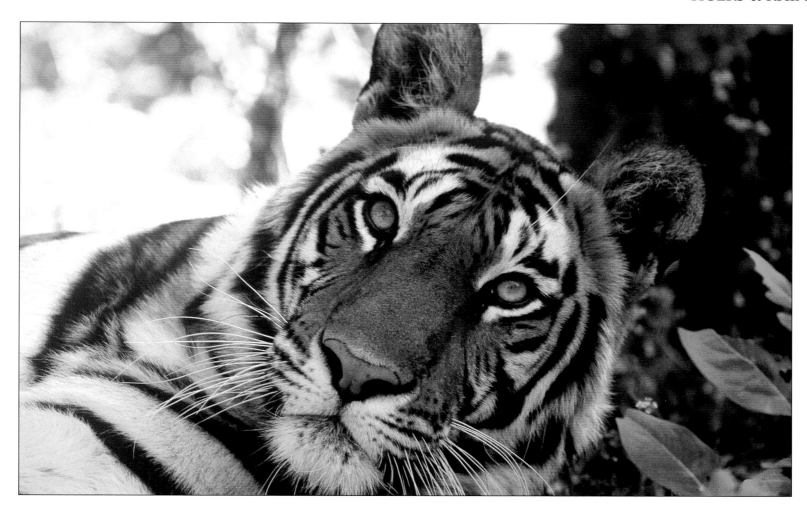

someone decides to care for nature? Bolting on a bit of caring for wild animals or adding good intentions to "me, me, me" doesn't actually change much - because the basic difficulty and existing psychological baggage still remain. An individual's limitations and defensiveness, learned from numerous instances of emotional disappointment going back to childhood and continuing through adult life, collectively act like a minefield - and these usually show up in the form of fear and hesitation, or as a series of emotional explosions. This psychological baggage seriously impacts on individual capability and project performance.

There is an obvious need for transparency with both NGOs and governments. But how will this actually happen when the individuals are full of psychological baggage, always ready to make the next excuse? Currently, project planning or evaluation does not even recognise this basic dysfunctional human factor - because it is so normalised. Add psychological avoidance to the equation and why should anything change when the "do nothing" option of continued mutual bullshitting remains, merely allowing more of the same? So, in the acceptable self-orientated world of "I'm alright, Jack", the tigers and rhinos keep on being endangered - with yet another conference or newsletter tomorrow. "Would you please donate £3 every month to our worthwhile cause?"

Above: The photographic image above is one of my limited edition prints which help to raise funds for our wildlife work. It is titled "Wild and free". How much longer will there be tigers in the wild? If they do survive, will they barely exist in but a handful of the better known and popular reserves? What will happen long-term to any tiny tiger population, with little or no genetic diversity? Will in-breeding be the final nail in the tiger's coffin? Or will the poacher's gun or snare finish this magnificent species forever? Will future generations only get to see living tigers in small zoo enclosures?

Komsberg
Wilderness Nature Reserve
A deeper approach to nature conservation

I am the director of The Wildlife For All Trust which owns and manages Komsberg Wilderness Nature Reserve in South Africa. We are pioneering in our approach and genuinely successful. The key to our success is attitude. Working on the principle of "actions speak louder than words", Komsberg is a persuasive demonstration that our approach really delivers.

Komsberg Wilderness Nature Reserve is a special place. It is situated within both the upland succulent Karoo and fynbos biomes (major ecosystems) - widely recognised as two of the world's 25 most important conservation hotspots for biodiversity.

It is a huge place: over 30,000 acres or 125 sq km in size, and 17 miles in length. Komsberg is bigger than several South African national parks and one of the biggest private nature reserves in the country. The sense of wilderness is authentic and truly awesome.

Three different habitat types are found within Komsberg: numerous mountains and mountainsides, extensive mountain plateaux with good grazing for wildlife, and a lower valley area 2,400ft (730m) below with thousands of acacias and other trees. Several dramatic overlook points provide excellent views of this spectacular scenery.

To establish a huge place like Komsberg involves serious hard work. We have erected over 98 km or 61 miles of perimeter fencing to a height of 2.4m. Unloading a delivery of hundreds of straining posts, then moving them into position, takes a lot of effort in itself.....and this is only a tiny part of what is required. We have carried all kinds of fencing materials up and down mountains or along endless stretches of plateau - in heat, cold, rain, and even snow. Plus tools, equipment, food and water. Day after day, month after month, year after year.

Right: Komsberg translates to mean "surrounded by mountains".

Far right: We re-introduced Burchell's zebra to Komsberg in September 2008 after an absence of approximately 197 years. Our first zebra foal was born in late November 2009 (photographed here as a youngster in January 2010).

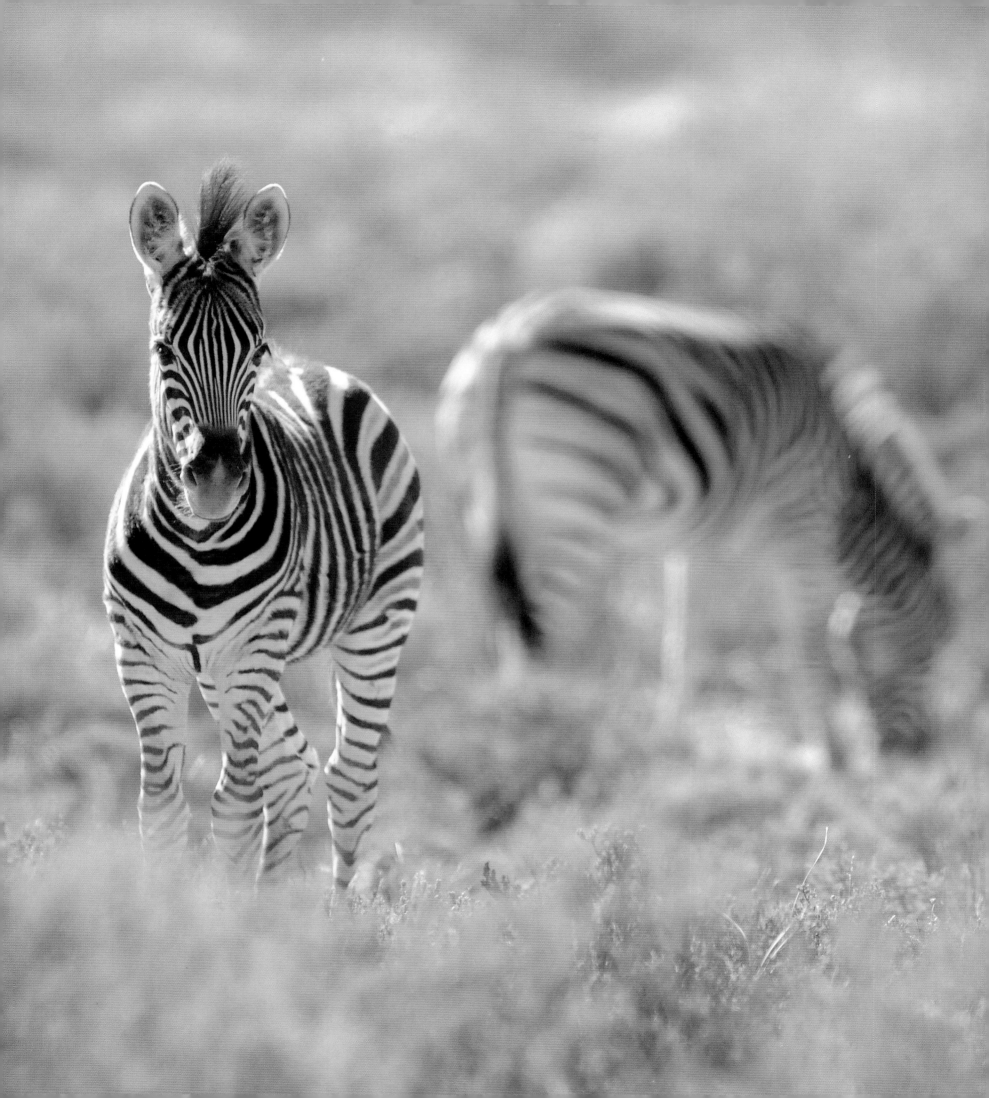

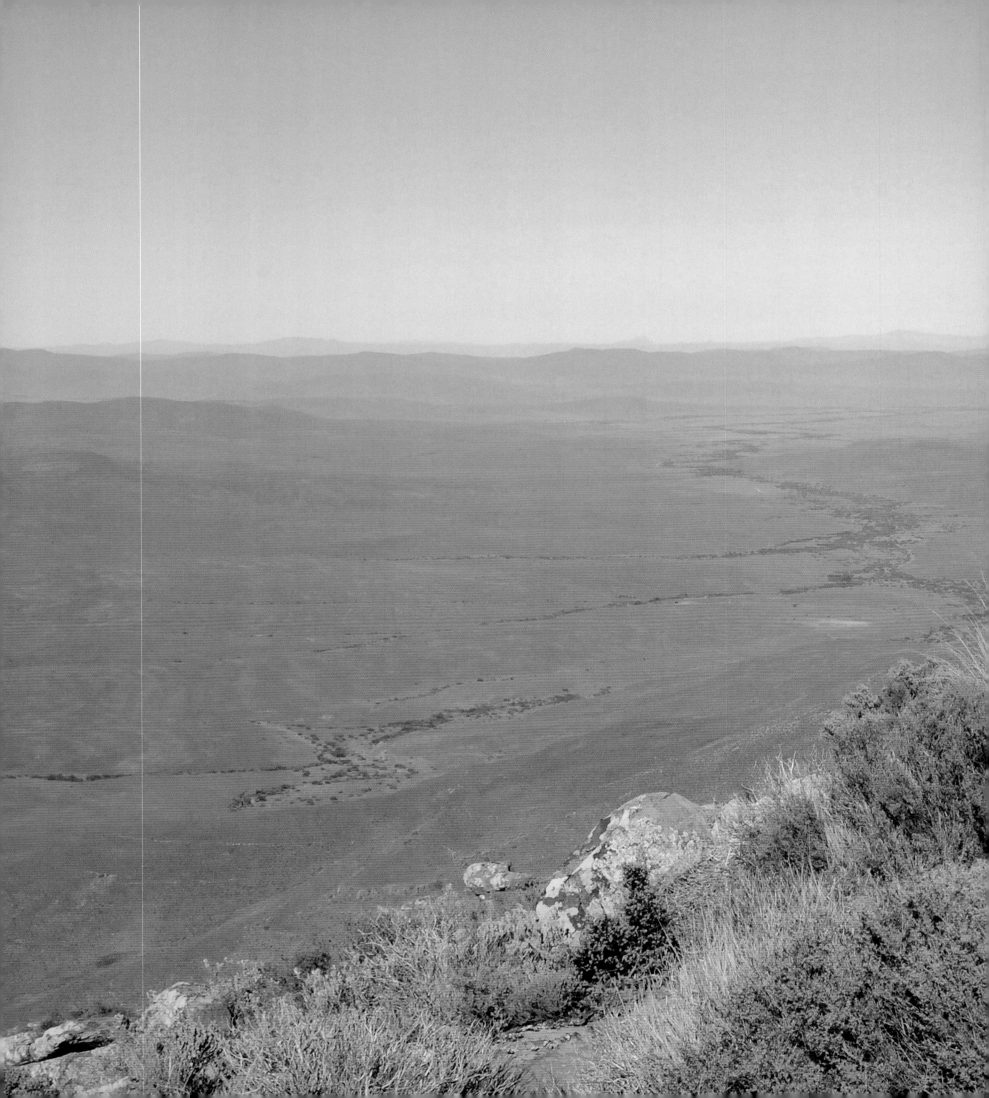

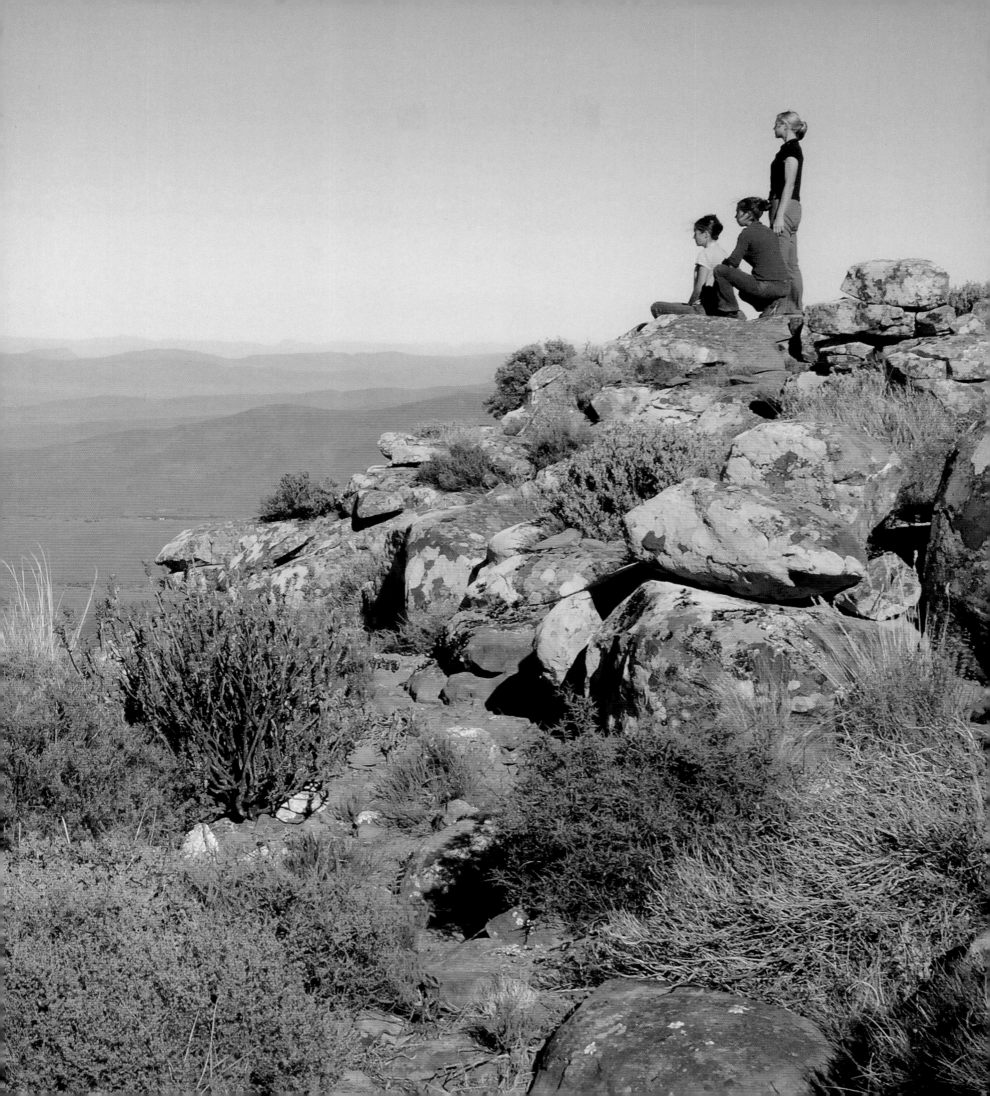

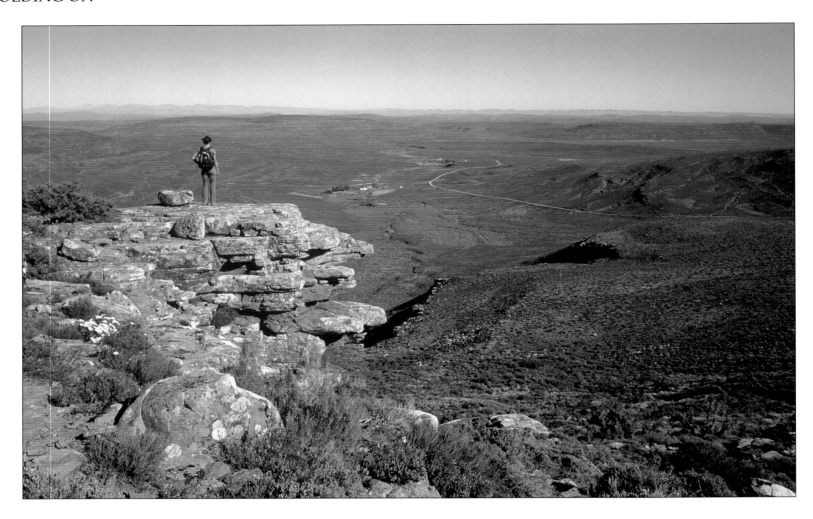

Above: *Becky standing at the edge of the plateau, overlooking our main homestead in the distance below.*

Previous pages: *One of Komsberg's many spectacular overlook points. This one is officially called Proposal Point, after Becky proposed to me here at sunset on Valentine's Day. (Surprised but happy, I quickly answered "Yes!")*

Everything had to be purchased and the overall cost was high. We do almost all of the fundraising ourselves, which also takes a lot of effort. And we don't waste money by unnecessarily paying ourselves.*

As well as erecting the perimeter fence, many miles of internal camp fencing had to be taken down so that the wild animals can run free. This is also difficult work and can seemingly go on forever. When it is finally all done, you have the satisfaction of seeing nothing. A visitor would be ignorant of the huge effort required.

Waterholes need to be maintained and adapted to wildlife use. Our roads need to be repaired, especially after thunderstorms. Jobs at the homestead are numerous but also important. The local plumber/electrician has only one hand and is much in demand; we therefore do whatever we can ourselves. Our water supply comes from a hole in the ground. Doing the shopping involves distances equivalent to travelling from the Sussex coast to Carlisle. Life in the middle of nowhere is challenging.

* Indeed, we purposely work as non-paid professionals - supporting ourselves financially with other part-time work. Nor do we have expensive offices; we save money by doing the administrative work from our homes. All my royalties as author of this book are donated to our charity work, as I choose not to benefit from my writing and photography.

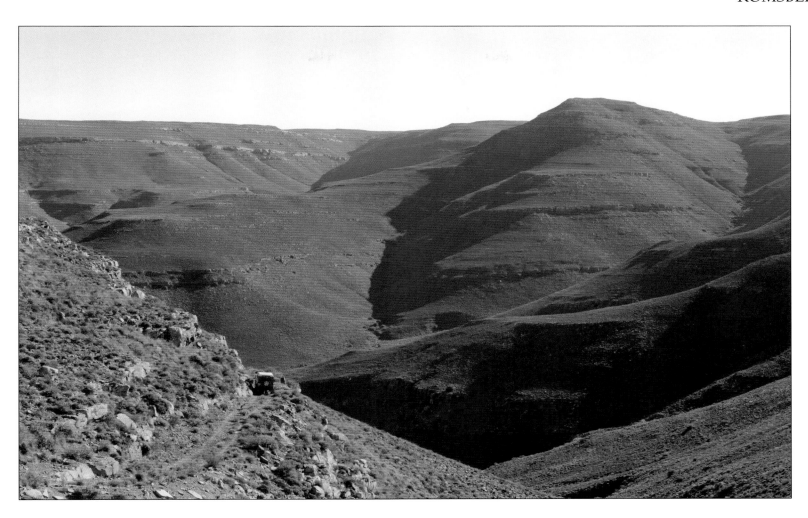

Once finished, the perimeter fence requires constant maintenance. Checks are done every 10 days or so. Walking around Komsberg West's perimeter, for example, involves a long and tiring day from dawn to dusk. Porcupine and aardvark are powerful diggers; the holes they make need blocking up with large rocks. If this is not done, you can lose your animals. Gemsbok, for example, are notorious fence crawlers despite their large size. Baboons frequently stress the perimeter fence as they climb over it. Lightning can cut through wires. Excessively wet ground, snowfall, and high wind will also test any vulnerability.

All this and more takes tremendous dedication, determination, and a range of other psychological strengths. Working at Komsberg is not for the faint-hearted. The reality of this huge place cannot be ignored; bullshit achieves nothing. There are no distractions or indulgences that people use to cope in the modern world - and the wilderness acts as a giant mirror, reflecting and exposing any personal weaknesses or limitations. The weather and landscape combine as a powerful force that cannot be messed with. We have learned that the following saying is true: "You can't f*** with Komsberg!"

Our animals and plants are unusual, brilliantly adapted to the semi-arid conditions. Indeed, a high percentage of Komsberg's species are unique to the region. Komsberg

Above: The beginning of "the road of death", our narrow access road leading down to the main valley 2,400ft (730m) below. The mountains you can see in this photograph are just a small part of Komsberg West - which, in turn, is just one of three sections of our nature reserve.

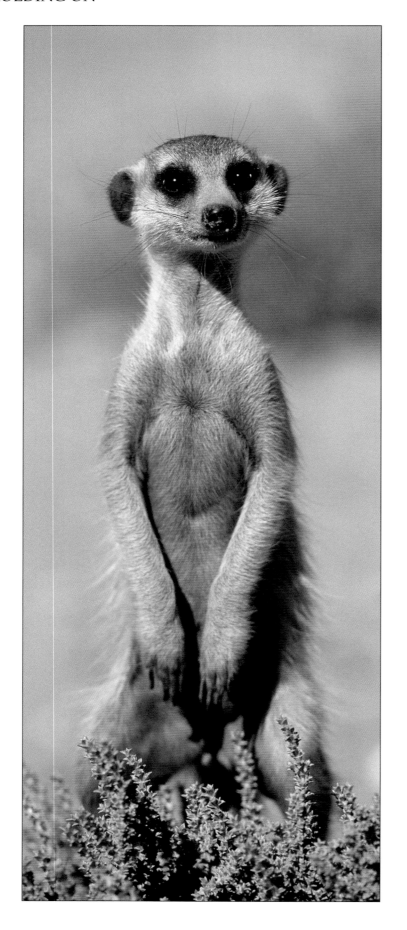

Above, left, and right: *Meerkats are highly sociable mammals. They are fierce predators, albeit of small size - but also preyed upon by black-backed jackal and birds of prey such as martial eagles. Their alertness, essential for survival in the wild, is very appealing. A group of meerkats warming themselves in early morning sunshine is a great sight. We are extremely lucky to have a good population of meerkats at Komsberg.*

The secret of meerkat society is co-operation. This is most obviously demonstrated and observed by the use of a sentry against the risk of danger. As most of the meerkats in a group forage, there is always at least one keeping guard. This sentry acts as a look out, standing upright on a rock or on top of a bush, carefully scanning the surrounding landscape and sky above. If a martial eagle or another feared predator is sighted, an alarm call is sounded and all the meerkats run for cover. Meerkats are a team and their survival is dependent upon this social strategy.

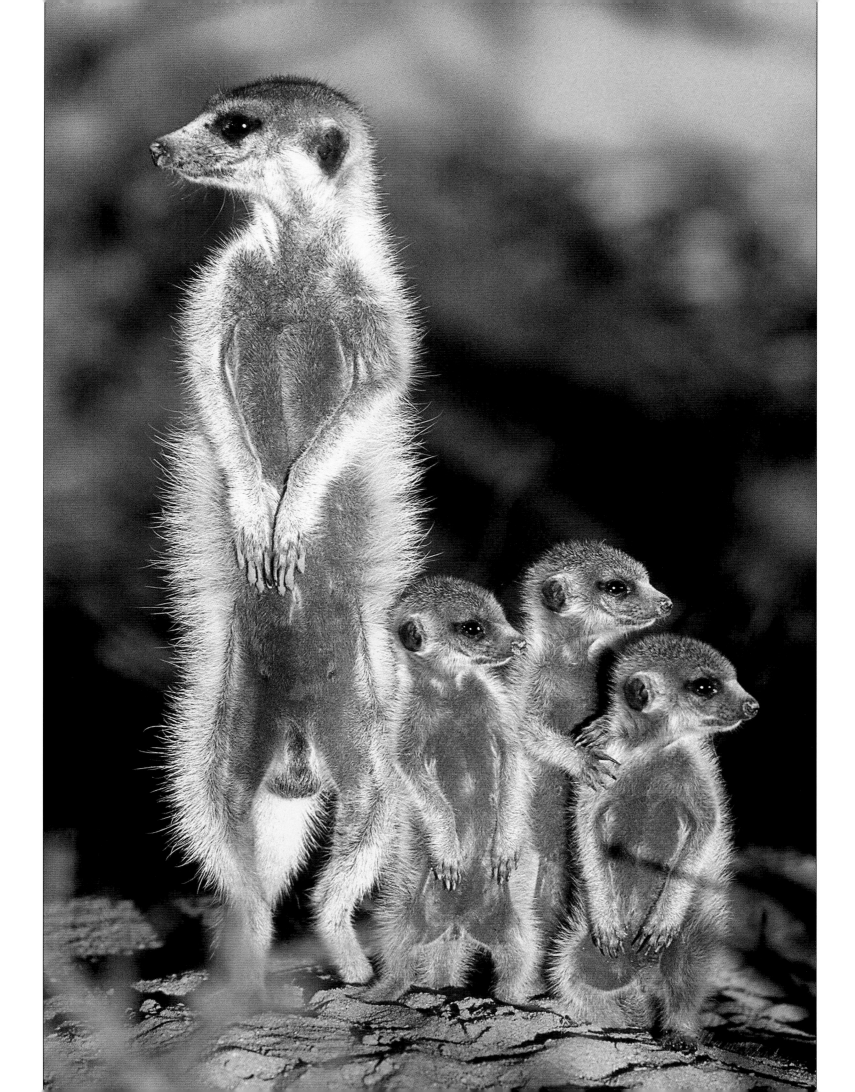

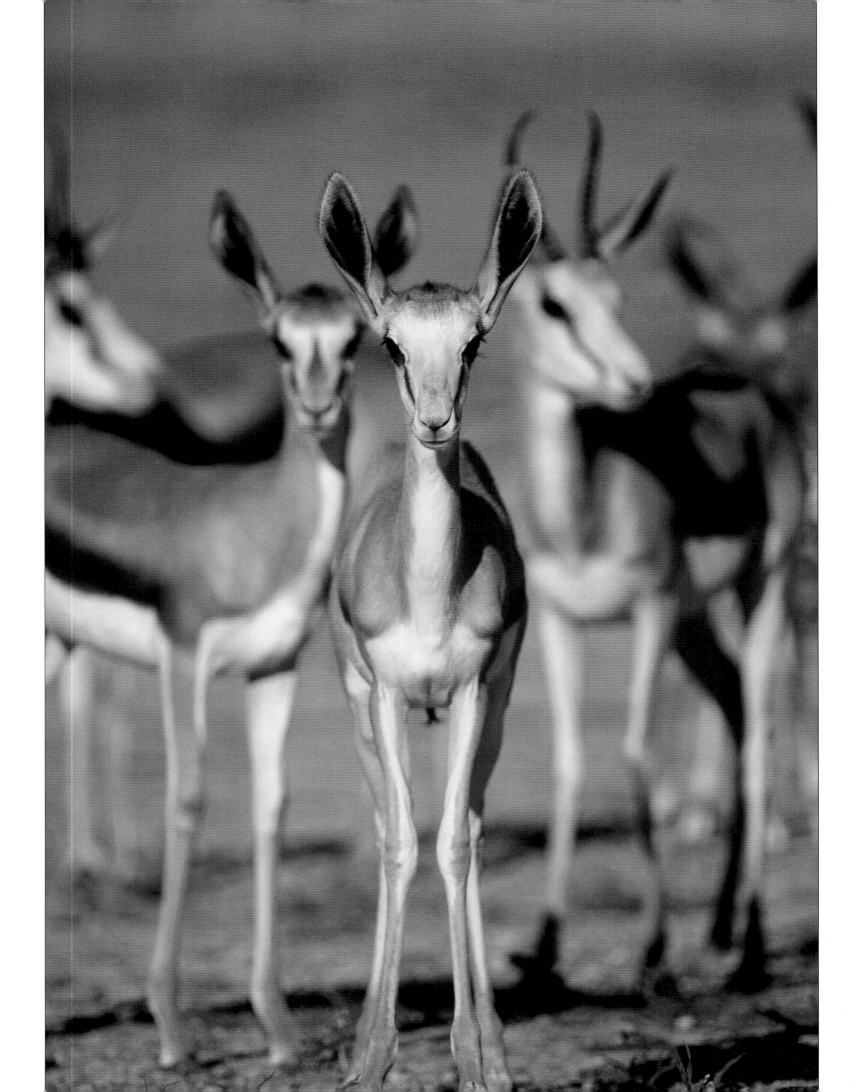

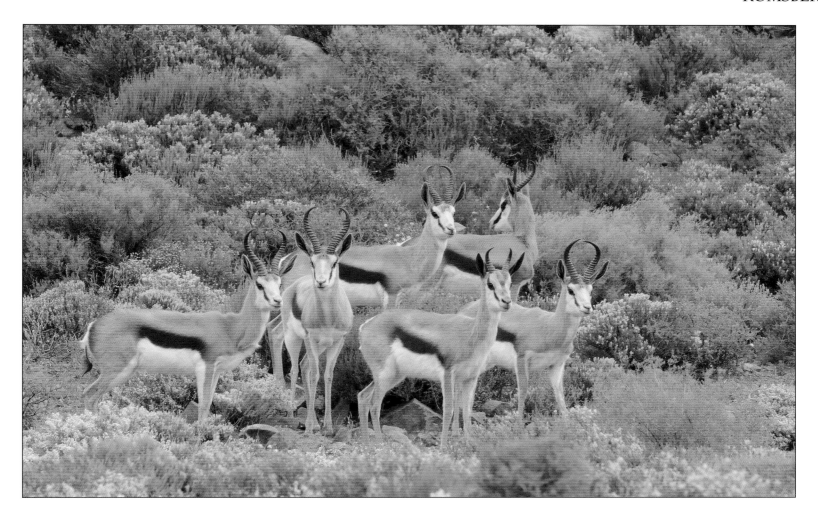

is actually within a special area for plant endemism - so we have species found only in our locality that do not exist anywhere else.

Symbolically, the animal most identified with the Karoo is the springbok. Prior to the European settlement of South Africa, this vast region was home to very large numbers of springbok; most were shot by the early 1900s. Historical records from the 1800s describe springbok migrations during times of drought that were seemingly endless, involving "uncountable" numbers of these gazelles. One farmer living in those days commented: "They were in such numbers that I found the sight frightening."

These awesome sights are no more, but the springbok remains a suitable symbol of arid regions in southern Africa. This is an endemic species and South Africa's only gazelle. Springbok are well adapted for survival in this tough environment. Their numbers can drop as a result of drought, but they are quick to recover once conditions improve again. A female is capable of conceiving at just seven months of age, with a short gestation period of only 25 weeks. Springbok can breed at any time of the year. So it is fitting that Komsberg has many hundreds of these antelope.

Large numbers and their relatively small size makes springbok an obvious target for several predators. They are the main prey species for cheetah. Black-backed jackal

Above and left: Before we bought Komsberg in 2002, the previous owners re-introduced a few springbok to Komsberg East in the 1960s. We then inherited a different springbok population when we bought a neighbouring sheep farm in 2006, almost doubling Komsberg Wilderness Nature Reserve in size. It is common for sheep farmers in the Karoo to also have a few springbok. We have released further groups of this beautiful gazelle, restoring them to Komsberg West.

Above: I soon appreciated the importance of grasses. To begin with, it was hard to find any palatable grass growing on Komsberg. Years of sheep farming, including over-grazing, had changed the habitat. Any survivors were hidden inside the protection of thorny bushes.

As I considered what animal species we could re-introduce, the importance of grasses quickly became obvious: gemsbok, red hartebeest, zebra, and wildebeest eat little else. So the recovery of Komsberg's grasses was essential and one of the most crucial things to understand. Thankfully, sufficient soil survived in enough places on the reserve to support a good population of grasses.

After two and a half years of being sheep-free, the grasses started to come back. After three and a half years, we slowly began to re-introduce a few of the large grazers. The recovery process really became obvious five or six years on from purchasing the land.

It is still vital to understand what is happening with all of the grasses, especially as we reach our full carrying capacity in the future. I never realised how exciting grasses could be!

The grass photographed above, being examined by Becky, may be a new species or sub-species. Botanists have already discovered that its DNA has several differences to that of common ehrharta.

Left: Thimble grass, growing in the valley section of Komsberg West, is of medium grazing value.

Right, above: Common ehrharta, an excellent grass, has recovered well since the removal of sheep.

Right, below: Hartebeest grass is also very palatable and eaten by all of our grazing antelope.

and caracal also regularly kill springbok. Furthermore, we have watched martial eagles hunting adult-sized springbok.

Between October 2005 and June 2011, we have had 18 releases of large herbivores to Komsberg Wilderness Nature Reserve . Several more are planned for the near future. In addition to springbok, we have re-introduced red hartebeest, kudu, and gemsbok. We have also added black wildebeest to Komsberg West and blue wildebeest to Komsberg East; these two species may not have been historically present in our locality but are nevertheless considered suitable for the ecosystem. In the late 1800s, black wildebeest came close to extinction with only 550 or so animals remaining. The species was saved due to the efforts of several conservation-minded farmers who realised the dire situation and used their farms as protected areas.

The re-introduction of Burchell's zebra to Komsberg East on 10th September 2008 and again on 10th April 2009 somehow seemed extra special - not just because they had been absent from the area for 197 years or so, but perhaps because zebra are one of *the* iconic African wild animals. Anyway, our appreciation of these amazing and highly intelligent creatures certainly escalated very quickly after their arrival. Komsberg's wildlife was getting back to something like it used to be!

Above: One family group of our endangered Cape mountain zebra on a steep mountainside, with pink-flowering succulent bushes in full bloom. We have been pleasantly surprised to discover how they utilise even the most dramatic of our mountain slopes. These incredible and well-named animals have definitely become one of Komsberg's "specials"!

7th October 2010 was certainly an historic day. We re-introduced the endangered Cape mountain zebra to Komsberg West. Four family groups were released. This beautiful mountain zebra was almost lost to extinction in the near past, with only 91 left in 1950. Earlier, in 1936, General Jan Kemp as the Minister of Lands was asked to help; he impatiently answered "No! They're just a lot of donkeys in football jerseys." However, he eventually relented and land was purchased to establish the Mountain Zebra National Park to save this species from imminent extinction.

The creation of a national park did not automatically safeguard the Cape mountain zebra's future. The small remaining herd (five stallions and one mare) had all died by 1950; they were replaced by 11 new mountain zebra from a neighbour and a further 30 animals boosted the tiny population later on. The situation has significantly improved today, but further progress still needs to be achieved.

The financial cost of re-introducing this endangered species to Komsberg was huge, but we never hesitated about our responsibility to bring it back. Indeed, we are the first to restore the Cape mountain zebra to our region. Komsberg is one of the biggest private nature reserves in South Africa and Komsberg West has numerous dramatic mountainsides as well as plateau. It is likely that Komsberg is the most spectacular place to see Cape mountain zebra and they should flourish over the years ahead.

Above and right: To date, we have released five lots of gemsbok to Komsberg West and Komsberg East. They will be re-introduced to Komsberg North as well in the near future. Seeing a large group of gemsbok is a spectacular sight. After an absence of many years, it is one of our many achievements to have restored this majestic antelope to Komsberg.

The handsome fawn-grey, black and white body and facial markings are striking. Long slender horns add to the impressive features. Weighing up to 240kg, this is a big antelope.

The gemsbok is another specialist of southern Africa's arid western regions. It has adapted to these dry conditions in several ways. The gemsbok can survive for long periods without drinking water. Its body metabolism is lower than normal for an animal of this size, thereby reducing food and water requirements. An elaborate network of blood vessels in the gemsbok's nasal region allows it to keep cool in high temperatures, protecting the brain from fatally overheating. This huge antelope needs to eat a lot of grass so we had to be sure that Komsberg's grasses were well on the road to recovery before considering the gemsbok's re-introduction.

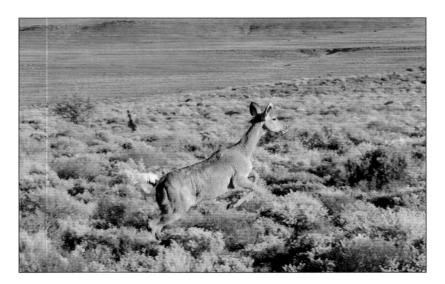

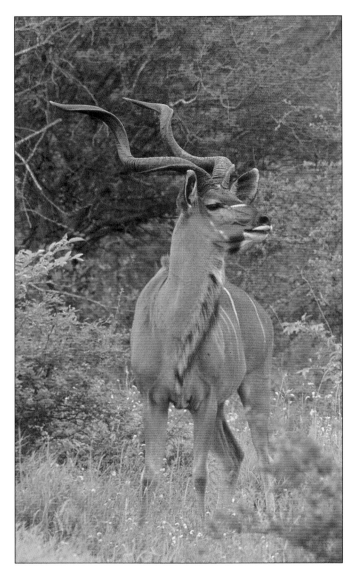

Above (all) and right: The kudu is the biggest of all our antelope species (at least, at the moment, as we will shortly be re-introducing eland to Komsberg North and these antelope are even bigger). Male kudu can weigh up to 300kg. Only the males have horns, which are spiral in shape and enormous in size. Despite their bulk, kudu are notorious jumpers and can easily clear 2m fences from a standing position.

Kudu are browsers and so utilise leaves of Acacia karoo and other trees/bushes that are common along the rivers in the valley section of Komsberg West. They favour rocky hills and wander up the rivers towards the base of our mountains. Although they are large, kudu can be elusive and sometimes hard to find.

We have had two releases of this beautiful antelope - in October 2005 and September 2008. Numbers are steadily increasing.

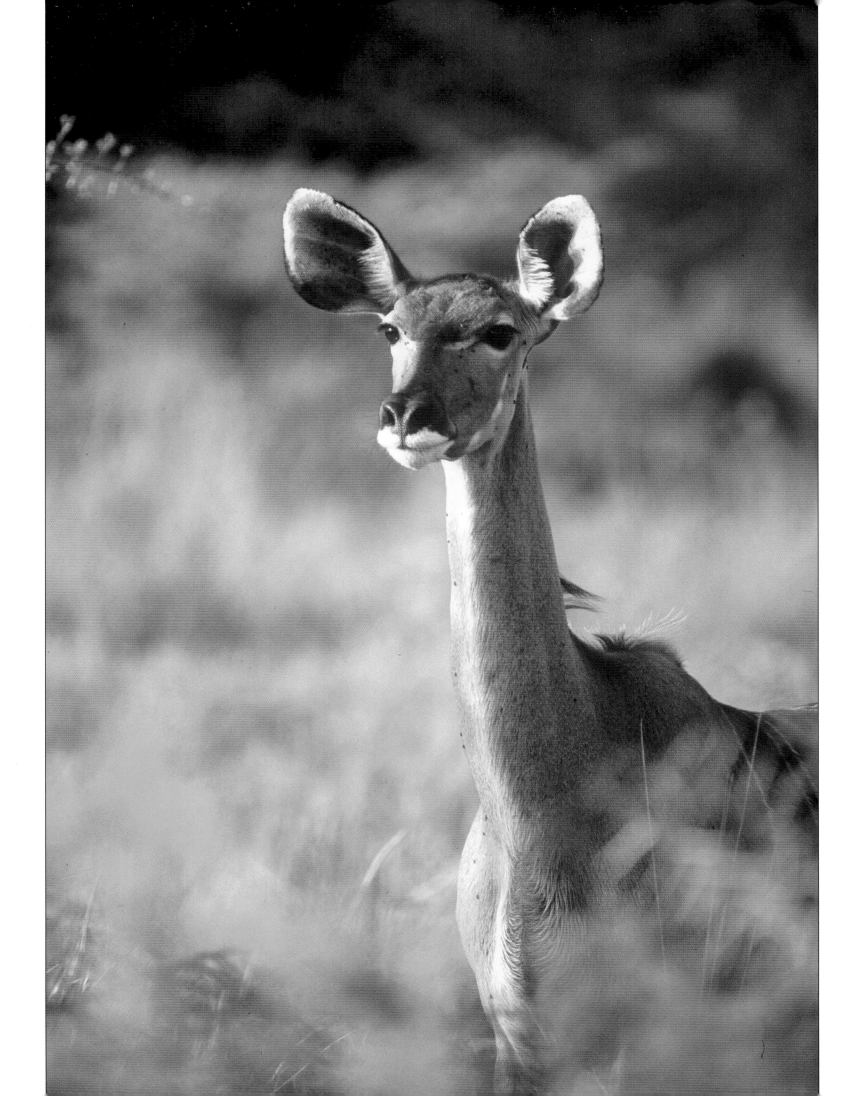

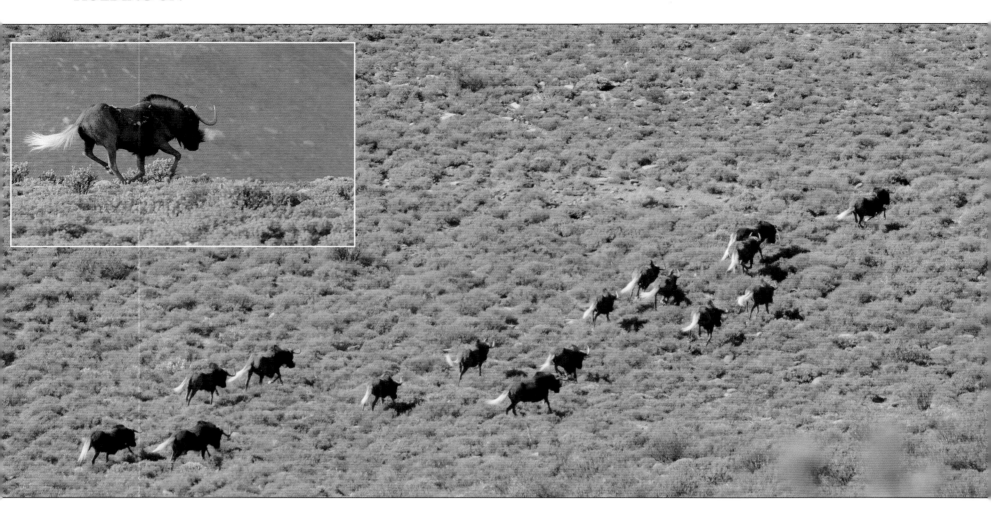

Above: The black wildebeest is endemic to South Africa. It is easily identified by its long white tail, whereas the more common blue wildebeest has a black tail. Black wildebeest almost became extinct in the late 1800s when numbers crashed to just 550 animals, due to widespread hunting and other pressures of human settlement. The species was saved by the efforts of a few conservation-minded farmers. They have settled well on Komsberg West.

Right: We re-introduced the red hartebeest to Komsberg East and they have already more than quadrupled in number.

The key to our success is attitude. We know that the "me, me, me" mentality causes problems and is severely limiting. Selfishness is the fundamental cause of our environmental crisis.

We are pioneering a deeper approach to nature conservation that is based on need before want. We recognise that qualities such as self-honesty and integrity are as necessary to project success as biological knowledge and sufficient finance. Indeed, such psychological qualities are probably *more* important.

And we don't avoid what is obvious. As the "me, me, me" mentality really is problematic and severely limiting, we look at how this shows up in the performance of individual team members. Defensiveness and psychological baggage have already built up, long before someone comes for an interview. So this needs to be looked at, logically and practically, and unlearnt on a step-by-step basis. We don't wallpaper over the cracks.

We are not interested in the "I can't, because…" excuses. They're immature and get in the way. Instead, we work on the "Why not?!" principle of service and duty. We make things happen, even if it means sacrifice on our part. We look for people who want to learn and move forward - individuals who can go beyond their limitations and realise their potential.

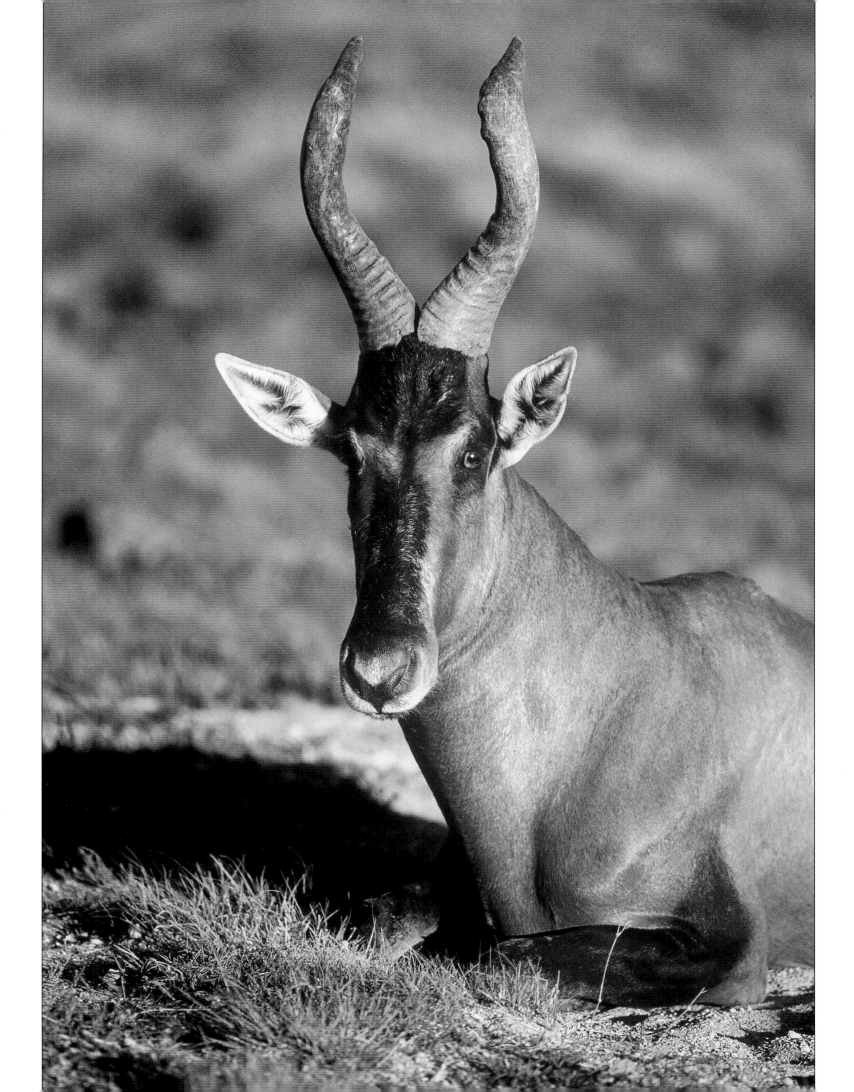

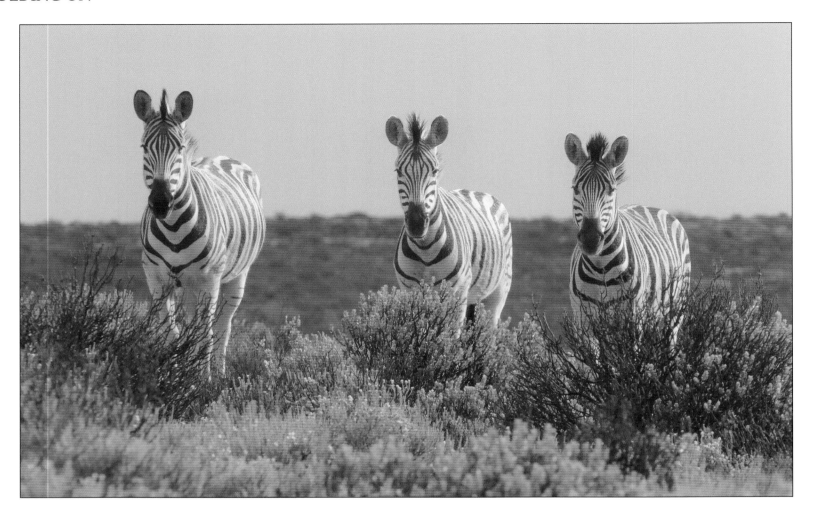

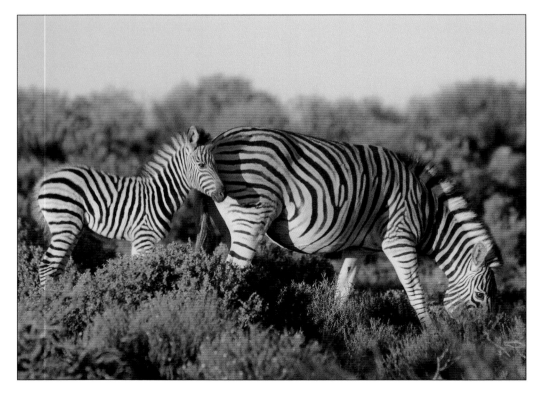

Above: Three of the first lot of Burchell's zebra re-introduced to Komsberg East.

Left: Another Burchell's zebra foal is born at Komsberg, named "Avoidance Doesn't Work" to emphasise this important issue.

Right (all): We re-introduced the Cape mountain zebra on 7th October 2010. This endangered zebra species was released on Komsberg West where we have numerous mountains and mountainsides, as well as plateau and valley habitats. This restoration has been a massive achievement.

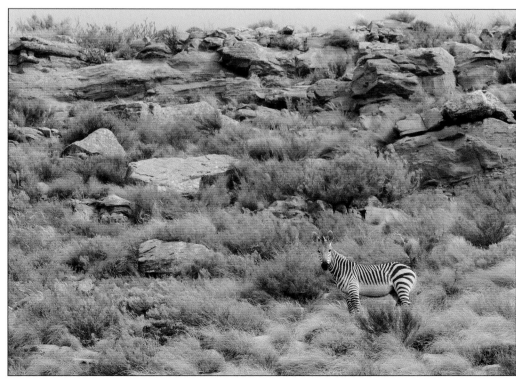

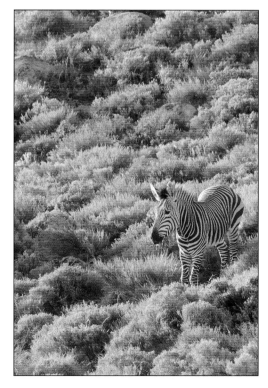

Above: *A juvenile martial eagle. Komsberg has five eagle species as well as many other birds of prey.*
The martial eagle is listed as vulnerable in South Africa and endangered in neighbouring Namibia. Bird experts say that there are only 100 to maybe 150 martial eagles in the whole of the Western Cape, Northern Cape, and Eastern Cape - an area covering more than half of South Africa. Presently, Komsberg has four martial eagles.*

** Komsberg is located in Sutherland District just inside the Northern Cape, close to the Western Cape border.*

Our work is pioneering, necessary, and no-nonsense. And to repeat: the key to our success is attitude.

The unusual success of Komsberg cannot be properly assessed just by looking at what we have outwardly achieved. Yes, it is appropriately big - but Kruger National Park is bigger. Yes, we are conserving an astonishing range of biodiversity including a number of endangered species - but so is Kruger. To fully appreciate what we have done, you need to look deeper.

We deliberately work as non-paid professionals, thereby saving a lot of money each and every year that would otherwise have been spent on salaries. There is a limit to how much funding conservationists have access to - and the genuine and urgent world-wide needs of threatened wildlife are many - so why waste money paying ourselves? This attitude then continues into how we spend our budget; we are extremely careful with money and frequently get specific material donations from businesses willing to help, made easier because managing directors and others recognise our integrity. Put simply, our approach is financially efficient. In comparison to either government run or business-driven nature reserves, we offer exceptional value for money. We provide the same for less, when compared to the very best.

Above: A martial eagle perched on a wooden electricity post. Notice the adult plumage compared to the image of a juvenile martial eagle (see left). The adult's head feathers are dark brown and there are brown blotches on the chest.

Right: The martial eagle has a huge wingspan of up to 8ft across (2.4m). It can spot potential prey up to 6km away, adequately demonstrating the popular saying "eagle-eyed".

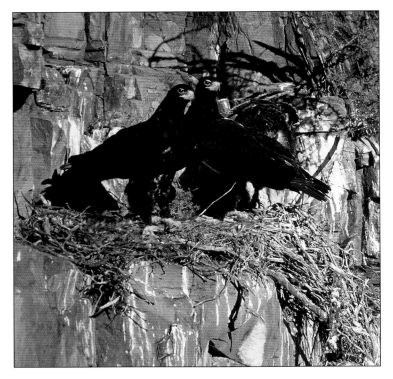

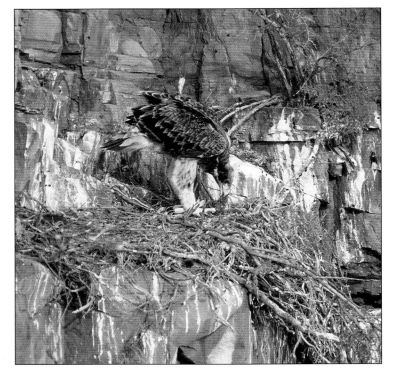

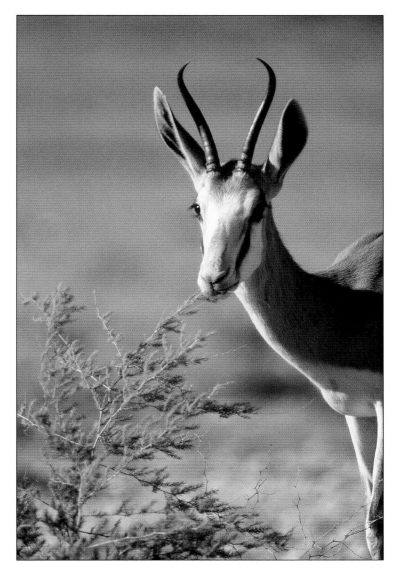

Above (left and right): The steenbok (left) is one of our smaller antelope and is a prey species of both martial eagles and black eagles. Even the larger springbok (right) can be taken by these birds of prey.

Left (all): The black eagle - more properly known in reference books as Verreaux's eagle - has a wingspan of over 9ft (2.8m) and is Africa's largest eagle. The martial eagle is a close second. Black eagles breed at Komsberg, building their nests in places where baboons cannot reach.

In our region, some 90% of a black eagle's diet consists of dassies (rock hyraxes). Dassies may look like plump rodents weighing up to 4.5kg but they are actually the closest living relative to elephants! Black eagles are monogamous and frequently hunt in pairs. They are commonly seen at Komsberg during early morning and late afternoon, flying low over exposed rock faces where dassies are sitting. The first black eagle often flushes its prey for the second to catch.

Female black eagles usually lay two eggs at a time, but only one chick survives due to siblicide. This is when the dominant chick kills the other to eliminate competition for food and it happens in more than 99% of cases.

We are proud to be able to say that Komsberg Wilderness Nature Reserve is a good place for eagles and other birds of prey.

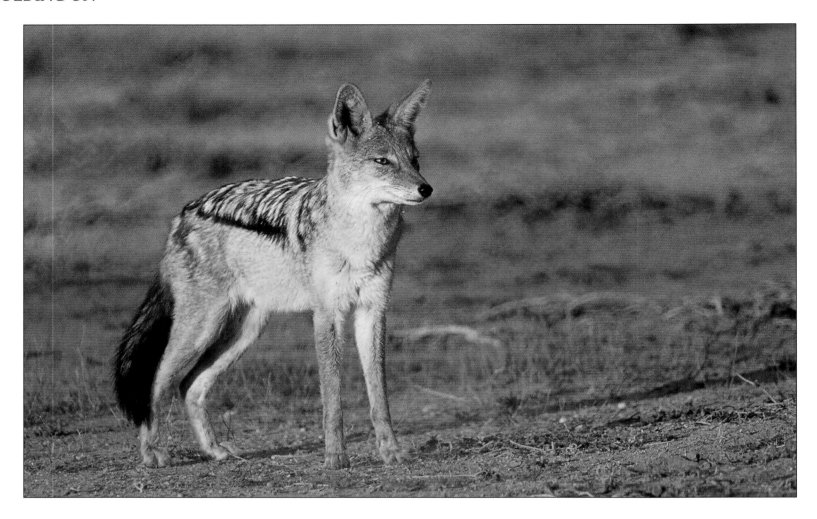

Above and right: Black-backed jackal are beautiful. They are also cunning and highly adaptable. They will eat almost anything that is available, from lizards to medium-sized antelope such as springbok and grey rhebok. In areas where large predators have been eliminated, the black-backed jackal plays an important role in maintaining the health of the ecosystem. It usually selects prey that are weak or sick.

Working our way takes less people to do exactly the same jobs. "If you want something done quickly and well, ask the busiest person!" is a true saying, easily explained in terms of attitude. There is a heightened sense of responsibility and a lack of excuses. To us, this approach is basic and not exceptional. We don't tolerate laziness or sloppiness in ourselves nor in our team. Why not? Because it doesn't make sense. Isn't there an urgent problem to solve?!

Our decision making is also much more appropriate. We get the big decisions right, not limited by self-orientated "I want" or "I can't, because..." considerations. And we therefore make better day-to-day decisions for the same reasons. We're not put off by the usual suspects such as "It's too cold", "I don't feel like doing that today", "I'm tired", and so on. There is more attention to detail. Boundary fence checks, for example, are done conscientiously - with suitable regularity and greater diligence.

It is also easier to manage a complex and challenging place like Komsberg, including long periods when senior management is not there. Team members share a common vision with directors and everyone appreciates the need for objective thinking and responsibility. This results in a greater degree of correct implementation of policy and high levels of trust. Vehicles and equipment are looked after with more care than usual. There is individuality, but with fewer hidden agendas. Management is relatively straightforward.

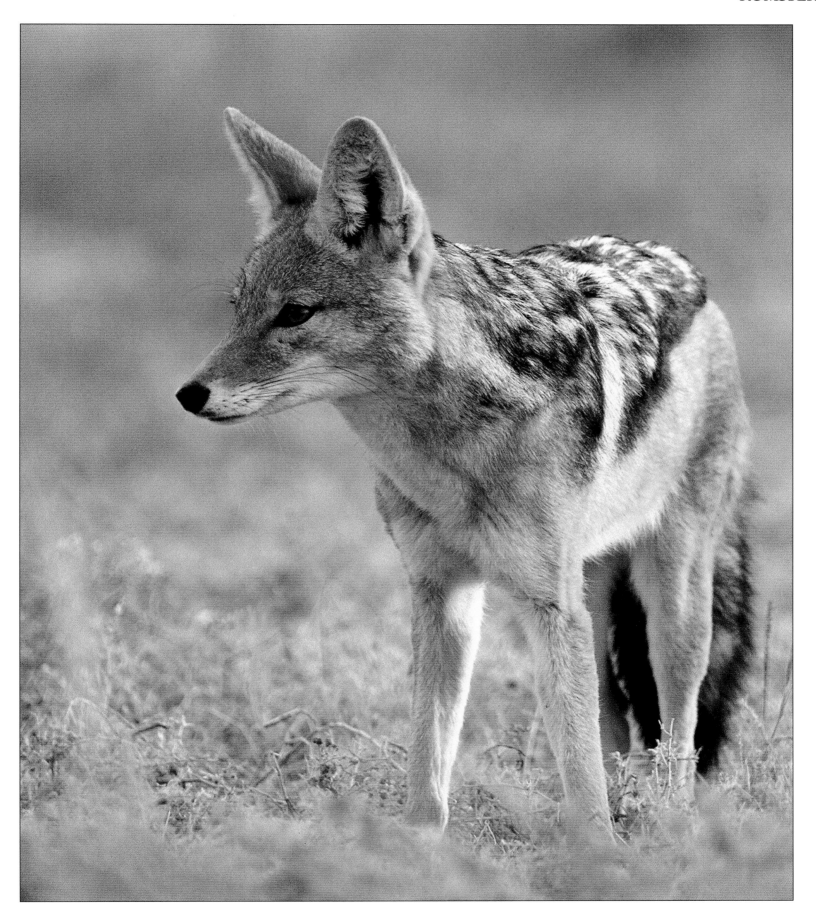

Left: Just as I was finishing the manuscript for this book in October 2011, we were given an orphaned black-backed jackal to hand-rear.....so final adjustments had to be made to include Happy! (This is the only young animal we have had to hand-rear at Komsberg in the past 10 years.)

Below (left): Happy visits a waterhole for the first time, with Becky nervously watching over him.

Below (right): "Have teeth, can bite!"

Right: The totally adorable Happy finding his feet in the great outdoors. Komsberg's own rock star!

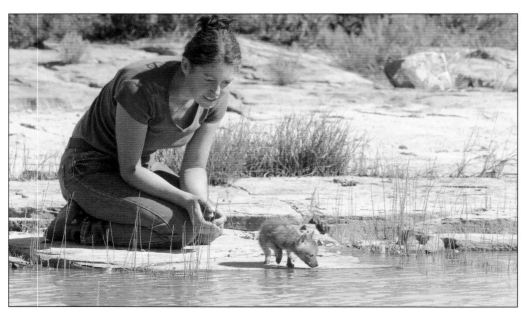

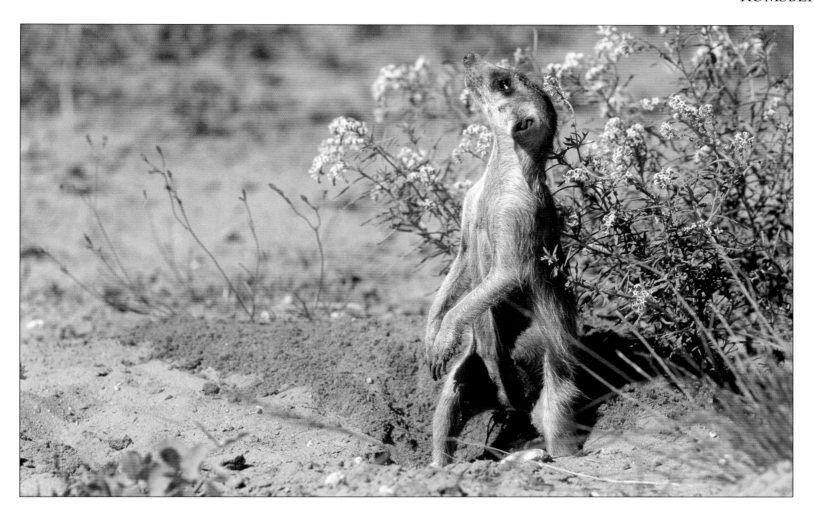

And the lack of a wage structure eliminates certain interpersonal jealousies and dubious career-building motives.

 When you are not so self-obsessed, this more mature attitude and approach shows up as better delivery. You are acutely aware of the normal "me, me, me" psychology but cannot easily fool yourself because the self-honesty includes knowledge of excuses and other forms of avoidance. You thereby develop a keen dislike of hypocrisy through improved self-awareness. When matched with a constructive way forward, this produces a freedom to do what is sensible for the greater good of all. Sacrifice and duty are seen as worthwhile qualities, whilst others with less understanding might view them with reluctance and a degree of negativity. Likewise, struggle becomes a good thing because you allow yourself to realise that without considerable effort and self-discipline you cannot expect much to change. (In recognition of this quality, we have named one of our Burchell's zebra foals "Struggle".) You willingly work much harder and want to excel. Any outstanding achiever will understand this, whether it is someone who is a top sports performer or an individual who is successful in business; the key difference being that our work aims to bring benefits for wildlife rather than fulfilling a self-centred personal ambition. That said, there are many indirect benefits for an individual who lives a more meaningful life.

Above and left: Meerkats have to be vigilant against attack from the air and ground.

Above: The caracal is persecuted by many sheep farmers - even though research shows that this predator is of no overall threat, any negatives being cancelled out by the benefits. (Caracal kill black-backed jackal, for example.)

Left: The caracal is usually described as one of the world's most beautiful cats. It is a highly capable predator, agile and fast. A caracal can leap 5m into the air from a sitting position and so is an expert at catching birds. It can easily kill springbok and grey rhebok, and has occasionally been known to take young kudu.

It has been well-established that people's behaviour is motivated by reward. You do well at school and get told you are clever, with plenty of exam passes on your CV. You go to work, probably Monday to Friday, and spend the money you get paid at the weekend. Or you save some of it and treat yourself to an exotic holiday later in the year, buy a better car, or move into a new house. You get your hair done, dress a certain way, and get a man or woman at the nightclub. You focus hard on training to excel at a sport and eventually win an Olympic gold medal years later. The examples are endless and range to differing degrees. What we do at Komsberg is still perhaps a form of rewarded behaviour, but it goes way beyond the "I want" limitations. Our thinking is much broader, intelligently understanding the many consequences of "me, first" - then we use our freedom of choice to primarily focus on the bigger picture and a more preferable psychological approach to life.

Interviewing and training potential team members can be challenging. Some people may have a vague dream of helping wild animals, but most have never really considered what it takes to make that dream become an actual reality. There is rarely any existing practical capability, yet these "passionate" individuals somehow expect to make a difference and are frequently offended when you point out the simple fact of their shortcomings. Only a few are willing to knuckle down and learn to be self-honest

Above: The grey rhebok is one of Komsberg's "specials", supremely adapted to our terrain. This medium-sized antelope is only found in the mountainous areas of South Africa. Watching a group of grey rhebok bounce effortlessly up (or down) a steep mountain slope is a memorable sight.
Komsberg possibly has the best population of grey rhebok anywhere.

Above: Komsberg is situated within the upper succulent Karoo and fynbos biomes (major ecosystems) - widely recognised as two of the world's 25 most important conservation hotspots for biodiversity. Komsberg is also within a special centre of plant endemism, having a high percentage of species found nowhere else. Therefore, many of our plants are unusual, as well as many of our animals. Komsberg has one of the richest habitats on the planet.

The Sutherland plateau is famous in South Africa for its cold weather, with snowfall recorded on several days each year and frost common during the winter months. Scientists call these "positive chill units" and have concluded that this is one of several relevant factors which account for the high number of unique plant species in our area. The almost extinct rye grass, for example, requires exposure to winter cold before it will flower.

Our numerous plant species are incredibly varied. In years of good winter rainfall, we see millions of Alonsoa unilabiata (above, left) flowering profusely in spring and have affectionately given it the nickname "flower of fear". Disperis purpurata (above, right) is one of the few orchids found at Komsberg.

Above: Romulea komsbergensis is one of several endemic species of this colourful family of plants. They frequently carpet seasonally wet areas of our plateau. As you will have probably noticed, it has been named after Komsberg.

Right: We have an interesting variety of succulent plants protected within the reserve. When not in its flowering stage, this particular succulent is much smaller and resembles an animal's dropping. It swells up after rainfall before erupting into a mass of small flowers. Many succulents have extremely bright-coloured flowers which easily attract the attention of pollinating insects. This helps them produce the seed that is necessary for reproduction and therefore survival in this often challenging environment.

Above (top): *Part of the seed production area for the endangered rye grass at our main homestead.*

Above (lower left): *An established rye grass plant growing well on the reserve.*

Above (lower right): *The rye grass needs early summer rain to stimulate flowering.*

and work hard. The present-day culture of volunteering is casual in the extreme. It is very much geared up to "I want" rather than service before self and does not prepare anyone for doing what is necessary to make a real difference. Sadly, some people are quick to misunderstand and blame, rather than questioning themselves. Going against what is accepted as "normal" is the one unfortunate aspect of daring to be different and pioneering a better way. But if we also dumbed down, our unusual success would quickly evaporate.

The captions on previous pages describe how special the plant life is at Komsberg. Our local area was historically named as the Roggeveld (Afrikaans for rye grass land) after the rye grass that was only found in this region. Prior to sheep farming which ravaged the natural vegetation beginning 300 years ago, the rye grass was locally common and must have been a wonderful sight when in flower - its long flower stalks gently blowing in the wind, similar to wheat or barley. Severe over-grazing for many years led to it becoming almost extinct.

When we established Komsberg in 2002, the rye grass survived on just one farm, Kanariesfontein. The elderly owners kindly gave us six plants and some seed to get started. Initially, we grew approximately 3,900 plants next to our main homestead in good soil.

Above: The endangered star tree is found in good numbers on our south-facing mountain slopes. It is a member of the rose family, although only botanists would see any resemblance to the popular garden rose. Another reserve in our region has rightly been awarded special Natural Heritage Site status and protects 150 star trees. We have at least 2,000-3,000 of these endangered trees at Komsberg.

Above: *Becky and Wussy in our storage barn with a pile of wooden straining posts.*

We set up a simple irrigation system to water whenever needed and thereby maximise production. Over the next few years, we harvested some 10 million seeds by hand. We sowed this seed in various places on the reserve, re-establishing the rye grass in over 30 different locations. It survived a bad drought in 2005/2006 and today is grazed by our large animals. We have been successful to date, but it is not the toughest of grasses and more work needs to be done to bring it back from the brink of extinction.

During November, we offer small groups of eco-tourists the opportunity to visit Komsberg in the form of 10-day working holidays. They get a taste of what it takes to run such a nature reserve. Guests might help with a bit of fencing or perhaps assist in mending a windmill (although not such a major task as replacing a tail - see next pages). We take them on walks and there is time to appreciate our wildlife.

Guest comments have included "From the moment you met us at the airport until we said our good-byes, you made us feel welcome and part of something worthwhile." And "I found the dedication, incredible hard work, and determination of the staff more inspiring than anything else I have encountered in many years." And yet again "Your 24 hour care of us was 'out of this world'." We genuinely do our best and these comments reflect that it is usually appreciated. But why do less than your best?

We also help educate small groups of local students about nature conservation who visit Komsberg with their teachers for the day. We broaden their experience by talking about why we are successful. Key topics include the need for hard work, having a meaningful aspiration, self-honesty, overcoming psychological baggage, and attention to detail.

What about the future? Komsberg Wilderness Nature Reserve is big, but ultimately there is an upper limit to the number of wild animals that any place can support. There is only so much grass that can be eaten, so many bushes that can be browsed, and so on with regard to the trees and edible flowers. The biological term used to describe this is carrying capacity.

If there is over-utilization, deterioration begins. The most palatable grasses and bushes begin to reduce in number, replaced by inedible plants. This veld degradation would then result in a loss of condition of the animals through poor nutrition - followed, eventually, by death. The aim is to stay at or near to the land's carrying capacity.

In the early years, we deliberately allowed the land to recover before re-introducing the large herbivores. We then did so slowly, with several small releases of animals rather than lots all at once.

Above: We have erected 98km or 61 miles of perimeter fencing. Size matters, of course, but it has to be matched with a huge amount of determination, dedication, and hard work. Komsberg demonstrates our motto "actions speak louder than words".

We planned ahead, estimating the increase of animals and what this meant in terms of carrying capacity. In order not to exceed the limits, we aimed to buy more land. We did this in 2006, slightly earlier than hoped, when we effectively doubled Komsberg in size by purchasing a neighbouring sheep farm. Over half of this new land was fenced by September 2008 and so allowed the Komsberg East section to be considerably expanded. At this stage, the animals had much more space and food - and the reserve's carrying capacity was completely re-calculated. If we expand still further in the future, this will also reduce the pressure of having too many animals for the land.

A common solution is to take off surplus animals every few years and sell them to other reserves, just as we have acquired our animals from elsewhere. This is done by experienced game capture teams.

Another option is to re-introduce a major predator to the reserve. This could be thought of as a more natural solution, as the predators will keep the number of antelope in check. After much consideration and planning, we are presently working towards re-introducing cheetah to Komsberg. Legally, this first involves us strengthening our perimeter fence and electrifying it. So the endless days, weeks, and months of hard work continue.

Above and left: The heavy and awkward tail of a windmill needed replacing. Wussy and Vicky did this difficult job themselves, much to the surprise of our neighbours. At this time of writing, "Windmill Wussy" has been part of our team for 6 years and Vicky for 15 years. Both capably demonstrate "service before self".

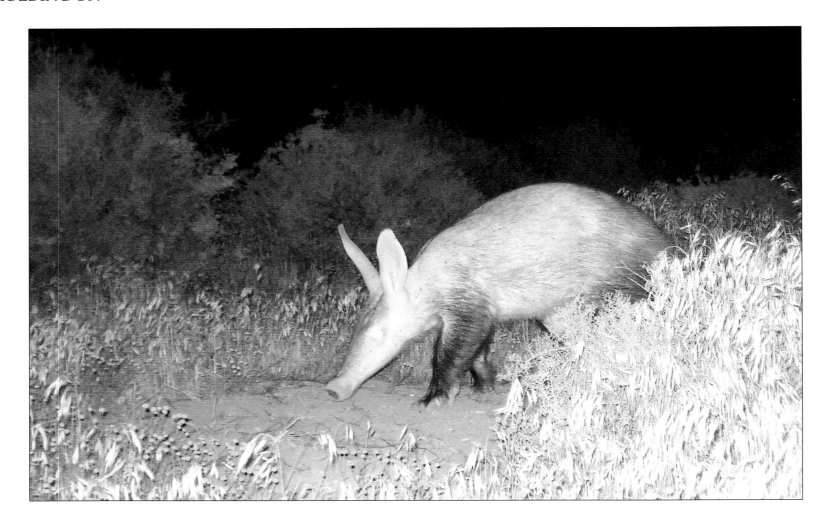

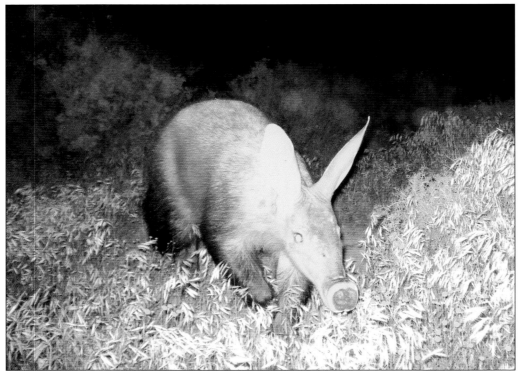

Above and left: The aardvark is a large, strong, and unusual animal weighing up to 65kg - yet it amazingly survives on a diet of ants and termites. They are notorious diggers and live underground in tunnels. They emerge to forage at night. A variety of other species make good use of aardvark tunnels for their own shelter.
Aardvarks prefer warmer conditions and so usually avoid the highest parts of the plateau area. They are common in our lower main valley section of the reserve. I took these two photographs remotely, using camera traps set up along known animal trails.

Above: The yellow mongoose (top, left) is one of our four mongoose species at Komsberg. Our African wild cats (top, right) have genetic purity, whereas the species in many parts of Africa has now been damaged by interbreeding with the domesticated cat. The honey badger (bottom, left) is the world's most ferocious animal according to The Guinness Book of Records; its reputation is deserved. We have many porcupines at Komsberg (bottom, right), seen mainly at night but sometimes in daylight.

Above: *The greater padloper, as well as the Karoo padloper, the tent tortoise, the angulate tortoise, the leopard tortoise, and the Cape terrapin are all found at Komsberg. The first four are endemic species.*

Left: *A juvenile tent tortoise. The tent tortoise is the most colourful of our various tortoises but must not be confused with its similar-looking relative, the endangered geometric tortoise, which is the primary focus of our other nature reserve in South Africa.*

Above (all): *Komsberg has more lizard species than are found in the whole of the UK. And more snakes. We have an incredible number of rocks lying on the ground, plus as many rocky crevices, which combine to provide a great habitat for these small creatures. Our various lizards include the Cape crag lizard (top), the Karoo dwarf chameleon (bottom left), and the southern rock agama (bottom right). Komsberg's biodiversity is incredible and we are proud to be able to conserve everything.*

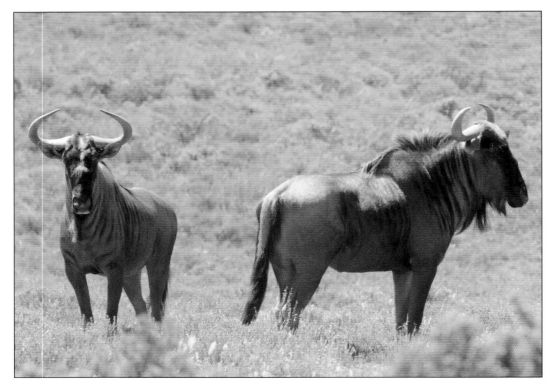

Above: Klipspringers live on the edges and steep slopes of our mountains, their name meaning "rock jumper". We have an excellent population of this small antelope, mainly on Komsberg West.

Left: We released blue wildebeest to Komsberg East.

Right: The Karoo means "the great thirst" but Komsberg nevertheless gets a reasonable annual rainfall of 337mm - although drought is still a risk. Every heavy downpour is welcomed, as the vegetation will afterwards turn lush and result in the improved condition of our animals. (Actually, we get really excited when it rains a lot!)

Above: *Greater flamingos visit our region each year from October to December.*
I took this image seconds after the flamingos had been attacked by an African fish eagle.

By re-introducing a major predator, we will be achieving even greater ecological integrity and fulfilling our duty to restore Komsberg as much as possible to its former natural state. The cheetah is vulnerable to extinction and Africa's most threatened large cat. Only 550 or so remain in the whole of South Africa.

Komsberg Wilderness Nature Reserve demonstrates what can be achieved when a small team of individuals has a no-nonsense attitude. It is a huge undertaking, with on-going responsibilities to match. 30,700 acres or 12,424ha (to be exact) of an important ecosystem has been successfully rehabilitated. The damage caused by human greed and ignorance is being reversed. The sheep have all gone. An abundance of wildlife is recovering.

If this example is to be seriously considered as a pioneering way forwards, then a lot of the current approach to nature conservation has to be questioned and changed. Those concerned for wildlife and the environment must begin with their own mindset. Young people being taught in schools and universities must be given better instruction; at present, their education is sadly lacking.

A foundation of core values is needed. As materialism has expanded and life has become more physically comfortable, people have become soft. There are crutches galore, entertainment and other distractions in plentiful supply, with little need for self-reliance

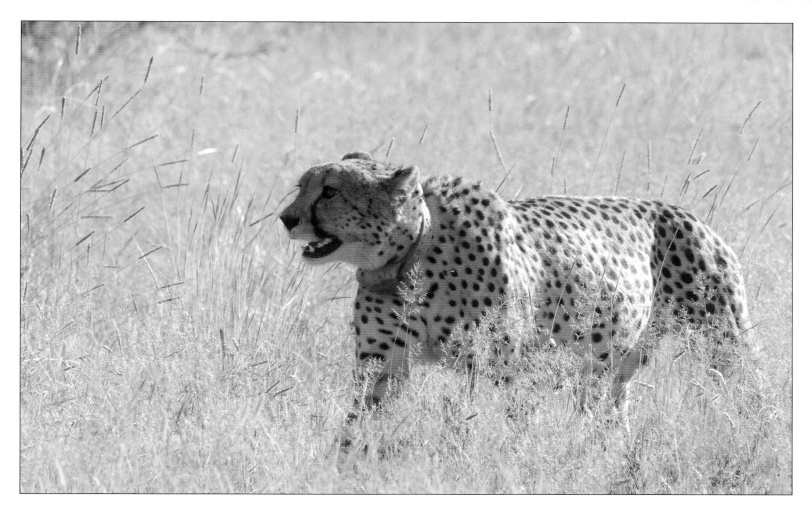

and actual capability. The rat race has become sophisticated and addictive. How many people aspire to levels of excellence?

The words of Thomas Edison, inventor of the light bulb and much more, provide a clear hint: "Opportunity is missed by most people because it is dressed in overalls and looks like work." And again: "The first requisite for success is to develop the ability to focus and develop your mental and physical abilities to the problem at hand, without growing weary. Because such thinking is often difficult, there seems to be no limit to which some people will go to avoid the effort and labour that is associated with it....." And yet again: "Our schools are not teaching students to think. It is astonishing how many young people have difficulty in putting their brains definitely and systematically to work." Thomas Edison died in 1931. His words are as relevant and in urgent need of consideration today as ever.....

Above: Cheetah have been recently re-introduced to the Mountain Zebra National Park. We plan to follow this success at Komsberg in the near future. It is very important to monitor cheetah by using radio collars for the first few years after release to help find out what is happening. Questions like "Where are they?" and even "Are they alive?" can be easily and reliably answered.

Conclusion
Growing up
and the challenge ahead

The environmental crisis is far from being solved; indeed, the situation is still getting worse. Human overpopulation is massively out of control and the consequences should be of serious concern.

Overall, there is a lot of awareness and talk - but with little resulting action. By merely talking the talk, and perhaps making a few minor lifestyle adjustments, it is easy for people to fool themselves that things are changing for the better. At best, people are starting to understand some of the problems. The environmental movement is still in its infancy. There is an urgent need for maturity and a deeper approach to nature conservation.

We thankfully have a worldwide system of national parks and other nature reserves (even if our own Lake District National Park seems to be mainly for sheep and holiday makers). And the wolves of Yellowstone are back. There is less pollution in many cities. We have laws against this and regulations against that.

So what are the main challenges ahead?

Self-honesty and a no-nonsense realism must be high on the list. We should have been able to achieve much more during the past 50 years; the failures of the past and present need to be admitted. There must be a lot less rhetoric, replaced with effective and efficient delivery. Individuals and organisations need to genuinely embrace the practical concept of "actions speak louder than words". Without this, how can there be transparency or any kind of accountability?

Right: *Cape mountain zebra males fighting. This species is back from the brink of extinction.*

Far right: *The wolves of Yellowstone National Park have been restored - a genuine success story.*

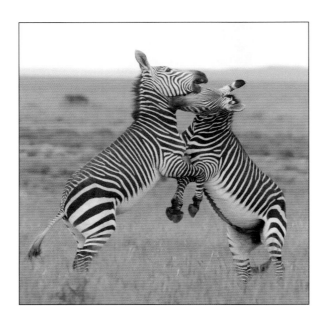

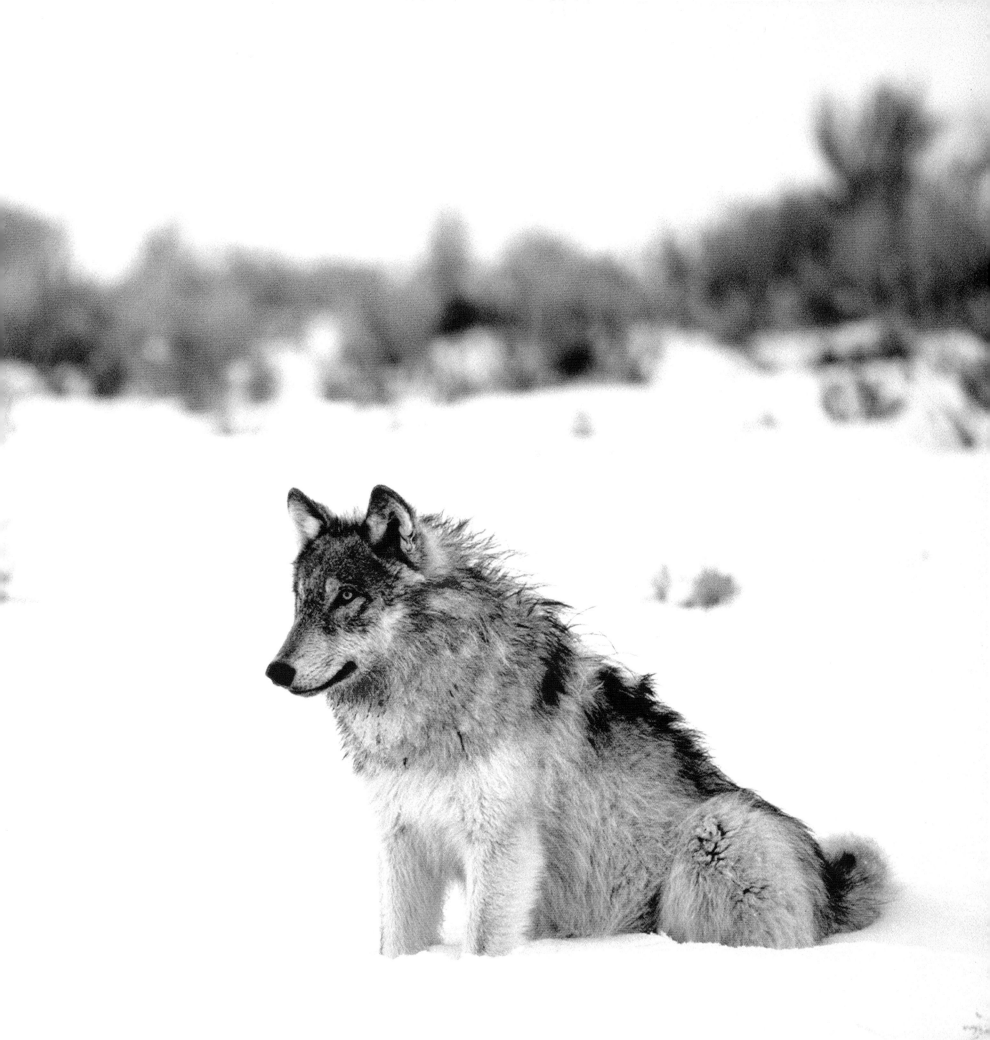

Above: India is obviously overpopulated. Already more than 1.2 billion people, India's population is predicted to rise by another half billion in the next few decades.

Right: The tiger is struggling to survive in the wild. Human overpopulation is part of the problem, with very little undisturbed forest habitat remaining.

Overpopulation should no longer be ignored by most of those who claim to be concerned for wildlife and the environment. This huge time bomb of a problem has to be acknowledged if there is to be any significant progress. Billions of extra people have a gigantic effect on the world - in direct competition for space, soil, and water that is needed to sustain the rest of our planet's life. Today, as I write these words, the BBC reported that the UK population has grown faster in the past year than at any other time in the previous 50 years - by a further 470,000 people. It was not headline news and the usual environmental groups stayed quiet. Re-read the population predictions for Kenya and Tanzania (page 46) and consider the future of Serengeti and Masai Mara.

Everyone should be intelligently discussing the subject of overpopulation because we all have a responsibility. This isn't a matter for government legislation. Each of us should think clearly. Couples should talk. Friends should talk. Families should talk. A simple guideline would be "two or less" children. As a young man, I thought 3 billion people was far too many. This is the second biggest problem of all.

The environmental movement - indeed, the human race - will not mature until the core issue of "me, me, me" is tackled. Selfishness is the root cause of almost every problem - whether it is environmental, social, or personal. And I'm not talking about the obvious

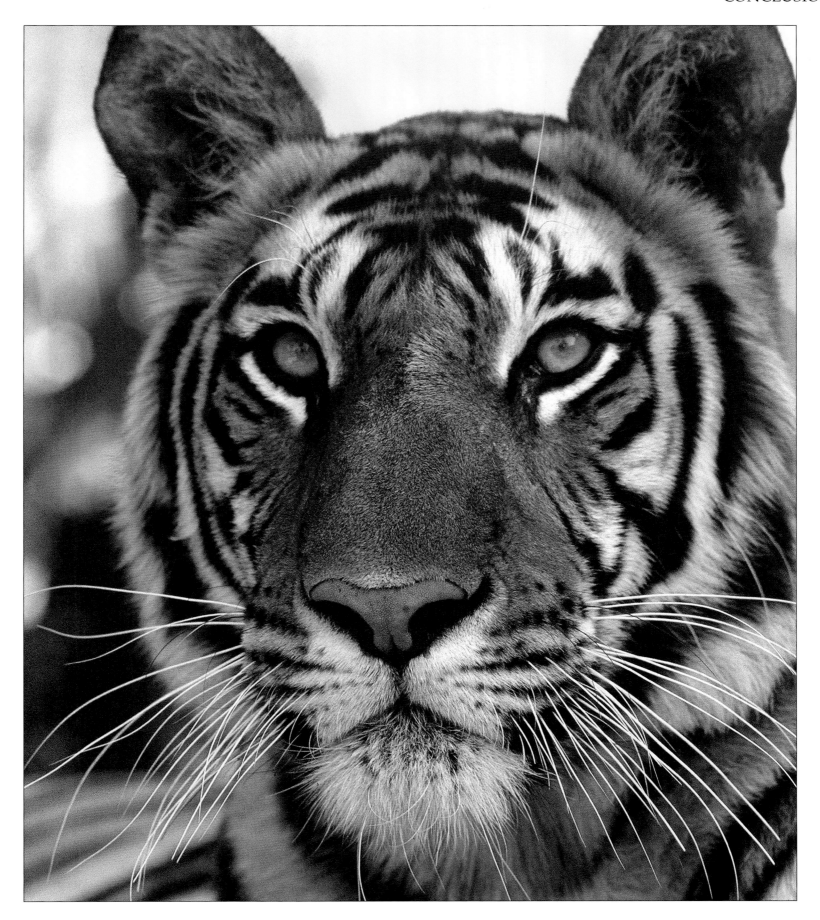

Above: The hustle and bustle of a crowded street in New Delhi, India.

selfishness, but rather the whole range of normalised and accepted self-orientated behaviour. Selfishness is a primitive strategy for survival and in the modern world it has mediocre benefits at best. Most suffering is unnecessary because we are allegedly intelligent and supposedly able to think; a solution exists.

At Komsberg, we have named a Burchell's zebra "Avoidance Doesn't Work" to emphasise one of the basic mechanisms necessary for change. Psychological avoidance may superficially appear to help, shutting off from disappointment, fear, or some other emotional pain - but this defensiveness actually makes matters worse. Having learned to react this way, you continue doing more of the same. As time passes, the psychological baggage just keeps mounting up. You "get by" and "cope", unwilling to fully understand or fully care or fully live. You settle for second best or even third best, perhaps grateful for mouldy old crumbs, as life whizzes by. People more or less copy each other; "monkey do what monkey see". It all becomes acceptable and normal. Oprah Winfrey wisely comments "All Americans are dysfunctional".....only failing to remember the rest of the world. (Perhaps the omission is explained by "God bless America"?!)

Before this fundamental issue of psychological behaviour can be tackled, it first needs to be understood. But there is an immediate problem. Most people don't want to know what the problem with them is. Avoidance kicks in; it's Ronseal and does

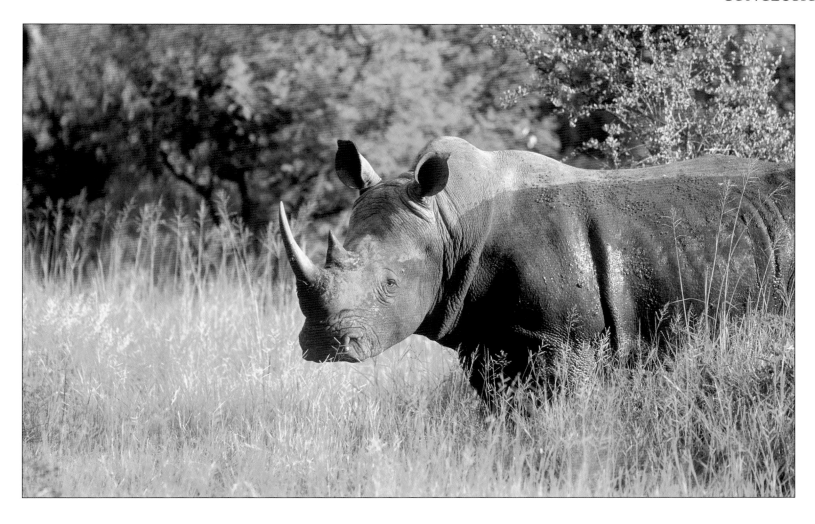

Above: We are into the second decade of the twenty-first century yet many people still indulge in superstitious beliefs and crave status symbols. And, yes, this comment intentionally goes beyond questioning just those in the Far East and Yemen who indulge in products made from rhino horn. Education should challenge limitations of all description.

Right: Overpopulation causes traffic jams in New Delhi, India, but also on the M25 motorway around London, on the freeways of Los Angeles, and in numerous other places. Something isn't necessarily preferable just because we have normalised and accepted it. The price of housing and food also goes up as a result of overpopulation. And there is more waste to dispose of.

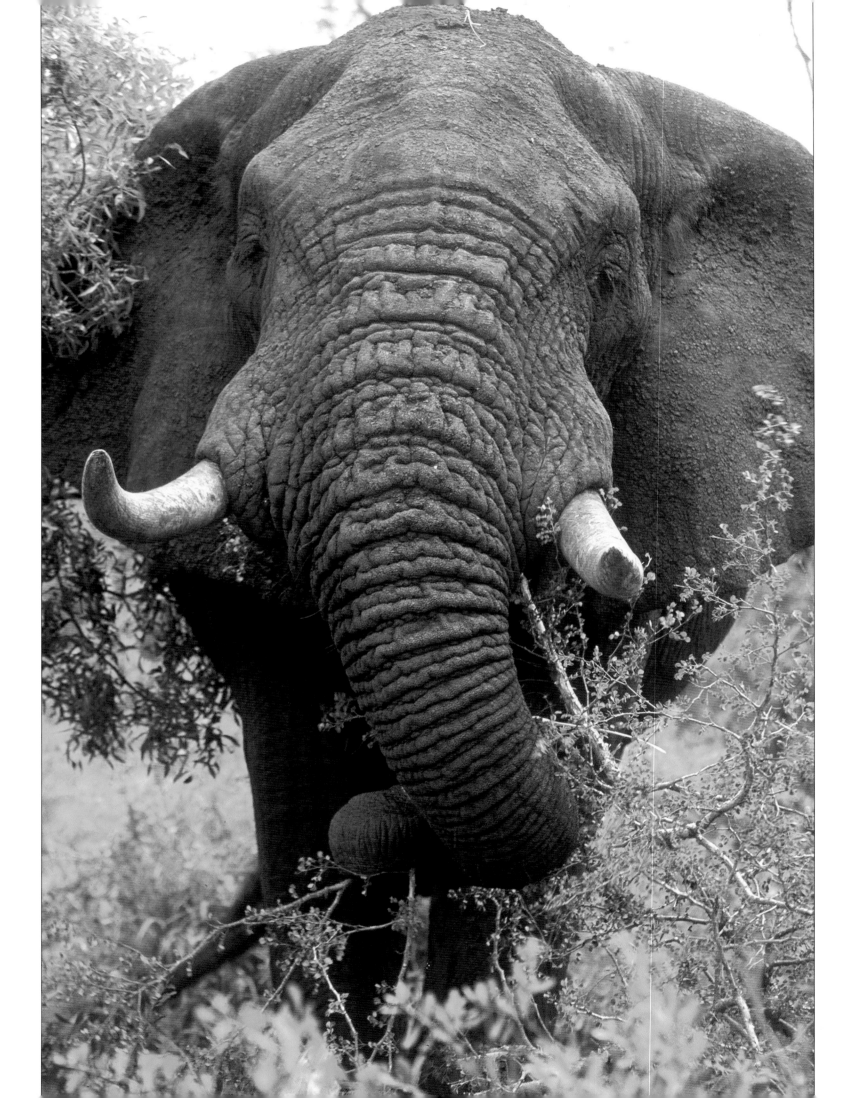

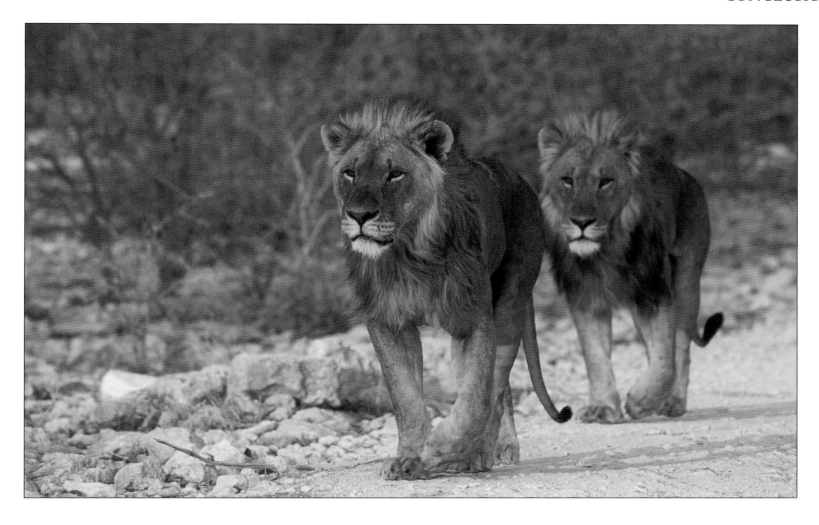

exactly what it says on the proverbial tin. Excuses roll off the tongue. A scapegoat is blamed. Intelligent people suddenly and conveniently misunderstand. Or the fog of apathy descends. Therefore nothing changes. The lid of Pandora's box stays closed.

If there is to be any significant environmental progress, human behaviour must first improve. Basic ethical values need to be identified and applied. The minefield of avoidance and hypocrisy has to be understood and cleared, step by step. Expectations have to be raised. There is a necessity for role models with integrity to emerge, who are worthy of consideration by others.

This is the biggest challenge of all. And I have previously described it as "an almost impossible task". But to ignore the fundamental problem is to guarantee continued failure or dysfunction.

If a journey of a thousand miles begins with the first step and then another and another, likewise a shift in the behaviour of humans must begin with one individual followed by another and another. Carlisle United's motto is yet again relevant here: "Be just and fear not."

Above and left: Anyone who has seen elephants and lions in the wild will have an appreciation for these magnificent animals. If we change our behaviour to become better human beings, this shift will benefit wildlife. And we will be helping ourselves.

Acknowledgements

Above: Becky (and Happy!).

Becky has capably assisted me in numerous ways for most of this book, sharing the high points and huge amounts of effort. Thank you for everything.

I next have to thank my friend and colleague Jonathan Braurer who has done much to help, as always. My other Wildlife For All Trust colleagues, both past and present, have also been supportive as needed. Vicky de las Heras and Wussy Gardner deserve special mention for their unstinting loyalty and duty. My ex-colleague Dave Mantle shared my first visit to Yellowstone, doing all the driving. Deanne Bennett spent most of the same trip in bed, seriously ill after her first cancer treatment, but was out there for *that* wolf encounter. We have all used our lives well in establishing Komsberg.

Thanks also to everyone who reviewed the manuscript for this book, including proof-reading. Jonathan was especially meticulous. Any errors or shortcomings are mine alone.

Becky and I were generously looked after by Vikram Singh, owner of Camp Mewar on Kettiya, whilst at Bandhavgarh National Park, India. The Maurya Sheraton & Towers and Marriott Hotel provided luxurious accommodation for us in New Delhi.

Travelling to and back from Etosha, we stayed at Old Mill Lodge and Mountain View Guest House in Springbok, South Africa, and at Windhoek Country Club Resort, Namibia. Our thanks to each of these for their kind hospitality.

Calumet is the UK's leading retailer of professional photography equipment. I am grateful for Calumet's generous support through the donation of a Nikon D300 camera body.

DayMen International kindly supplied my Lowepro camera bag and other accessories. Manfrotto Distribution Ltd provided my tripods; I have used Manfrotto tripods for the past 33 years and I appreciate their support for this essential part of my equipment. Fuji Ltd repeatedly donated Velvia film. A Rab jacket helped keep me warm during the two trips to Yellowstone in freezing conditions.

In the past, my colour transparency film was developed at The Vault - a professional digital photographic laboratory in Brighton. The Vault also then generously scanned all these photographic images in preparation for printing. Thanks to David Lane and Simon Evans.

Patrick Mahony again patiently guided me through any technical support needed in the design and layout of the book.

Photographic notes

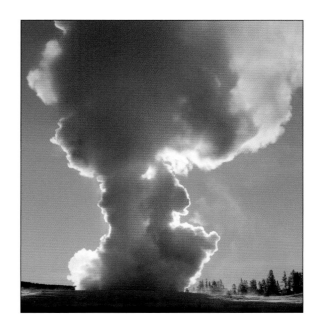

Most of the photographic images in this book were obtained using colour transparency or slide film, in particular the excellent Fujichrome Velvia. Eventually, like almost everyone else, I switched to digital.

Digital photography has overall advantages when it comes to using the acquired images for various purposes. However, I worry that today's young photographers will neglect one important lesson from no longer shooting with old-fashioned film. In the past, you were potentially limited by how much film you had available. With the digital format, you can just keep clicking away. Yet self-discipline is part of being a capable photographer; it is key to composing an image and also in deciding exactly when to click. Digital photography is easier than shooting with film and you can get lucky if you are Mr Clicky-Clicky-Clicky taking thousands of photographs.

Self-discipline is also important when editing your images. Don't keep anything less than the very best. Be highly critical of your results, striving for excellence. Your mother won't necessarily be the best judge of ability. If you do this, you'll probably get better and better - and, maybe one day, be good.

For over 20 years, I used a Nikon F4 SLR camera. The digital body I mainly now use is the Nikon D300. I find the following four Nikkor lenses sufficient for most situations: 28mm, 55mm macro, 80-200mm f/2.8, and 300mm f/2.8. I never use autofocus, preferring instead to trust myself by manually focusing at all times.

I almost always use a sturdy tripod to help reduce camera shake. My personal choice is the Manfrotto 190XBD and 804RC2 head. The quick-release plate allows for a speedy response. When shooting from the window of a vehicle, I use a large and heavy beanbag holding more than 8kg of rice.

My camera bodies, various lenses, and other equipment is kept safe in a Lowepro bag - specifically the CompuTrekker Plus AW.

When in a national park or reserve, I start before dawn and finish after dark. Many of the best wildlife opportunities happen in the first hour and last hour of daylight. This is also when the best light is usually available. Always be alert, ready for anything to happen.

Know where you're going well before travelling and find out if there is a prime time of the year to visit. Once there, quickly familiarise yourself with the key locations. Is a place best in the morning or afternoon?

Always respect wild animals, knowing they can be potentially dangerous. Be patient and humble. See what is going on and anticipate what might happen next.

Above: Old Faithful, Yellowstone. Backlighting can add dramatic effect. Visiting during the cold of mid-winter offers the opportunity to photograph this famous geyser with a huge column of steam.